SOFA
CHICAGO
SCULPTURE OBJECTS
& FUNCTIONAL ART

The Sixteenth Annual
Sculpture Objects & Functional Art Fair

November 6-8
Navy Pier

Produced by The Art Fair Company, Inc.

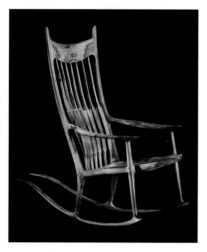

front cover:
Sam Maloof
Rocking Chair, 2001
zircote
45 x 26 x 46
courtesy of Dee and Charles Wyly
photo: Jason Dewey

All dimensions in the catalog
are in inches (h x w x d)
unless otherwise noted

Library of Congress – in Publication Data

SOFA CHICAGO 2009
The Sixteenth Annual Sculpture Objects & Functional Art Fair

ISBN-13: 978-0-9789206-4-7
Library of Congress Control Number: 2009908590

Published in 2009 by The Art Fair Company, Inc.

Graphic Design by Design-360° Incorporated, Chicago, IL
Printed by UniqueActive, Cicero, IL

SOFA CHICAGO

SCULPTURE OBJECTS & FUNCTIONAL ART

The Art Fair Company, Inc.
Producers of SOFA CHICAGO 2009
4401 North Ravenswood, Suite 301
Chicago, IL 60640
voice 773.506.8860
fax 773.345.0774
www.sofaexpo.com

Michael Franks
Chief Executive Officer
The Art Fair Company, Inc.

Mark Lyman
President
The Art Fair Company, Inc.
Founder/Director, SOFA Fairs

Anne Meszko
Julie Oimoen
Kate Jordan
Greg Worthington
Barbara Smythe-Jones
Patrick Seda
Michael Macigewski
Bridget Trost
Aaron Anderson
Stephanie Hatzivassiliou
Ginger Piotter
Heidi Hribernik
Erinn M. Cox

Conte

SOFA CHICAGO
SCULPTURE OBJECTS & FUNCTIONAL ART

7 Acknowledgements

12 Lecture Series/Special Exhibits

16 Essays

18 *The Hemingway of Hardwood: Sam Maloof 1916 - 2009*

24 *Of Kilns, Cows and The Ghost of Leon Trotsky*
By David Linger

28 *Václav Cigler: Spherical Spaces*
By Jana Šindelová

32 *Silver & Design – Where do we go now...?*
By Alastair Crawford

36 *Regarding BIGG*
By Scott Benefield

42 *AIDA's Gems – Israel's Jewelers*
By Erika Vogel

46 *Will there be a New Generation of Woodturners?*
By Mary Lacer

50 *No Pretense: The Evocative Glass Sculpture of Lucy Lyon*
By Leanne Goebel

54 *Shozo Michikawa: Nature into Art*
By Simon Martin

56 SOLO at SOFA

68 Exhibitor Information

224 Partners

274 Index of Exhibitors

280 Index of Artists

Welcome to SOFA CHICAGO 2009!

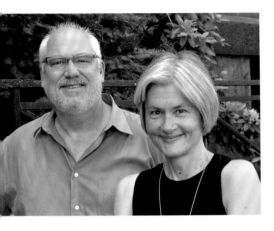

Welcome to the 16th SOFA CHICAGO!

As Founder/Director of SOFA and President of The Art Fair Company (AFC), which now produces the SOFA Fairs, I welcome you to SOFA CHICAGO 2009. This past summer, the SOFA brand headed west, debuting SOFA WEST: Santa Fe with 35 top presenting galleries and over 10,000 visitors crowding the aisles! We were blown away by the response, and hope you will plan now to attend not only SOFA NEW YORK 2010 in April, but also SOFA WEST: Santa Fe in July—Santa Fe's high season with the Opera and many other arts events in full swing!

When Anne and I heard the grievous news that that legendary furniture artist, Sam Maloof had passed away in May, we immediately wanted to honor him with a very special tribute at SOFA CHICAGO. For Sam was the living embodiment of fine hand-craftsmanship. Even when his furniture began reselling for 100 times its original price, he continued to refer to himself modestly as a "woodworker."

Events planned for the SOFA CHICAGO Maloof Tribute include a fundraising dinner on Opening Night to benefit The Sam and Alfreda Maloof Foundation for Arts and Crafts, whose mission is "to perpetuate excellence in craftsmanship, encourage young artists, and make available to the public the treasure house the Maloof's lovingly created." Nestled at the foot of the San Gabriel Mountains in Alta Loma, California are Sam's workshops and two adjoining, sprawling hand-built residences—one he shared with his second wife, Beverly Wingate Maloof, whom he married in 2001; the other, he shared with his first wife and business partner of fifty years, Alfreda, who passed away in 1998. This original residence is now open to the public. It is a magical world that Sam created for himself and his family and I urge you to read this catalog's essay describing the charitable Foundation, and plan to visit the gorgeous six-acre compound to see for yourself the living legacy of the Arts and Crafts Movement.

Sam's artistry will continue with the "boys," as he affectionately called them, continuing his business, Sam Maloof Woodworking, Inc. Don't miss *The Legacy Continues* special exhibit at SOFA CHICAGO, where you will see how well the Master trained his apprentices over the course of many arduous and happy years.

The tribute dinner on Opening Night will also support Anderson Ranch Arts Center Maloof Scholarship Fund, and The Furniture Society Scholarship Program. Many thanks are in order to Honorary Chairpersons Beverly Maloof, Lee Eagle, Jack Lenor Larsen, George Larson and Chicago's own uncommonly dedicated arts supporters, Joan Harris and John H. Bryan. Also to the Maloof Tribute advisory committee: Gail Fredell, Chairperson, Sylvia Bennett, Robyn Horn, Don Reitz, Ray Leier and William Zimmer. We will all miss you very much, Sam.

Many thanks again to Chubb Personal Insurance for their generous sponsorship which makes possible the SOFA CHICAGO VIP lounge and other special happenings at the Chicago fair. Our thanks also to the many individuals and organizations supporting the top-notch special exhibits at SOFA CHICAGO and presentations in the Lecture Series.

And saving for last, the most important persons to thank—the SOFA CHICAGO 2009 presenting galleries and dealers, who in this tough economy are back with their finest artists on view—they are betting big that art means more to SOFA visitors than the blue chips. I urge you to purchase art according to your means, which will not only give you lasting pleasure but also support a hard-working gallery community so that they may continue to nurture the very artists who make SOFA such a wonderland of discovery. For after all, an art fair is first and foremost, a marketplace.

So, let us all dig deep in support of those who make SOFA CHICAGO happen.

Enjoy!

Mark Lyman
President, The Art Fair Company, Inc.
Founder/Director, SOFA

Anne Meszko
Director of Advertising and
Educational Programming, SOFA

photos: David Barnes

The producers of SOFA CHICAGO would like to thank the following individuals and organizations:

Participating galleries, artists, speakers and organizations
AF Services
Paul Allingham
American Airlines
American Association of Woodturners
Art Alliance for Contemporary Glass
The Art Institute of Chicago
Art Jewelry Forum
The Arts Club
Association of Israel's Decorative Arts
David Bagnall
The Bailey Family
Linsey Bailys
Bannerville USA
Ryanne Baynham
Judy Bendoff
Scott Benefield
Melinda Bennett
Ginny Berg
Ros Bock
Jim Bradaric
Lou Bradaric

Donald Bromagin
John Brumgart
Bryan Cave LLP
John H. Bryan
Winn Burke
Anthony Camarillo
Carol Fox Associates
Center for Craft, Creativity and Design
Eileen Chambers
Chicago Art Dealers Association
Chicago Woodturners
Chubb Personal Insurance
Pam Clark
Collectors of Wood Art
Camille Cook
Corning Museum of Glass
Keith Couser
John Cowden
Crabtree Farm
Susan Cummins
David Daskal
Beth Dempsey
Design-360°
Floyd Dillman

Dobias Safe Rental
Hugh Donlan
Anne and Lenny Dowhie
Bryan Dowling
Lee Eagle
Bridget Eastman
Catherine Edelman
Marianne Encarnado
Glenn Espig
D. Scott Evans
Jane Evans
Sean Fermoyle
Focus One
Carol Fox
Friends of Contemporary Ceramics
Friends of Fiber Art International
The Franks Family
Gail Fredell
Don Friedlich
Carlo Garcia
Steve Gibbs
Tim Gillengerten
Andrew Glasgow

Justin Glasson
Tom Gleason
Leanne Goebel
Judith Gorman
Fern Grauer
Trudi Greenway
Deb and John Gross
Richard Harned
Lauren Hartman
Constantine Hatzivassiliou
Tom Hawk
Scott Hodes
Robyn Horn
Michael Hribernik
The Hribernik Family
Intuit: The Center for Intuitive and Outsider Art
J&J Exhibitors Service
Mary Jane Jacob
Scott Jacobson
James Renwick Alliance
Howard Jones
Tom and Sandi Kully
Cris Levy
Mary Lacer

George Larson
Peggy Leslie
Lillstreet Art Center
David Linger
Linda Lofstrom
Jeanne Long
Suzanne Lovell
Ellie Lyman
Nate Lyman
Sue Magnuson
Jeanne Malkin
Beverly Maloof
Frank Maraschiello
George Mazzarri
Rob McGinley
Metropolitan Pier & Exposition Authority
Metropolitan Capital Bank
Matt Miller
Mint Museum of Craft + Design
Dominic Molon
Michael Monroe
Bill Murphy
Mary Murphy
Nancy Murphy

Susan Murphy
Museum of Contemporary Art
Ann Nathan
Betsy Nathan
NFA Space Contemporary Art + Exhibit Services, Inc.
Emily Nixon
John Olson
Pagoda Red
Commissioner Michael J. Picardi
Karl Piotter
Pilchuck Glass School
Valerie Pistole
Joe Ponegalek
Jennifer Poskin
Racine Art Museum
Amber Reyes
Richard H. Driehaus Museum
Christoph Ritterson
Bruce Robbins
Elisabeth and Norman Sandler
Robert Shearer
Miroslava Sedova

Stacey Silipo
Franklin Silverstone
Jana Šindelová
Dana Singer
Jan Mirenda Smith
Society of North American Goldsmiths
Ethan Stern
Dorit Straus
Surface Design Association
Tattooed Tees
Greg Tazic
Heather Van Delft
Natalie van Straaten
Erika Vogel
Watershed Center for the Ceramic Arts
James White
Marilyn White
Namita Gupta Wiggers
The Wingate Foundation
Ron and Anita Wornick
Kate Zeller
Karen Ziemba
Shira Zisook

7

60 internationally known
interior designers and architects

Building the SOFA brand

Promoting the Fairs
to their colleagues

Attending with discerning clients

SOFA National Designer Committee

Special thanks to the National Designer Committee for their support of SOFA.

SOFA CHICAGO 2009

Designer Breakfast and Fair Preview

Friday, November 6, 9:30 am

Champagne cocktails and un petit

déjuner with remarks by special

guest designer George Larson

Honorary Chair

Jack Lenor Larsen

Co-Chairs

Nancy Epstein

Steven Gambrel

Amy Lau

David Ling

Suzanne Lovell

Maya and Joyce Romanoff

Committee

Frank de Biasi and Gene Meyer	Richard Mishaan
Bruce Bierman	Juan Montoya
Lars Bolander	Brian Murphy
Darcy R. Bonner	Sandra Nunnerley
Christopher B. Boshears	Dennis Rolland
Geoffrey Bradfield	H. Parkin Saunders
Patricia Brownell	Tom Scheerer
Mario Buatta	Steven Sclaroff
Barclay Butera	Betty Sherrill
Sherrill Canet	Michael Simon
Ellie Cullman	Marjorie Shushan
Joanne De Palma	Stephen Miller Siegel
Jamie Drake	Matthew Patrick Smyth
Arthur Dunnam	Stephanie Stokes
Douglas Durkin	Carolyn Tocks
Andrew Fisher	Timothy Van Dam and Ronald Wagner
Lisa Frazar	
Patrick Gallagher	Alan Wazenberg
Jennifer Garrigues	Jennifer Watty
Alexander Gorlin	Jeffrey Weisman
Philip Gorrivan	Ilene Wetson
George Larson	Matthew White and Frank Webb
Timothy Macdonald	
David Mann	Rod Winterrowd
Brian McCarthy	Michel Cox Witmer
	Stephanie Wolhner

photos: David Barnes

OFFICE OF THE MAYOR

CITY OF CHICAGO

RICHARD M. DALEY
MAYOR

November 5, 2009

Greetings

As Mayor and on behalf of the City of Chicago, it is my pleasure to welcome everyone attending the 16th Annual Sculpture Objects and Functional Art Fair: SOFA CHICAGO 2009 at Navy Pier.

SOFA CHICAGO 2009 features a wide variety of artistic styles and medias from glass, ceramics and wood to metal and fiber. This 16th annual art fair features work from 70 international galleries and dealers. Continuing this year will be an extensive lecture series and several special exhibits. Over the years, attendance at SOFA CHICAGO has more than doubled, and each year more and more of our residents look forward to the unique experience the show offers.

Chicago has a long and vibrant artistic tradition and we are proud to host SOFA CHICAGO 2009. I commend the artists represented here for their talent and hard work, as well as The Art Fair Company, for bridging the worlds of contemporary decorative and fine art. May you all have an enjoyable and memorable exposition.

Sincerely,

Mayor

CHICAGO ART DEALERS ASSOCIATION

730 North Franklin
Suite 308
Chicago, Illinois
60610

Phone
312.649.0065

Fax
312.649.0255

November 5, 2009

Mark Lyman
SOFA CHICAGO 2009
4401 North Ravenswood, #301
Chicago, IL 60640

Dear Mark,

On behalf of the Art Dealers Association of Chicago, I would like to welcome SOFA CHICAGO 2009 back to our extraordinary city. Now in its 16th year, SOFA CHICAGO brings together dealers from many disciplines, showcasing fine and decorative arts. Featuring glass, ceramics, furniture, jewelry and mixed media arts, SOFA CHICAGO continues to exhibit innovative works which expands our understanding of the various art forms.

The Chicago Art Dealers Association applauds The Art Fair Company and participating galleries and artists and their commitment to Chicago. Congratulations on another successful art fair.

Sincerely,

Catherine Edelman, President
Art Dealers Association of Chicago

Salon

Lecture Series

sponsored by SOFA CHICAGO 2009

Admission to the 16th Annual SOFA CHICAGO Lecture Series is included with purchase of SOFA ticket.

Friday
November 6

Fiber Art: Expressions and Aesthetics, Part I
Fiber artists Marcia Docter, C. Pazia Mannella, Carol B. Shinn and Barbara Lee Smith share their ideas and inspirations. *Presented by Friends of Fiber Art International*

Represented by (in order): Snyderman-Works Galleries; Snyderman-Works Galleries; Jane Sauer Gallery; Snyderman-Works Galleries

Emerging Artists 2009
Lauren Kalman, Arthur Hash and Robert Longyear create jewelry that blurs the boundaries between sculpture, installation, photography, technology and handwork. *Presented by the Society of North American Goldsmiths*

Represented by (in order): Sienna Gallery; Sienna Gallery; Charon Kransen Arts

Lucy Lyon: Adding a Dimension
Glass sculptor Lucy Lyon discusses her transition from stained glass to cast glass sculpture, and her fascination with the figure, emotional gesture and placement in space.

Represented by Thomas R. Riley Galleries

Fiber Art: Expressions and Aesthetics, Part II
Fiber artists Jon Eric Riis, Geoffrey Gorman, Marilyn Pappas and Kate Cusack share their ideas and inspirations. *Presented by Friends of Fiber Art International*

Represented by (in order): Jane Sauer Gallery; Jane Sauer Gallery; Snyderman-Works Galleries

Pain and Glory: The Birth of the Studio Glass Movement
Artist Tom McGlauchlin, a colleague of Harvey Littleton, shares personal insights into the birth of studio glass and its influence on his work.

Represented by Palette Contemporary Art

Sam Maloof and the Secondary Market
Frank Maraschiello, Vice President and Director of 20th Century Decorative Art, Bonhams presents an in-depth analysis of the work of Sam Maloof and its rise on the secondary market, including the record setting sale of 2007.

Weaving a Persian Heartbeat
Bahram Shabahang and Geoffrey Orley traveled to Iran with Chicago art patron John Bryan and designer George Larson to observe the creation of Orley Shabahang's contemporary Persian carpets. Speakers: Bahram Shabahang and Geoffrey Orley, principals, Orley Shabahang; and George Larson, George Larson Consultancy

Connecting Journeys
Australian artist Giles Bettison looks at his 20 year journey with murrini glass and the converging themes that he has explored during that time.

Represented by Jane Sauer Gallery

Now that I bought this thing, what's it worth?
You bought it because you love it. But now, how do you put the proper value on it? Get inside tips on art valuation from experts. Speakers: Leatrice S. Eagle, JD, ASA, AAA; Frank Maraschiello, Vice President and Director of 20th Century Decorative Art, Bonhams; Dorit Straus, Worldwide Fine Arts Manger, Chubb Personal Insurance; moderated by Scott Jacobson, Scott Jacobson Gallery. *Presented by Chubb Personal Insurance*

Philanthropy: The Impact of Scholarships
Panelists discuss the impact of philanthropic scholarships on emerging talent in our field, and the benefit to recipients and participating university programs. Speakers: Russell Baldon, Assistant Professor, Furniture Program, California College of the Arts (CCAC); Yvonne Mouser, student, CCAC; Vita Plume, Associate Professor, College of Design, North Carolina State University, Raleigh; Andrea Donnelly, student, NCSUR. *Presented by Ron and Anita Wornick, Windgate Foundation, and the Center for Craft, Creativity and Design*

Laura de Santillana: Containers
de Santillana discusses her artistic world through the theme of the container and her love for boxes and vessels. With Janet Koplos, Art Critic and Guest Editor-in-Chief of *American Craft* and Catherine Futter, Curator of Decorative Arts, The Nelson-Atkins Museum of Art, Kansas City, MO.

Represented by Barry Friedman Ltd.

Mirjam Hiller: Simplicity, Intensity and Jewelry
Mirjam Hiller talks about her work and inspirations, "Sometimes it is loud, sometimes quite subtle. Sometimes it is dazzlingly colorful, sometimes colorless; sometimes it is everything at once." *Presented by the Society of North American Goldsmiths*

Represented by Charon Kransen Arts

Václav Cigler: The Universe through Optical Glass
A preeminent pioneer of Slovak glass innovation, Václav Cigler has influenced generations of sculptors. Using optical glass, Cigler's geometric works invite the observation of the universe, from the astronomic cosmos to the microcosm of a cell. Linda Tesner, Director and Curator, The Ronna and Eric Hoffman Gallery of Contemporary Art, Lewis & Clark College, Portland, OR *Presented by Litvak Gallery*

LEGENDS: What Makes Them Great?
Janet Koplos talks about the work of Ruth Duckworth, Jim Melchert, Don Reitz and Toshiko Takaezu and the context of their emergence and mastery in the ceramic arts. Koplos is the Guest Editor-in-Chief, *American Craft*, and co-author of Makers: 20th Century American Studio Craft. *Presented by Watershed Center for the Ceramic Arts*

Identifying Breakthrough Ideas in Global Glass
Organizers and jurors of the exhibit *BIGG: Breakthrough Ideas in Global Glass* discuss how they selected more than 40 international artists for this innovative exhibition. Speakers: Richard Harned, Director, OSU Glass Program; Tom Hawk, Director, Hawk Galleries; Tina Oldknow, Curator of Modern Glass, Corning Museum of Glass; Lino Tagliapietra, Italian glass maestro; Kelly Stevelt Kaser and Valarie Williams, OSU Urban Arts Space

Michael Cooper – Late Bloomer
A visual journey in sculpture of an unusual combination—form, materials, engineering, humor and movement—even some work you can sit in!

Represented by William Zimmer Gallery

Insight and Inspiration: The Legacy of Sam Maloof
Artists reflect on the creative and life lessons learned from Sam: his humble, down-to-earth instruction, shared workshop experiences, and lively stories of the perils and joys of pursuing artistry in furniture. Speakers: Thomas Hucker, artist; Roseanne Somerson, artist, Department Head, Furniture Design, RISD; Rick Sturtz, artist; moderated by Gail Fredell, artist, Director of Programs and Development, The Furniture Society

Special Exhibits

Saturday

November 8

Looking Backward:
Historic Influences on
Contemporary Work
The marquetry furniture decoration of artist **Silas Kopf** references antique furniture. The key is making the "old" modern.

Represented by William Zimmer Gallery

MATERIAL TRANSFORMATION:
Found and Procured
Fiber artists **Jan Hopkins** and **Lesley Richmond** discuss their innovative use of materials and processes to create alternative forms and surfaces. *Presented by Surface Design Journal*

Represented by Jane Sauer Gallery

Curatorial Conundrums:
From Collection to Exhibition
Curator **Namita Wiggers**, Museum of Contemporary Craft, Portland OR, explores how curators communicate important experiential qualities of contemporary art jewelry in a museum setting. Followed by the Art Jewelry Forum's presentation of their 2009 Emerging Artist Award to artist **Sharon Massey.**
Presented by Art Jewelry Forum

Written: Word As Image
Artist **Jeanne Raffer Beck** makes the gestural act of writing the artistic subject of her textile works, combining fragments of contemporary and ancient texts with invented language.

Represented by Maria Elena Kravetz

Michael Peterson:
Evolution / Revolution
A conversation between wood sculptor **Michael Peterson** and Bellevue Arts Museum curator **Michael Monroe** based on the artist's retrospective exhibition organized by the Museum and touring nationally.

Represented by del Mano Gallery

Stories from the Crystal
Palace: New Jewelry from
Barbara Seidenath
Seidenath, who has been exploring the use of enamel in jewelry for more than 30 years, guides you through her world, sharing sources of inspiration and explaining her work process.

Represented by Sienna Gallery

Progressions: an
Artist's Journey
From the crutches of skill, to a world of technique and discovery, **Alex Gabriel Bernstein** discusses the constant search for his artistic voice.

Represented by Chappell Gallery

Material, Influences, Poetry
Thomas Hucker discusses the extraordinarily expressive potential of wood and historic uses of the media—and how the dialog between the two influences his current furniture.

Represented by William Zimmer Gallery

Hyper-Realistic Mosaics
Italian artist **Andrea Salvador** discusses his hyper-realistic, glass mosaic narratives that explore the intimate thoughts of his subjects.

Represented by Berengo Studio 1989

A View of Nature: the
Ceramic Art of Kurt Weiser
"I gave up trying to control nature, deciding instead to express ideas about nature itself and my place in it." Artist **Kurt Weiser** presents an illustrated overview of his work over the last four decades.

Represented by Ferrin Gallery

Influence & Inspiration: the
Evolving Art of Woodturning
Emerging artists and their mentors discuss the creative process. Artists **Joey Richardson, Jakob Weissflog, Binh Pho** and **Hans Weissflog,** moderated by **Kevin Wallace,** Director of the Beatrice Wood Center for the Arts, Ojai, CA. *Presented by the American Association of Woodturners*

All artists represented by del Mano Gallery

Silver & Design:
Where Do We Go Now?
A look at the potential future of silver manufacture in today's world of fashion and design. **Alastair Crawford,** Crawford Contemporary

Living with Sam
A discussion of the philosophical insights and inspiring life example of Sam Maloof. Each panelist will talk about Sam's unique qualities and what they gained from their relationships (real and implied) with him. Speakers: **Michael Monroe,** Curator, Bellevue Arts Museum; **Garry Knox Bennett,** artist, represented by Scott Jacobson Gallery and William Zimmer Gallery; moderated by collector **Lee Eagle**

SIX GREAT MOMENTS
in the history of glass
The lecture, illustrated by objects from the Corning Museum of Glass, focuses on six moments in the history of glass between the 15th century BC and the present. **Dr. David Whitehouse,** Executive Director, Corning Museum of Glass, Corning, NY. The Corning Museum of Glass is the recipient of Art Alliance for Contemporary Glass's annual award for an institution furthering the studio-glass movement. *Presented by Art Alliance for Contemporary Glass*

The Legacy Continues:
Sam Maloof Woodworking
As a leader of the California modern arts movement, the late Sam Maloof designed and hand-crafted furniture infused with elegant artistic vision for more than half a century. Sam Maloof Woodworking, Inc. continues his legacy with woodworkers Larry White, David Wade and Mike Johnson at the master's bench, to whom Maloof entrusted the business, and whose work, alongside Maloof's, will be on view. *Presented by Sam Maloof Woodworking, Inc. and the Sam and Alfreda Maloof Foundation for Arts and Crafts*

AIDA's Gems –
Israel's Jewelers
The Association of Israel's Decorative Arts (AIDA) fosters the development of contemporary decorative artists from Israel by connecting them to an international audience of galleries, institutions, and collectors. This year, AIDA returns to SOFA with an exhibition of art jewelry by former AIDA artists and newcomers. *Presented by AIDA in cooperation with Jim and Nancy Yaw*

BIGG: Breakthrough
Ideas in Global Glass
An exhibition exploring the future of glass by examining the works of a broad cross-section of recent graduates using the medium, organized around the concept of a breakthrough idea: works that pioneer new territory—conceptual or technological. *Presented by Ohio State University and Hawk Galleries*

Influence & Inspiration: The
Evolving Art of Woodturning
An exhibition of works by emerging woodturners and their influential mentors—a one-on-one supportive relationship critical to growing a new generation of artists and collectors. *Presented by the American Association of Woodturners*

LEGENDS: Watershed
Artists Honor Artists
Watershed Center for the Ceramic Arts honors and presents the work of four artists—Ruth Duckworth, Jim Melchert, Don Reitz and Toshiko Takaezu—whose influence and contribution to art and ceramics continue to shape generations of artists and collectors. *Presented by Watershed Center for the Ceramic Art*s

Essays

The Hemingway of Hardwood:
Sam Maloof 1916 - 2009

Of Kilns, Cows and The
Ghost of Leon Trotsky
By David Linger

Václav Cigler: Spherical Spaces
By Jana Šindelová

Silver & Design –
Where do we go now...?
By Alastair Crawford

Regarding BIGG
By Scott Benefield

AIDA's Gems – Israel's Jewelers
By Erika Vogel

Will there be a New
Generation of Woodturners?
By Mary Lacer

No Pretense: The Evocative
Glass Sculpture of Lucy Lyon
By Leanne Goebel

Shozo Michikawa: Nature into Art
By Simon Martin

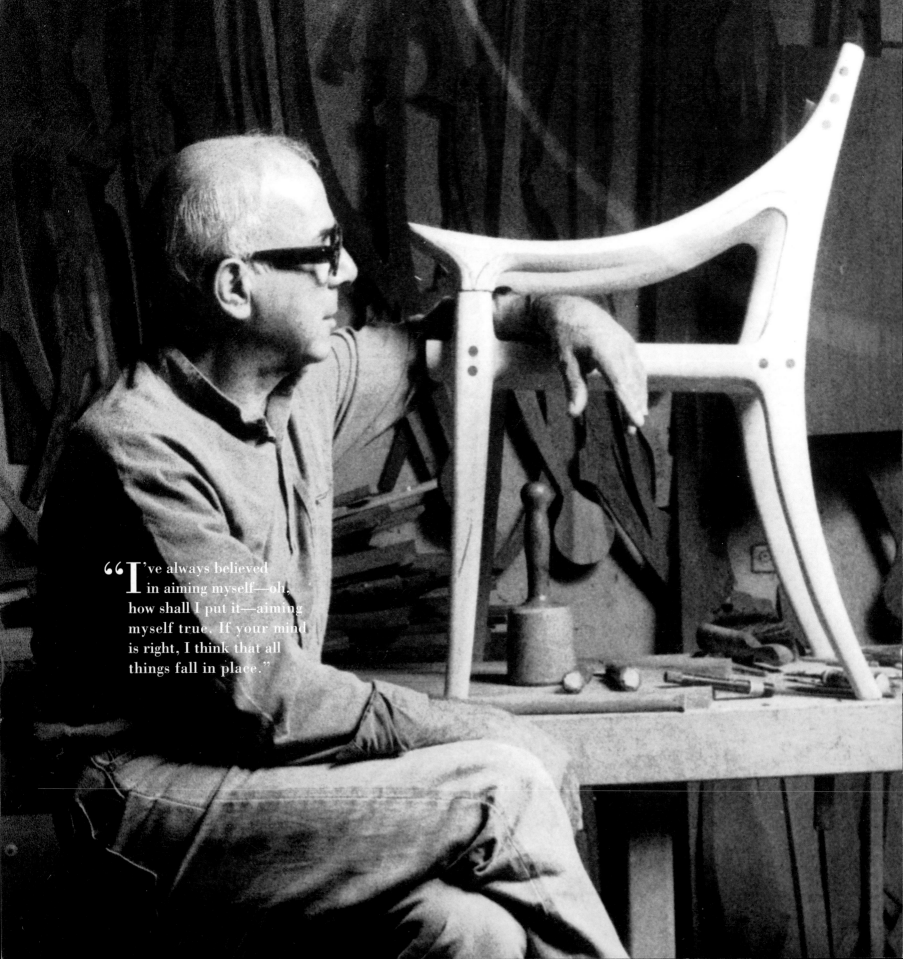

66 I've always believed in aiming myself—oh, how shall I put it—aiming myself true. If your mind is right, I think that all things fall in place."

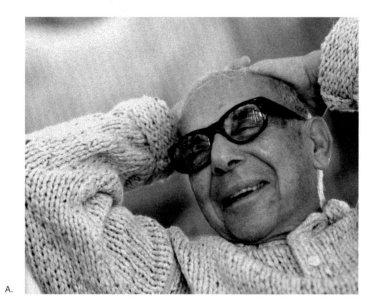

A.

Sam's artful legacy will continue on at Sam Maloof Woodworking Inc., a privately owned company, with woodworkers Larry White, David Wade and Mike Johnson at the Master's bench. The three men trained and worked closely with Sam on his signature furniture for many years, perfecting his sweeping sculptural style renowned worldwide for its exquisite craftsmanship and design. Sam left the business to "the boys" as he affectionately called them and their work, alongside his, is on view in *The Legacy Continues* special exhibit at SOFA CHICAGO.

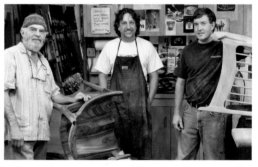

B.

THE HEMINGWAY OF HARDWOOD:
SAM MALOOF 1916 - 2009

As a leader of the California modern arts movement, Sam Maloof designed and hand-crafted furniture infused with artistic vision for more than half a century. His many achievements included a MacArthur Fellowship, an honorary doctorate from the Rhode Island School of Design, and a retrospective at the Smithsonian American Art Museum's Renwick Gallery. Sam always humbly referred to himself as a "woodworker," even as his furniture became part of the nation's finest private and museum collections such as the Metropolitan Museum of Art. "I like the word," he said. "It's an honest word."

Sam's contributions will also live on with the important work of The Sam and Alfreda Maloof Foundation for Arts and Crafts, a 501c3 charitable organization established in 1994 and located in Southern California. Nestled at the foot of the lovely San Gabriel Mountains are Sam's workshops and two adjoining, sprawling hand-built residences—one he shared with his second wife, Beverly Wingate Maloof, whom he married in 2001; the original residence he shared with his first wife and business partner of fifty years, Alfreda, who passed away in 1998. The latter is now a museum open to the public and contains Sam's fine art collection, which encompasses work from all media, including many renowned artists such as Maria Martinez, Millard Sheets, Harrison McIntosh, Paul Soldner, Kay Sekimachi, and Bob Stocksdale.

The Foundation's mission is to perpetuate excellence in craftsmanship, encourage artists and make available to the public the treasure house the Maloofs lovingly created. It is also responsible for the protection and conservation of the art, furnishings, structures and grounds entrusted to it. The museum residence itself is one of the most treasured parts of the collection, reflecting the living spirit of the arts and crafts movement. The Foundation also makes the Maloof Center available to the public, artists and researchers and is developing a variety of programs, including visiting craftsmen, workshops, and arts and crafts exhibits. The Jacobs Education Center provides gallery and meeting space.

A.
A staff photo from the Inland Valley Daily Bulletin

B.
From left to right: Larry White, David Wade, Mike Johnson
photo: Sioux Bally–Maloof, Heartstone Arts

"**O**nce you have breathed, smelled, and tasted the tanginess of wood and have handled it in the process of giving it form, there is nothing, I believe, that can replace the complete satisfaction gained. Working a rough piece of wood into a complete, useful object is the welding together of man and material."

"**I** love wood, or I would not be working with it. Nevertheless, I do not build up a mystique about it. A craftsman must respect his material. Out of this respect comes a fusion that allows the creation of an object, the making of which brings a satisfaction and contentment that few people ever experience. How much more meaningful it becomes if one wears a bit of humility that allows him to acknowledge that it is truly God who is Master Craftsman. He uses us. Our hands are his instruments."

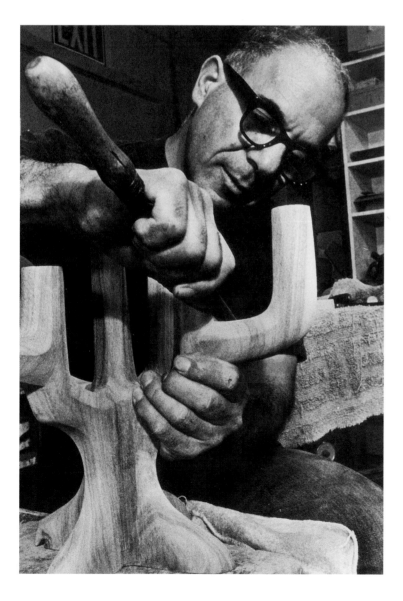

"I do not try consciously to make my pieces reflect their maker, but I hope that my furniture is an outgoing part of my personality and my way of thinking. I hope that it is vibrant, alive and friendly to the people who use it."

"The very best way to live is doing something you love, in the surroundings you built for yourself and your family."

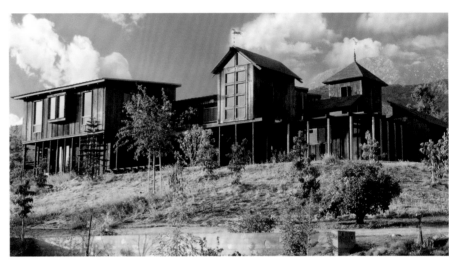

C.

"Whatever I am working on, I get excited. It does not matter if I have done the same piece many times. I still cannot wait to get out to the shop in the morning. This is especially true when I am working on a piece that I have never done before. Work is a renewal of energy. People ask me what my favorite piece is. My favorite piece is the piece I am working on."

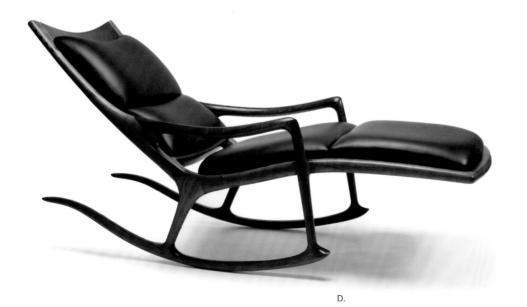

D.

Published in conjunction with the SOFA CHICAGO 2009 Maloof tribute dinner, lecture *Insight and Inspiration: The Legacy of Sam Maloof* and special exhibit *The Legacy Continues: Sam Maloof Woodworking* presented by Sam Maloof Woodworking, Inc. and The Sam and Alfreda Maloof Foundation for Arts and Crafts. For more information visit www.malooffoundation.org.

Special thanks to Beverly Maloof, Lee Eagle, Joan Harris, John H. Bryan, Jack Lenor Larsen, George Larson and the SOFA CHICAGO 2009 Maloof Tribute Advisory Committee: Gail Fredell, Chairperson; Sylvia Bennett, Robyn Horn, Don Reitz, Ray Leier and William Zimmer.

C.
photo: Sioux Bally–Maloof, Heartstone Arts

D.
One of Sam's last pieces, created in celebration of his 93rd birthday
photo: Gene Sasse

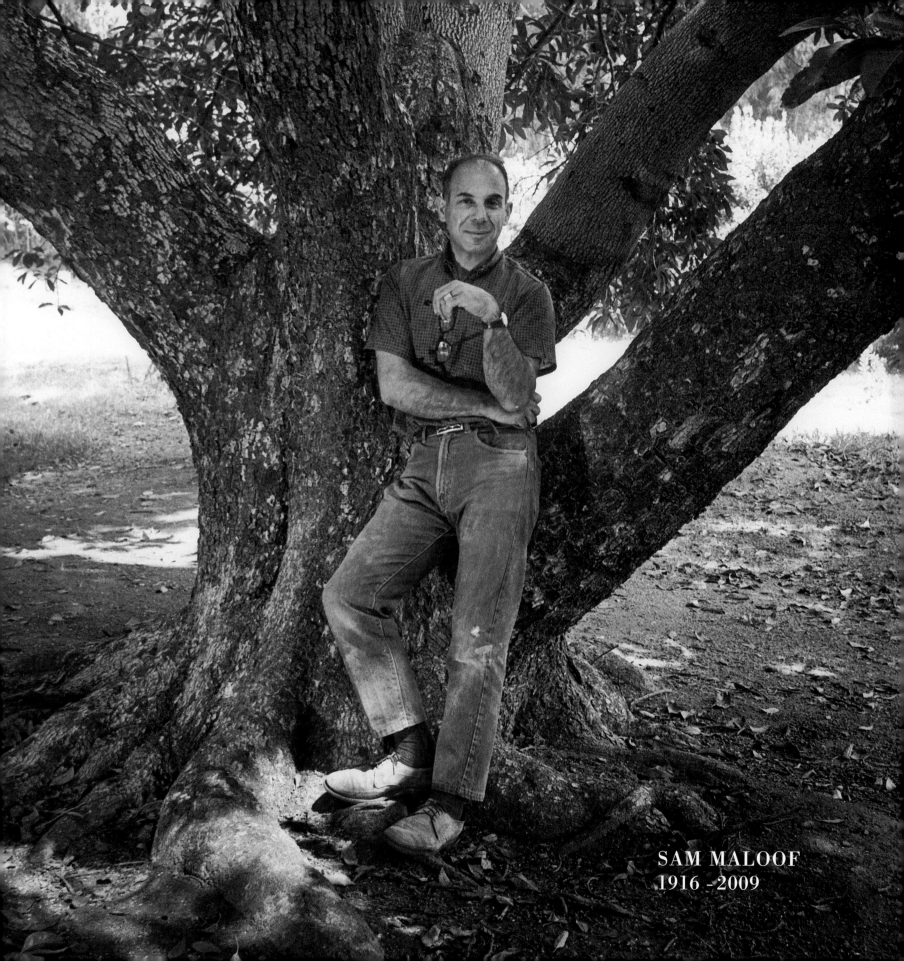

SAM MALOOF
1916 -2009

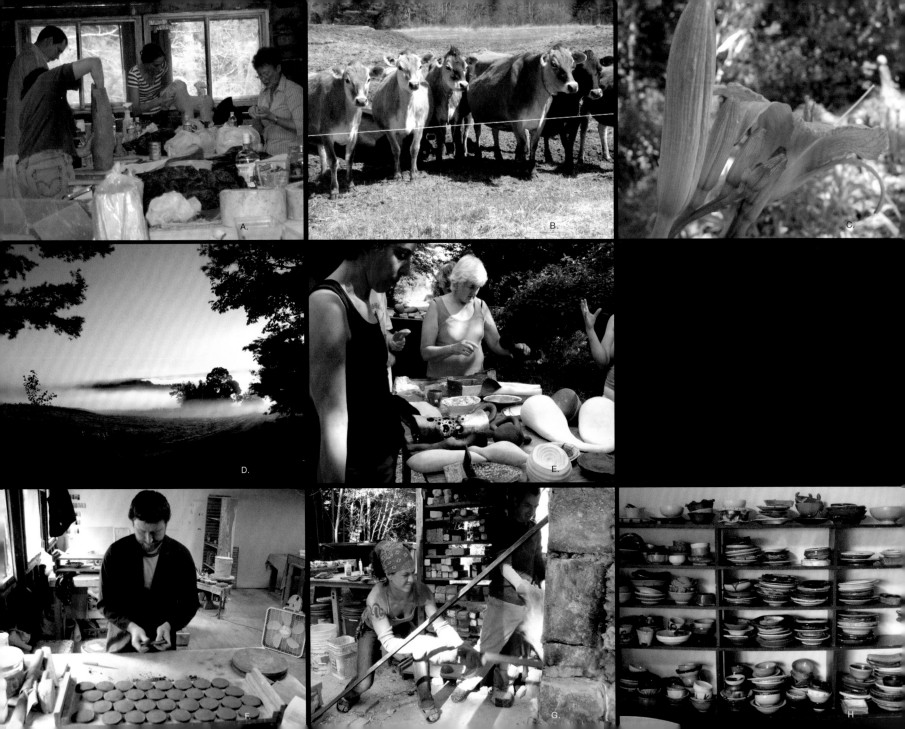

A.

B.

C.

D.

E.

F.

G.

H.

When I got a cryptic email from Nancy Selvin in the spring of 2006, I began to worry. Nancy had been a student at Berkeley in the golden age of the great and crusty Peter Voulkos, and had been teaching ceramics for decades at serious schools. She had viewed my work on numerous occasions and was always friendly, but after each visit I was left with the impression that she considered me a lightweight. As always, I took it personally. The mysterious tone and timing of the email, just as I was about to graduate from her alma mater, convinced me that Nancy, with her unimpeachable gravitas, had decided it was her duty to defend the dignity of the profession and save me from real-world humiliation by telling me to quit while I was ahead. Instead, she told me that I was being offered a scholarship for a two-week residency at Watershed Center for the Ceramic Arts, in Newcastle, Maine, where she was a member of the Board of Trustees.

This amazing reversal of fortune triggered a flood of questions: What exactly was Watershed? What went on there? Were the other residents going to be famous and intimidating? Would I be expected to throw off my superego, like Judy Chicago, and produce a dinner service expressing my innermost longings? *Were there ticks?* I wanted details, and Lesley Baker, a professor of ceramic art who had been to Watershed a few times, supplied plenty. She described the Watershed summer routine: wake up, eat breakfast, bond, make ceramics in barn, eat lunch, put on bug repellent, make more ceramics in barn, eat dinner, drink beer, sit by bonfire, go to bed. Or, wake up, eat breakfast, do laundry in town, get lobster roll at Red's, jump off rocks at swimming hole, make ceramics, play with dog, drink beer, eat dinner, make ceramics, bond, help with wood firing, drink beer, go to bed. There were obvious variations.

The beer-drinking part sounded pretty straight-forward, but the group approach to creating art made me queasy. I had recently come to ceramics from painting, a famously solitary activity, and it was difficult to imagine spending two weeks in a steaming pasture (it would be July; cows were mentioned) where dozens of strangers would wake up virtually next to each other, be friendly first thing in the morning, happily wash each others' breakfast dishes, then troop off like the Seven Dwarfs to dig red clay out of a hillside. Dark memories of childhood games and images of Soviet collectivization made me fee as vulnerable as Trotsky. On the bus from Boston I tried to come up with an idea that would transform me into a warmly approachable team player. Someone had told me that the barn where everybody worked had been a brickworks, so I thought of a clever idea: I would enlist everybody to make hundreds of bricks and glaze them in various colors. Residents would personalize their bricks and use them to create intricate structures, changing hourly. This would be very entertaining: people would walk by, see what had been done, move a brick. Someone would do a time-lapse video. I would be the Mephistopheles of bricks.

It wasn't a good fit.

As the bus approached Portland it occurred to me that I could make a break for the airport and be at the take-out window of my favorite San Francisco taco truck by lunchtime the following day. But the bus window was open, and memories wafted in on the scent of pine. A former resident of Boston, I always thought of Maine as a lobster parade near lapping waters, where people from sizzling cities went to breathe a little easier when the weather was unbearable at home. Maine had always been a balm; it precipitated a state of mind similar to that resulting from making or viewing art: like Maine, art offered a necessary

I.

escape from the stultifying conditions of the everyday. In the minds of many artists who make the summer pilgrimage to Newcastle, Maine, Watershed represents an escape into the world of ceramics, a place where they step out of their slip-cast groove and create all the things in clay that time and other constraints prevent them from making at home. I was aware of the exultation-in-clay aspect when I arrived in Newcastle, and I wasn't convinced.

On the first night, Lynn Thompson, director at the time, clarified the situation. She introduced herself, told the history of Watershed, and sketched an outline of the facilities and the way the residency would function in terms of materials and costs. Then she got to the meat: while we were free to spend two weeks up to our necks in mud, the bigger idea was for us to have time in a place where we could exist away from the demands and limitations of our normal lives, where needs would be taken care of, with every kind of noise turned down low. Making and firing ceramic works was definitely encouraged, but in no way required. The clear inference was that Watershed clay did not necessarily exist to be made into something. It could continue to reside undisturbed in its hillside where it had sat for millennia, rained upon, frozen and baked. We could just gaze at it, thinking about its larger implications.

Lynn was speaking in a former chicken coop, now the communal dining room. The chickens were only a memory, but previous human inhabitants had left tracks. On one wall were tall shelves containing sculptural works, a sort of physical history of artists who had come before. Opposite the sculptures were stacks of dishes, bowls, cups and saucers, all made on-site over the years and meant to be used. When Lynn finished absolving us of any labor, it appeared that a small, energetic contingent, talking energetically about attacking the hillside with pickaxes and shovels, had not understood. I took the director at her word, and began focusing on the idea of spending two weeks contemplating my navel, which had had too little attention in recent years. Clearly, a wonderful accident had befallen me. As Trotsky's ghost faded to black, I went looking for beer.

Accidents permeate every aspect of ceramics. In any field or any endeavor, accidents can be relied upon to bump one's expectations off the board, thereby producing wondrous or horrific results. In ceramics, wondrous and horrific results have almost equal billing. Divine or other intervention is inherent in the equation, and ceramists, who consign their labors of love to kilns, are like witches and alchemists, with their newts, frogs, and cauldrons: all three professions require the relinquishing of personal power to the arcane, and all three are forced to wait for something else to show them what they have done.

Hecate:

O! well done! I commend your pains,
And every one shall share i' the gains.
And now about the Cauldron sing,
Like Elves and Fairies in a Ring,
Enchanting all that you put in.

- Macbeth, Act 4, Scene 1

Alchemy looms large in the history of ceramics. In the early 18th century, Johann Friedrich Böttger, the most famous reluctant ceramist in ceramic history, was busying himself with alchemical attempts to change lead into gold. When Augustus the Strong, Elector of Saxony, found out about Johann's activities, he did what anyone with absolute power would do: he locked the golden goose up in a laboratory and waited to be made rich. The alchemist eventually conceded failure, but Augustus gave him a second chance:

Johann could save his skin by discovering how to make porcelain, long imported from the Far East but never produced in Europe. While this ceramist was particularly motivated to succeed, he did only what every experimenter in ceramics has always done when looking for a new result: he mixed and fired, altered the chemistry, mixed and fired, altered the chemistry again, mixed and fired again, always hoping to move toward the right outcome. In the end, Böttger did make porcelain, but the magnificent discovery sealed his fate: to keep him from spilling the beans, Augustus moved him to a more secure location and kept him under the watchful eye of a minder for the rest of his life.

Ceramics has never transcended this kind of drama. To create something successfully in clay has always been an act of faith and an assertion of some sort of deliverance, often with dubious consequences. Painters can only blame themselves if they make bad work; linseed oil is linseed oil; titanium is titanium. A block of marble will always tell a good cutter where to put his chisel; and when a bronze caster pours alloy into a well-prepared mold, it is fairly certain that later there will be an object he can polish and present. Trade secrets in painting, stone carving and bronze casting, for years integral to the craft, are now mostly a matter of record.

But for ceramists working from even the most reliable sources, nothing is ever certain, and it is a hard lesson, never fully learned, for to give up personal control and allow for failure is also to permit success. A beginner follows these instructions: mix a batch of clay by measuring every ingredient with a precise scale (no newts; no frogs). Form an object: walls not too thick, not too thin. Dry it carefully; bisque it slowly. Apply a white glaze whose recipe has existed for a hundred years. Fire it according to an established schedule in a community kiln, cool the kiln, and voilà, shards. It is oddly exciting for someone new to discover that, despite thousands of years of experimentation in civilizations of every description all over the globe, no one really knows what they will find when they crack the kiln. Logically, for the seasoned clay artist, but amazingly, for a novice, when the door swings open and it becomes evident that 200 hours of work by ten artists have been for naught, no one but the most hard-bitten prima donna gets upset! With a shrug, someone with a car and a little money goes out and buys a few cases of ale, and everybody takes a little break before

J.

J.
Jim Melchert
Park Forest, *2007*
broken and glazed porcelain
18 x 36
photo: Alice Shaw

K.
Ruth Duckworth
Untitled, *2006*
porcelain wall mural
6.5 x 22.5 x 2.75
photo: Guy Nicol

L.
Toshiko Takaezu
Green Moon, *2004*
stoneware
33 x 22 x 22
image courtesy of
Perimeter Gallery

M.
Don Reitz
Flying X, *2007*
anagama-fired stoneware
32 x 16 x 9.5
photo: courtesy of
Lacoste Gallery

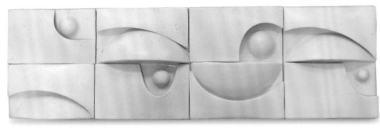

K.

going back to the wheel. Which brings us to the three S's that have always defined artistic endeavor: Soviet collectivization, the Seven Dwarfs, and the superego.

Just kidding.

But it does bring us back to the experience of being at Watershed Center for the Ceramic Arts, back to the idea of prying open the creative process by allowing it to breathe within the context of a group. The unpredictable nature of creating art in clay is perfectly suited to the unpredictability of human beings working together. Ceramics finds its own level in the collective dynamic, and while reliable unpredictability is terra incognita for a painter, for a ceramist it is simply where you are. For someone who came late to the ceramic party, that is revelation enough, but the joy at Watershed is in the details. To walk together in steaming pastures, it turns out, is a transformative, if not biblical, experience. In early morning the famous cows are silent, shrouded in *jade* mist. That's jade mist. Breakfast is the time to find out who is what, and it's an easy task; though sometimes incoherent, almost no one is at his or her most defensive before noon. When the old barn is empty and midday heat beats down on the roof, it is a child's dream of dusty corners and half-made treasures; when the barn is full it is a nest of elves toiling away, trading hammers and secrets. On the hillside beyond the studio windows, a carpet of green hides the red clay beneath. Everywhere, the air is thick with questions, never entirely answered.

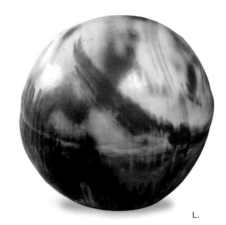

L.

David Linger is a Lecturer in Ceramic Sculpture at the University of California, Berkeley, and at Mills College in Oakland, California. He has shown his work extensively in galleries and museums in California, in the San Francisco Bay Area and beyond, and in Philadelphia, Pennsylvania and White Plains, New York.

Published in conjunction with the SOFA CHICAGO 2009 special exhibit *LEGENDS: Watershed Artists Honor Artists* presented by Watershed Center for the Ceramic Arts, Newcastle, Maine.

M.

Václav Cigler: Spherical Spaces

By Jana Šindelová

A.

"Universe ... world ... life ... an impetus
and a challenge understanding
the secret of the challenge is to
understand the sense of one's own,
and not only one's one life."

Václav Cigler

Spheres as spherical spaces or forms have been
represented in Václav Cigler's work since the
1960s. As a universal space around the globe,
or the arch of the heavens, spheres have long
been the inspiration for his visionary architec-
tonic projects. Fascination with the universe,
the first space flights and the construction of
interplanetary laboratories, as well as spherical
organic forms in nature, serve as inspirations
for Cigler's sculptural expressions.

Since the late 1950s, Václav Cigler has focused
on glass sculpture. His objects are based on
the formal language of optical lenses, pebbles
and natural boulders, stylized male and female
contours, often referencing an ovoid or egg-like
form. The first spherical half-eggs were exhibited
in a solo exhibition of Cigler's work in Museum
Boymans-van Beuningen in Rotterdam in 1975.
In these seminal works, concealed beneath the
apparent simplicity of the shapes and material,
lies an inner world much more resonant than
that which we see on the surface. For example,
Round Panorama is based on the shape of a
pebble eroded by water and modeled by nature.
It is as if it came into being gradually by the
action of organic influences and pressures. In
Cigler's conceptualization, it is a rounded, optical
panorama in which we cannot see the edges
of the planes, and therefore the reflected image
of the surrounding landscape.

A.
Václav Cigler
Rippled, 2009
sheet of glass, water, speakers
9 x 30 x 0.5'
photo: Michal Motyčka
and Martin Vičan

Light Field, 2009
Museum Kampa, Prague
sheet of glass, light source
9 x 30 x 0.5'
photo: Michal Motyčka
and Martin Vičan

B.
Half-Sphere, 1990
optical glass, blue mirror
11 x 11 x 10
photo: Michal Motyčka
and Martin Vičan

C.
Round Panorama, 2009
optical glass
13 x 13 x 9
photo: Avraham Hay
and Yona Schley

D.
Black Sphere, 2005
metal-sheathed optical glass
10 x 14 x 10
photo: Avraham Hay
and Yona Schley

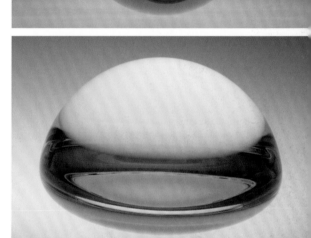

B.

C.

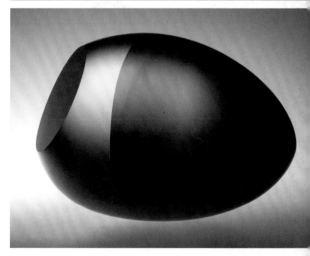

D.

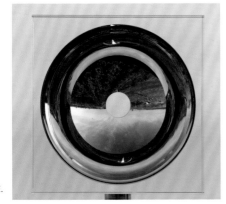

E.

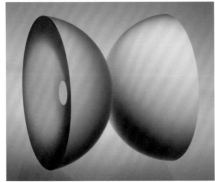

F.

G.

Vane is an optical glass object with a clear, partially metal coil leading to an aperture in the center affording us an undistorted view of the landscape. Upon looking deeply into this object, we find ourselves confronted with the distorted reflection of the reality behind us, and the partially framed landscape before us; our eye is thus drawn into a new visual perspective—we perceive a collage-like space of reflections of reality. *Couple of Hemispheres* is a sculpture inspired by gravity and the movement of bodies in the universe. It is also influenced by observation of the transformations of the shape of the sphere in the intermediate phases of the moon. *Column* constitutes the vertical axis of a three-sided prism of optical glass, which is capable of causing under certain conditions both refraction of light and partial reflection, thus creating new light, chromatic and spatial relationships.

Spheres in Cigler's conception can also be interpreted as primal embryos that link the dual energies of body and soul; or as embodiments of the living essence of man, animal or plant, all dependent on the emergence of the living cell. The cell itself creates its own construction materials and builds the body on the basis of genetic information, which it "decodes" and therefore "contains" in principle, birthing a new world. Is this process not similar to the emergence of a work of art? In ancient art based on mythology, the so-called universal egg was a symbol of the beginning of new life, civilizations and cultures. In fine art referencing the creation of the world, it is man's creation or creation by man that is most frequently depicted. But Cigler is fascinated by the living presence of matter–that which could be "before life" as if there exists a "first moment."

Cigler's *Spheres* installation designed for Litvak Gallery is created not only as an artistic whole, but also as an event. It becomes a living organism that has its own horizons and relationships. Our presence co-creates it, and therefore also transforms it. It consists of "spheres" above

the individual centers of objects or above their common focal points, which within themselves connect their own inner and outer embryonic symbols. They surround us. They completely fill the space with their radiance, just like a cosmic element, if we were to place it in an imaginary space. The egg as universal egg is endowed with a sense of the infinity of space and time on both a macro and micro scale. It has a sense of infinite depth as well as a sense of proportion. In its dimensions and effect, it appears incredibly calibrated. At the same time, the egg is not defined mathematically as either a body or a shape. It is as if all the enchanting play of light on the surface ever recedes into new dimensions of universal substance. Eggs have their interior, we might say their "just-for-themselves," their embryonic energy and their secrets. Cigler leads us into this intimate space by his meditation on the work itself: "I am excited only by art created out of compulsion, out of intoxication, out of excess pressure, out of an obsession with searching. I am excited only by that which is ingrained, fervent, pure. I am excited by the hidden mystery of internal order. I want to track it down, try to reveal it."

Cigler's work concentrates on objects made from optical glass—designs and realizations of illuminated objects and jewelry, drawings, installations and compositions for architecture representing five principles: space, glass, water, light and the individual. Space and glass become elements of communication; water and light symbolize the basic elements of life such that the observing individual and space fuse with the art. Cigler has a special gift—a kind of "feeling for space", a need to transform material not into a form of an object, but into a manner of existence—a process drawing the viewer into a spatial experience. Cigler explains, "Glass may continue to dazzle us with the exterior beauty of its surface, but increasing attention is being paid the entire volume of glass, which draws people in and submerges them. Glass can be a panel or a wall, a sensitive, protective organism reacting to light, heat, changing its color and transparency."

Space as a means of communication is the fundamental structural motif in Cigler's work: "I organize space, define and open it, for me a person is both form and content, everything is human to me." Since the 1960s, Cigler has been intrigued with the relationship between the landscape and the person situated within. Free hand drawings give shape to his ideas for architectural installation which he conceives of

E.
Vane, 2008
metal-sheathed optical glass
10 x 10 x 4
photo: Michal Motyčka
and Martin Vičan

F.
Couple of Hemispheres, 2008
glass, 13.5 x 12 x 13.5
photo: Avraham Hay
and Yona Schley

G.
Column, 1990
optical glass
94 x 4 x 4 cm
photo: Michal Motyčka
and Martin Vičan

H.
Meeting Place, 2009
Museum Kampa, Prague
metal-sheathed glass, metal, wood
65 x 65 x 6.5'
photo: Michal Motyčka
and Martin Vičan

I.
Reflective Wings on
water surface, 2009
Fraeylemaborg Chateau,
Netherlands
metal-sheathed plate glass
74 x 6.5 x 7.5'
photo: Michal Motyčka
and Martin Vičan

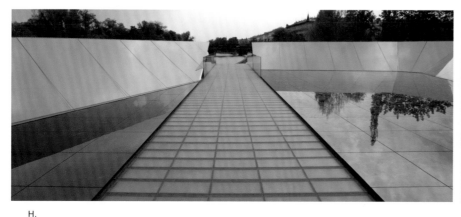

H.

I.

as encapsulations, always keeping the viewer in mind, for whom he would like to reveal the most luminous and spatial environments; spaces where we can listen to text or music, meditate, be alone with, and calm ourselves.

Meeting Place in the countryside is an environmental installation defined by light, a place of certain definition, both in terms of the ground space and its relation to the space above. We can meet here; perhaps look up at the sky. Cigler has always been fascinated with landscapes and the potential to influence them, not merely by walking through them. "Nature is partially hidden, everyone experiences it in their own way, this unpreparedness may also be an adventure." His basic impetus for creating landscape projects has been the confrontation between organic natural forms, which can be made more legible as one walks through landscaped space, with recognizable vertical or horizontal forms. An island in the shape of a fingerprint is placed within a great round form of the Earth, into which we may enter and meditate. A cut in the landscape in the form of lips appears to be a decoration. Cigler's places, bathed in golden light, are a tribute to multifarious forms of Earth's landscape and its sacredness. "The Earth is precious, the Earth is sacred, and in this environment, which is being pushed to the limits of use, it is a reminder that we must handle it with care."

Water as a principle is ever present in Cigler's work as a fundamental element of life, as well as that of the human experience in the sense that both mediate an interaction with nature. Cigler proposes and creates fluid objects—wells, still or rippling water, mirrored benches on the water or water sanctuaries. His most systematic

approach to this topic was his entry in the First International Water Sculpture Competition, Louisiana World Exposition 1984. By means of the forms of the objects, for example, glass receptacles for river water juxtaposed with a receptacle for highly purified water, he fore-grounded various "purification systems." He created sculpture models in the form of water blossoms, water gates, glass footbridges and water pipes in sketches, drawings, models and modifications of photographs. The intention in the winning design of the fountain was to create a final image of a "rainbow," under the arc of which it would be possible to walk along a metal grid positioned at the mouth of the Mississippi. Still topical are unrealized water projects and compositions of objects on water in the form of floats or buoys. Natural light and water, with which Cigler works in landscape sculpture designs, are substituted in the studio with the diffraction and reflection of light in glass elements. In both, he directs a dialogue between the space and the viewer, orienting him/her towards a place of solitude as well as a gathering place, with the goal of "leading the pedestrian through walls of water, live vegetation or vertical blossoming surfaces, curtains of light, mists or scents."

He opens up the landscape or presents teasing glimpses of it through narrow apertures leading the viewer to perceive an exterior or interior landscape with horizon, shape, color, substance, scent, light and light vibrations. He designs paths and glass footbridges on water, retreats and refuges, sanctuaries formed from meshes for climbing plants in the form of pergolas. Elsewhere he extends viewing points telescopically towards the crowns of trees, to the sky, to benign

silence. He is interested in the creation of relationships—dual relationships—the unity of person and space, of places and the order within them, of inner form and outer environment.

Glass is for Cigler a pretext for expressing a different spatial and emotional perception of the world. The glass object thus not only becomes material within space but simultaneously a literal and figurative sphere that merges people and space—coloring, reflecting, refracting and unfolding, transforming both viewer and viewed.

Cigler is thorough and tirelessly meticulous. As an artist he is convinced that he bears final responsibility for his exhibits, for the installations and selection of works, as well as the form and content of the catalog. He designs, transects spaces with varying media, speaks through projection, transforms through process, and often dramatically provokes. His works could not be realized without the technical assistance of Miroslav Špaček and Jan Frydrych's perfect execution of cut glass objects. Since 1999, Cigler has collaborated with the architect Michal Motyčka, who prepares his exhibitions and resolves apparently simple projects from the 1960s in relation to their promised spaces for realization.

Jana Šindelová studies Arts and Crafts Education, Pedagogical Faculty, Palacky University, Olomouc, Czech Republic; Art Theory and History, Philosophical Faculty, Palacky University, Olomouc; Academy of Fine Arts, Prague. Since 2004 she has collaborated as a curator with the architect Michal Motyčka.

Published in conjunction with Litvak Gallery's presentation at SOFA CHICAGO 2009.

Silver & Design – Where do we go now...?

By Alastair Crawford

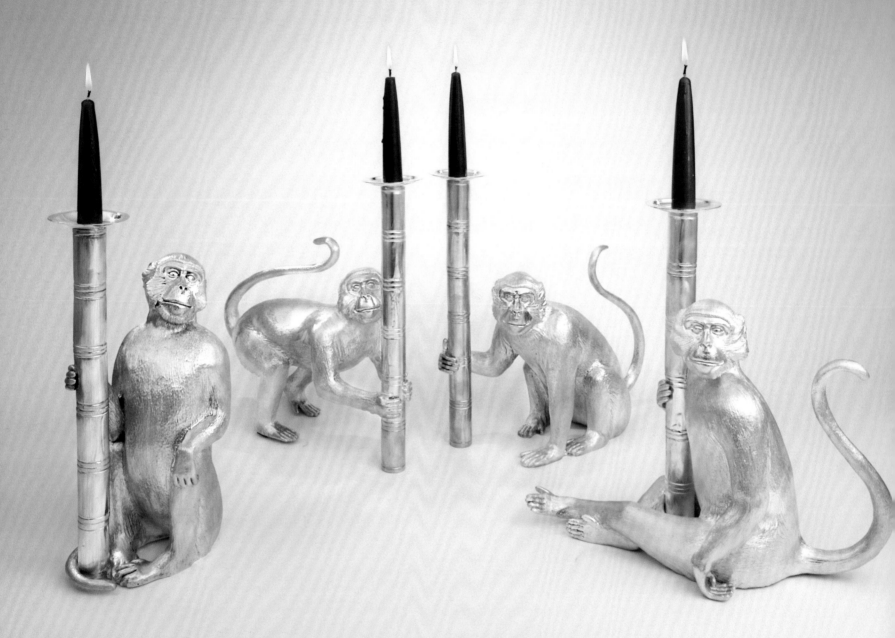

A.

"Silver is the best material we have, gold is precious in value but not in effect. The character of silver is satisfactorily obstinate, it has to be conquered—and then it has this wonderful moonlight lustre, something of the light of a Danish summer night. Silver can seem like twilight, or when it dews over, like ground mist rising."

Georg Jensen, 1926

Before contemplating the future, it is sometimes necessary to examine the past, and it is certainly of merit when examining the prospects of sterling silver and its ability to survive in the world of design today.

The history of silver and its associated designs throughout the ages are based on a simple, if not vulgar, display of wealth. The metal silver was for thousands of years hard cash and those who were fortunate to have the luxury of a surplus, could indulge in melting down their precious coins and having them fashioned into articles that gave aesthetic pleasure. In leaner times the process was of course wholly reversible.

Designs in silver were almost always dictated by practical and religious demand. In the middle ages, the Church of almost every land in Europe was the greatest consumer of this treasured metal.

It was not until the end of the 17th century that fashion and domestic use came into play and that meaningful secular design began to play a role. We see for example the first silver tea pots around 1670 that paralleled high fashion for this imported luxury. A pound of tea then was almost the equivalent of a farm labourer's annual income. Silver was being designed to accommodate the expensive tastes of the super rich; tea caddies, tea and coffee sets, trays, candelabra and other opulent items that served a strictly functional and domestic purpose.

And what of design? The design followed the European fashion of the day that was dictated by the super rich—especially those that could afford to travel and introduce stylish new fashion from overseas.

Designs in silver evolve in a fairly predictable way. They follow the changing models for architecture, furniture, porcelain and other luxury items. We recognise the austere early 18th century round and octagonal designs, that soon give way to the majestic rococo designs in the 1740s. By the 1760s we see the neo-Classical designs dominate the field of silver design as the upper classes return from extensive and fashionable Grand Tours of ancient Rome and Greece. We also see the gauge of silver become increasingly less generous as the cost of the silver bullion price sky rockets. Then we move on to the magnificent Regency period, and by the 1820s designs in silver are at the height of extravagance in both lavish design and volume.

And there, rather like an expiring firework, the design stops in a disappointing downward spiral. By the 1840s advances in the design of silver are overtaken by huge leaps forward in manufacturing processes. Machinery and technical inventions are everything. Steam driven stamps, dies and presses, right through to the invention of electroplating in 1840, mean that silver is affordable not just to the rich, but to almost every middle class household. Where was the great contemporary silver design of the 19th century? The trend was more to copy designs of previous generations—or even worse—to "redecorate" existing plain silver pieces with heavily ornamental swags of fruit and flowers. There were in fairness a few notable fresh designs.

In 1854 for example, Japan was opened up for the first time in centuries to western visitors as Captain Perry of the U.S. Navy is sent under presidential command to negotiate international trade opportunities. Soon everything Japanesque from mixed metals to oriental engraving becomes the fashion of the day. Tiffany and Gorham especially revel in these exotic silver designs. There are other notable 20th century designs in silver: massive ornamental trophies and centrepieces of military and sporting themes, humourous novelty items as well as an Egyptian influence, but largely design in this century was about reproducing the antique.

By the beginning of the 20th century there is thankfully a revolt against the mass-produced, machine-made designs, and the Arts and Crafts Movement inspires fresh designs for modern silver by names such as Omar Ramsden, Ashbee, Louis Comfort Tiffany, Gorham, Christopher Dresser, Wolffers and Georg Jensen. Here the accent is on the Art Nouveau with strikingly modern design and a return to artistically made silver at the hands of skilled silversmiths. Interestingly, many of the most noted silver designers of the day worked and shared designs with furniture designers, jewelers, ceramicists and once again, designs in silver followed similar patterns of design within the luxury industry.

Art Nouveau moves on to Art Deco, but there seemed to be only a handful of talented designers working in silver. Georg Jensen, a 20th-century power house of design in its own right, evolves as a leading light; and Harald Nielsen, Georg Jensen's great Art Deco designer stands at the forefront. There is Puiforcat, Tetard and a handful of others, but their output of designs is limited.

A.

Group of sterling Monkey Candlesticks designed by Alastair Crawford, 2009 12 inches high, 88 ounces each

The post-World War II years are a wilderness for silver design. The only major design house to produce designs of substantial merit is Georg Jensen, who employed outstanding designers of international standing and merit: Soren Jensen, Alan Scharff, Verner Panton and of course, possibly one of the most talent post-war silver designers ever, Henning Koppel. With the exception of Minas in the 1980s, even the Georg Jensen stable peters out of fresh designs in silver after the 1970s.

The decline of fresh designs in silver at the end of the 20th century is directly coupled with the slow, but seemingly incurable death of the consumer market for silver. Those manufacturers and silver-smithies managing to stay in business cling to reproducing the antique, but fashion has changed once more. Tea sets are no longer useful. Sterling flatware gives way to every day drab stainless steel. People eat out at restaurants rather than entertain at home.

Is that then the end of silver and design? After centuries of evolving [and occasionally revolving] design—is that it? If you were asked to name twenty important jewelers with household names operating today you would have no problem. Cartier, Bulgari, Harry Winston, Chopard, Boucheron, Graff and the list rolls on. If you try the same exercise in silver you are left with Georg Jensen, Tiffany, Bucellatti, Christoffle and then the list starts to dry up. Not one of those has produced any meaningful silver design in years. Georg Jensen, the great silver designer himself, once commented that to stay young in the game you can't rely on the antique, but should focus on the new. Design is coupled inextricably with fashion. Maybe it is the other way around. Either way, you can't keep offering the decorative art market the same old designs.

Perhaps the re-emergence of silver design is almost too late. No designer can create effectively without working through the process to physical manufacture. Despite the vast and increasingly rapid advances in design technology, the processes involved in most silver manufacturing have barely changed or evolved in the last 100 years. Of greater concern is the paucity of qualified and competent silversmiths capable of executing designs in silver. Since 1904 Georg Jensen trained all their silversmiths by having apprentices sitting directly—and copying and learning—beside the master craftsmen. This learning process is passed down this way from generation to generation. The average appren-ticeship is a minimum of five years and it is generally reckoned that it requires ten years before a silversmith can tackle a major piece. The number of silversmiths has been in steady decline for decades. In the 1950s Georg Jensen employed over 250 silversmiths in Denmark. Now they are down to four. Some highly skilled trades within the silversmithing industry are in danger of becoming extinct unless a new generation of gifted apprentices is in place to counterbalance retiring master craftsmen.

Is there a future in silver design? Yes, of course! Silver is the most versatile and rewarding metal. Contemporary design in every other sphere from abstract installations, video imaging to wacky outsized metal sculpture has never been so vibrant and opportunities for design in silver abound.

So where will the future path of silver design lead? There are a small handful of gifted silver-smiths, most notably in London who are emerging with new designs in silver, backed by serious patrons and encouraged and endorsed by the Worshipful Company of Silversmiths, which was founded in 1300 and today continues to promote excellence in silver design.

Modern silver design is akin to sculpture and other three-dimensional art. The direction however will most likely continue to be biased towards the domestic, practical product— perhaps even still portraying that display of wealth, which was the original catalyst all those centuries ago. Ironically, the future path to success and even survival of silver design may be a path that turns a full circle in history.

Silver is a durable metal that will outlast genera-tions. Despite the occasional gentle polish, it is virtually maintenance free. If damaged, it can almost always be restored to its original condition. It is an efficient conductor of both heat and cold and lends itself perfectly to domestic use. There is, in short, no reasonable argument to overlook the medium.

Contemporary glass, furniture, jewelry, painting, sculpture and all kinds of related media have enjoyed an unprecedented boom in the market for contemporary design over the last fifty years —and yet it appears that silver designs have been neglected to a point of near extinction. There is no reason why silver should remain the poor relation.

As we begin the 21st century, the small creative flame of silver design is still ready to be fired up. The craftsmen are there—just. There are more talented individual designers of worldwide recognition now than probably at any time in history. The cost of silver metal is still reasonable despite the meteoric rise of its more glamourous gold cousin. All that is needed is the imagination of the consumer, designer and retailer to fire up that flame again and rekindle the limitless opportu-nities of this historic and beautiful medium.

At the end of the day, the future of silver and design rests with the community of designers. It is up to them to realise the beauty and scope of this precious metal. No designer today should be overawed by the deep history of this metal, nor weakened in intent by the task of manufacture, but should embrace the opportunities that silver can offer in design and fire up the demand from the decorative art world.

After all, the strength of any design is a testament to its immorality.

Alastair Crawford has dealt in vintage silver for over 30 years, the last 10 years exclusively in Georg Jensen silver and jewelry both in London and New York. This year he launched Crawford Contemporary, manufacturing and retailing his own unique silver and jewelry designs.

Published in conjunction with Crawford Contemporary's presentation at SOFA CHICAGO 2009.

B.
Sterling Magnum Wine Cooler designed by Alastair Crawford, 2009, 12 inches high, 230 ounces

D.
Sterling Gurgling Fish Pitcher designed by Alastair Crawford, 2009, 12 inches high, 57 ounces

C.
Georg Jensen Octopus Candelabrum designed by Georg Jensen in 1920, Design #383 Made in Copenhagen, Denmark 10.75 x 12.5

E.
Sterling Centerpiece Bowl designed by Alastair Crawford, 2009, 15 x 6, 82 ounces

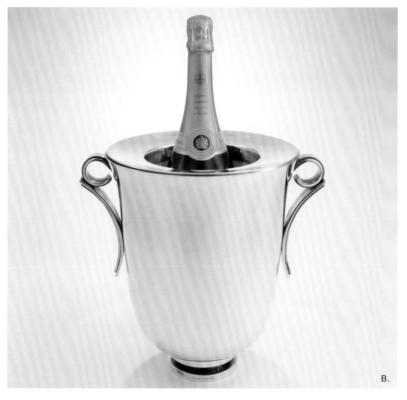

B.

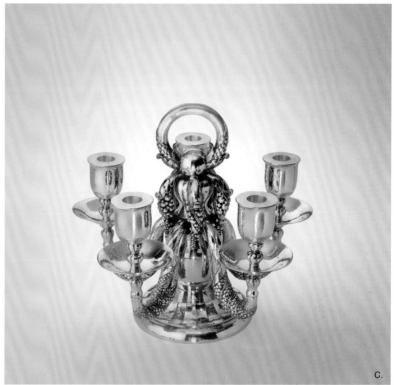

C.

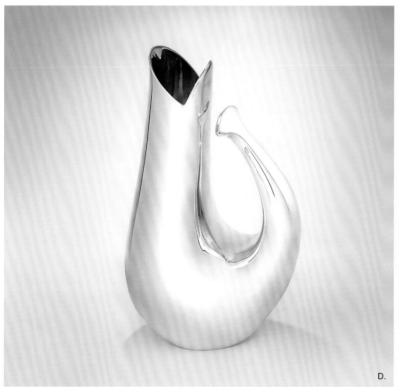

D.

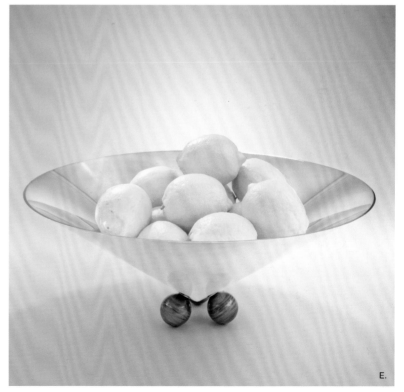

E.

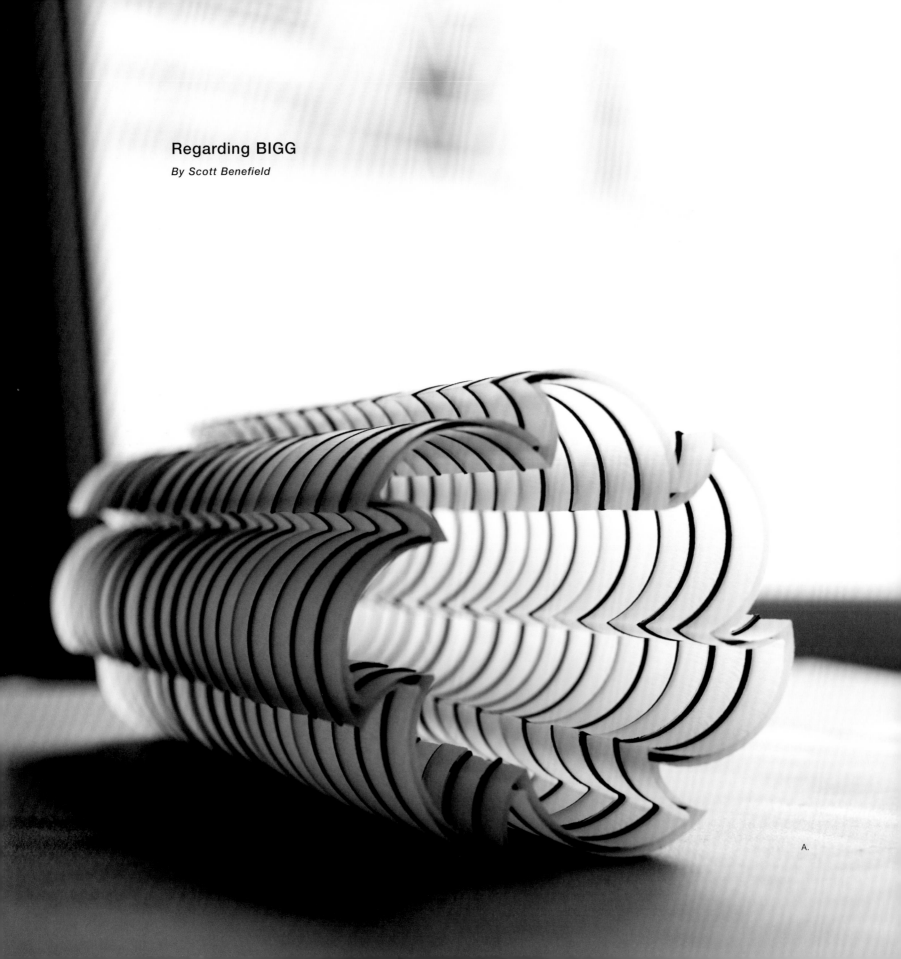

Regarding BIGG

By Scott Benefield

A.

A

Vanessa Cutler
Spine, 2009
glass
15 x 4

B.

From Left to Right:

Artists and exhibition organizers celebrate the opening
of BIGG: Breakthrough Ideas in Global Glass on July 10,
2009 at the OSU Urban Arts Space and Hawk Galleries.

Ohio State University President E. Gordon Gee
joins Professor Richard Harned and students to try
his hand at blowing glass.

BIGG Exhibition jurors Lino Tagliapietra,
Tina Oldknow, and Tom Hawk

It is often said that the studio glass movement is not a movement per se—that is, one with a binding philosophy or aesthetic program that gives it a unitary identity. It is perhaps more accurately described as a global community, with a sense of fellowship established through the use and appreciation of a common medium. But it occurs to me that what has evolved over the past forty years has been an entire ecosystem that embraces creation, education and the business of art.

The concept of an ecosystem hinges on the idea of interdependency and a shared environment; it runs counter to a dichotomous view of independent function. The studio glass ecosystem comprises many different components—artists, students, educators, educational institutions, shops, galleries, gallerists, collectors, critics, publishers, curators, impresarios, suppliers, manufacturers and, of course, an audience. The presence and activity of one group necessarily influences and affects the existence of the others. It is impossible to extract one element or consider it autonomous of the others. The whole is not only greater than the sum of its parts, but it is also the product of an organic growth.

In the United States, this ecosystem has been particularly well developed in one area in particular: the market for glass that exists here is more extensive than anywhere else in the world. It extends vertically from giftware to mid six-figure pieces destined for major museum collections, and horizontally from single beads to architectural-scale installations. For those of us living and working exclusively in the United States, it is easy to lose sight of what an extraordinary and singular development this has been. This healthy market for glass, despite recent fluctuations in the overall global economy, consequentially nourishes diversity and a proliferation of activity to a degree that exists in no other country. It also attracts artists from around the world to events such as SOFA (Sculpture Objects & Functional Art), which in turn has been the inspiration for the establishment of SOFA-like events in other countries such as London's Collect.

It is within this metaphor of an ecosystem that I came to view the BIGG (Breakthrough Ideas in Global Glass) exhibition, which draws together so many strands of art, education and commerce that it could be understood as a study of the diversity and complexity that exists in the world of studio glass at this moment. It is selective in many important respects—for instance, it doesn't touch upon sited work or production work—but within its stated parameters, it offers a view of the field that is unusually inclusive and open-minded.

Art, Education, Commerce
Large exhibitions typically originate in a single institution, even if they are destined to tour other venues. They are the product of a single institutional vision, adhering to the goals and mission of one organization, and as such often have a coherent and easily stated premise. One of the features that distinguish the BIGG exhibition is the nature of the partnership from which it originated. Two years ago, Tom Hawk, Director of Hawk Galleries, approached Richard Harned, Professor and Glass Program Coordinator at The Ohio State University, about partnering to mount a global overview of emerging artists working in glass. Harned then suggested utilizing the newly opened Urban Arts Space, OSU's venue for presenting the work of its students and faculty in a downtown Columbus gallery, which is located just blocks away from Hawk Galleries. The common ground that all three entities shared was the desire to identify promising emerging artists and help develop their careers. Hawk and Harned also saw the value and appropriateness of approaching SOFA CHICAGO for sponsorship to present the BIGG exhibition on an international stage. Mark Lyman, founder and director of SOFA, embraced the concept, and generously donated exhibition space.

Of all of the goals of BIGG's principal organizers, perhaps the most abstract was the desire to draw some conclusions about the future of glass by examining the work of recent graduates using the medium. It was thought that by looking at a cross-section of international emerging artists, educational trends manifesting themselves in their work could be discerned. The field's general arc of development could be seen by the degree to which their work stood in contrast to previous trends, projecting some future trajectory.

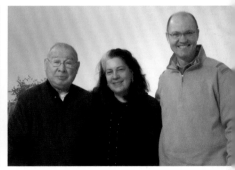

B.

Emerging Artists

The common denominator linking the three partners is an active interest in the work of emerging artists. The glass department at OSU exists to develop the abilities of students and, in their graduate program, transition them from student to emerging artist. OSU's UAS has a broad mission to program a space that provides an interface between the University and the wider community, showcasing the work of emerging artists. Hawk Galleries have a vested interest in identifying promising emerging artists and providing them with opportunities that will sustain their practice.

If the established artist lives a precarious life, too often struggling to find an audience or the means to continue their art, the emerging artist lives one that is even more precarious. In the few years that lie between finishing the preparation for a career in the arts and the establishment of some kind of professional practice, they must invent a strategy for survival—unique in its particulars—which will allow them to beat the odds and continue to work productively. The attrition rate for young artists is daunting, as they struggle to replace support systems in place during their years in school: access to facilities, critical review, peer support, studio space, and exhibition opportunities. If they don't succeed in their struggle and find a way to keep working within a relatively short period of time, their prospects diminish rapidly and a career change beckons.

Emerging artist is a loosely defined term, but one that is usually taken to mean an artist who has yet to distinguish themselves in the field. Any opportunity to be singled out for recognition—by selection for grants, residencies, prizes, publication or exhibition—is a step towards establishing a professional practice and, I suppose, emerging as a mid-career artist. The role that these opportunities play in the career of a young artist cannot be overstated: this is the means by which individual talents become appreciated, as they are exposed to an audience of peers, critics, collectors, and the general public.

In a medium like glass, which has a comparatively brief and recent history, the significance of emerging artists is disproportionately small. Unlike the contemporary art market at large, the focus of attention in the studio glass world remains on artists who had established their careers by the 80s. The Old Masters of studio glass—who date back to the 60s and 70s—are still active in the field for the most part. And yet, surely emerging artists, who will be producing work for the next forty years, represent the future of the field. There's a sense that a crust has formed at the top, and one function of an emerging artist survey show like BIGG is to break through it to expose new work by fresh faces.

Selection

The selection process for the BIGG exhibition could be seen as a series of filters, and the exhibition itself as a product of that filtering process. To begin with, the criteria for selection included the completion of either an applicant's professional training or terminal degree program by 2000. It is interesting that this filter makes a provision for artists who did not take an academic route, several of whom were included in the exhibition. It is also noteworthy that selection criteria specifically excluded were any restriction by age, nationality, technique or functionality. BIGG was designed to draw from the largest possible pool of applicants.

An additional filter would be the process of self-selection, by which artists responded to the particulars of the prospectus. For instance, because artists were required to submit images to the jury of the actual pieces they proposed to exhibit, they had to have a certain amount of documented work at hand. (Furthermore, since BIGG was always intended to be a selling show, the submitted work had to be available for sale.) Not every artist, especially at an early stage in their careers, has an inventory of resolved work on the shelf. Cash awards, professional opportunities and gallery representation constituted incentives for respondents, and no doubt motivated a certain number of applicants.

The final filter was the jury, comprised of Tina Oldknow, Curator of Modern Glass at The Corning Museum of Glass; Italian maestro Lino Tagliapietra; and Tom Hawk. The variety of backgrounds and interests of the jurors (and the lack of any academics) certainly shaped the exhibition to a great degree, building in a diversity of tastes and standards. They met at the Tagliapietra residence on the island of Murano in Italy in April 2009 to review all of the entries. The jury had aesthetic autonomy in their choices and selected work based on a consensus regarding the resolution of ideas and form.

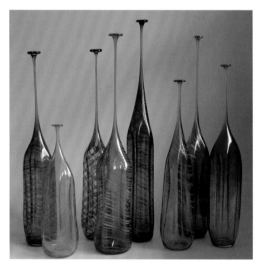

C.

D.

E.

C.
Darren Goodman
Vetrobottle Grouping #2, *2008*
blown glass
30 x 26 x 9

D.
Kait Rhoads
Comb Brick, *2008*
blown glass
10 x 7.5 x 5.5

E.
Johanna Jansson
Graffiti Birch Vase Series, *2007*
blown glass with cold work
various sizes

F.
Ben Johnson
Swell, *2008*
blown glass, sand-carved
and acid-etched
16 x 7 x 7

G.
Quincy Neri
Hydrogen Collapse, *2006*
blown glass, enamels
17 x 12 x 10

F.

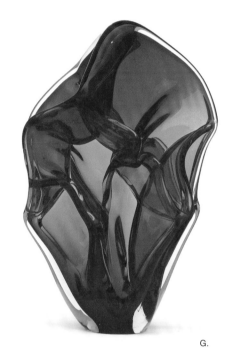

G.

Breakthrough Ideas

One of the original inspirations for the BIGG exhibition was that of the breakthrough idea: presentation of an idea that pioneers new territory and enables future exploration. The innovation can occur in any area—it can be conceptual or technological; it can relate to the material or a mode of display—or embrace a number of them. But the emphasis remains on an upheaval of the known in favor of creative discovery.

Innovation has always been a primary value in visual art, but it has a particularly exciting relevance to a medium that was only fully embraced by studio artists beginning in the early 60s. The canon is still developing. The sense of discovery as artists continue to explore the material and techniques is still very fresh, enhanced by the relatively recent breakdown in hierarchical boundaries which has allowed glass to foray into territory originally reserved for fine art.

Global Glass

Another important feature of the BIGG exhibition is its emphasis on the global nature of the studio glass movement and its future as a global phenomenon. Although the origins of studio glass were concentrated in the West, it was an international movement from its very beginning and has continued to spread throughout the world. This growth is reflected in the fact that the final BIGG selections included work from 15 different countries. It can also be seen in the diverse educational background and work experiences of the selected artists, which includes many students from one country receiving their degree in another, or finding residency or exhibition opportunities abroad. This cross-pollination within the glass world goes hand in hand with increased globalization of culture in general, where information and images are universally available through electronic media, and the accessibility of air travel. There has always been an elevated degree of mobility within the glass community, which fosters international exchange and can be seen in the vibrant activity of summer workshops and conferences worldwide.

A Glance at the Exhibition

It is neither easy nor wise to generalize about the work that was selected for exhibition, because it was deliberately chosen for its broad diversity. It is decidedly eclectic, providing examples of traditional, functional vessel forms (Hyunsung Cho) and work that uses traditional, functional vessels forms to make a conceptual point (Christopher Watts). There is figural work that ranges from highly representational (Richard Price) to cleverly schematic (Charlotte Hughes-Martin).

There are singular achievements within the exhibition that defy any attempt at categorization. Ditte Johansson's astonishing knitted pieces invent an entirely new formal expression for the medium; Vanessa Cutler's water jet cut constructions likewise invent a new language for a piece of industrial equipment. A new, uniquely post-millennial theme was stated in Robert Geyer's work, through his deliberate choice to work with found and recycled materials and thus confront the sustainability of working in an intensively energy-consuming medium.

H.
Hyunsung Cho
Living in the Lightbulb, *2009*
glass, enamel
16 x 13 x 6

I.
Amy Rueffert
Portrait (Charteux), *2008*
solid and blown glass,
vitrolite, decals
13 x 10 x 10

J.
Bridget Boss
Time's Twenty Nine, *2006*
blown glass, enamels,
copper inclusions
13 x 7.5 x 7.5

H.

I.

J.

But despite the significant, individualistic work that predominates, within that diversity of work, there are some observable common denominators. There are a surprising number of pieces that conform to the long heritage of volumetric containers (Laura Birdsall, Christopher Bohach, Bridget Boss, Johanna Jansson, Darren Goodman, Ben Johnson, Martie Negri, Elizabeth Perkins, Kait Rhoads), and, given its ubiquity in mainstream contemporary art, a relative lack of work derived from new media (with Stine Mikkelson as an exception). At the same time, some of the vessels that took a traditional form also took that heritage as a decorative arts medium as their subject matter (Amy Reuffert, Marie Repten). These artists bring a self-awareness to their work that confronts associations which have been too often dismissed as irrelevant to artists working in glass.

In the Columbus exhibition of BIGG, the Urban Arts Space was the primary venue for large scale work and educational programming. Hawk Galleries afforded the opportunity for the emerging artists to be exhibited in the same space as mid-career artists. Work that addressed issues of scale did so through a tactic of stacking repetitive modular elements (Andrew Newbold, Robert Geyer, Sungsoo Kim) with the exception being a long, horizontal floor piece by Karen Reid. (Even Vanessa Cutler's smaller, precise constructions utilized repetitive stacking to create form.) This basic idea was given more intention by artists whose beginning and end points were less arbitrary (Scott Darlington, Steven Durow, Erika Tada).

The Event: Columbus

Columbus emerged as a significant landmark in the studio glass community with the establishment of a glass department at Ohio State University in 1981. Since 1986, Tom Hawk has strived to expand the studio glass dialogue by building bridges between artists, the gallery and museums. By connecting curators and artists, Hawk has played a partnership role in staging several solo exhibitions at the Columbus Museum of Art, and in facilitating numerous museum acquisitions. By coordinating demonstrations with Glass Axis and Harned's OSU glass program, and featuring artist lectures at gallery openings, artist dinners and studio tours, Hawk has taken an active role in connecting the various strands that make up Columbus' glass community.

One example of the culmination of these partnerships is the relationship Dale Chihuly shares with the city. Because of the strong support of local patrons and the Columbus Museum of Art, Chihuly chose Columbus as his second conservatory venue (subsequent exhibitions were held in Atlanta, Miami, London, New York and Phoenix). The Franklin Park Conservatory exhibition proved so popular that several local foundations and individuals came together to purchase the entire collection. In 2009 Chihuly will mount three major Columbus exhibitions including *Chihuly Reimagined* at the Franklin Park Conservatory, *Chihuly Illuminated* at the Columbus Museum of Art, and *Chihuly XIV* at Hawk Galleries.

Over the years Columbus has fostered the growth of a variety of institutions and organizations that have supported the development of the glass community and kept contemporary glass in the public eye. The glass program at Columbus College of Art and Design; the public access facilities at Glass Axis; and the Franklin Park Conservatory, with its Chihuly Resource Center and hot shop, all contribute to the growth and appreciation of studio glass in the city and throughout the region. The Columbus Museum of Art will open a permanent collection of contemporary glass in 2012.

The July 2009 opening of the BIGG exhibition in Columbus was an occasion for many of the artists to gather together to view the show, meet one another and participate in informal exchange throughout the weekend. Several artists from Europe and Asia were able to attend on travel stipends. In addition to the gala opening, there was an informal roundtable discussion the next day at the Wexner Center for Contemporary Art, where many of the artists gathered to exchange their views on the exhibition and its implications.

Impact

The most immediate impact of the BIGG exhibition might well be on the artists themselves—inclusion in the show, with the possibility of showing with Hawk Galleries at SOFA—is highly visible, public exposure for any artist and especially one at the beginning of their career. The additional possibilities of a Research Residency at Steuben or a Fellowship at Ohio State University enhance the potential benefits. The other immediate impact will be experienced by the audience for studio glass, including collectors and curators, who will be exposed to a new generation of promising talent, via OSU's Urban Arts Space, Hawk Galleries and this catalog.

But a greater impact, with implications for the field as a whole, will come if the BIGG concept is extended into the future and the exhibition becomes a recurring feature on the landscape and a fixed date on the calendar. An established, periodic survey show of emerging artists would be a way to keep an upper crust from ever becoming completely solidified. It would gain momentum as word spreads among educators, students and young artists throughout the various communities that make up the larger global glass network. More applicants would make the exhibition more competitive and increase the extent to which BIGG can cast its net. It would be an important vehicle by which reputations are established and talent is recognized, fostering excellence and making its own unique contribution to the growth and development of the field of studio glass.

Scott Benefield is an artist, educator and writer who was formerly the editor of the Glass Art Society newsletter. He is currently a Visiting Scholar at Osaka University of the Arts.

Published in conjunction with the SOFA CHICAGO 2009 special exhibit *BIGG: Breakthrough Ideas in Global Glass* presented by Hawk Galleries and Ohio State University. Sponsored by Steuben Glass.

AIDA's Gems – Israel's Jewelers

By Erika Vogel

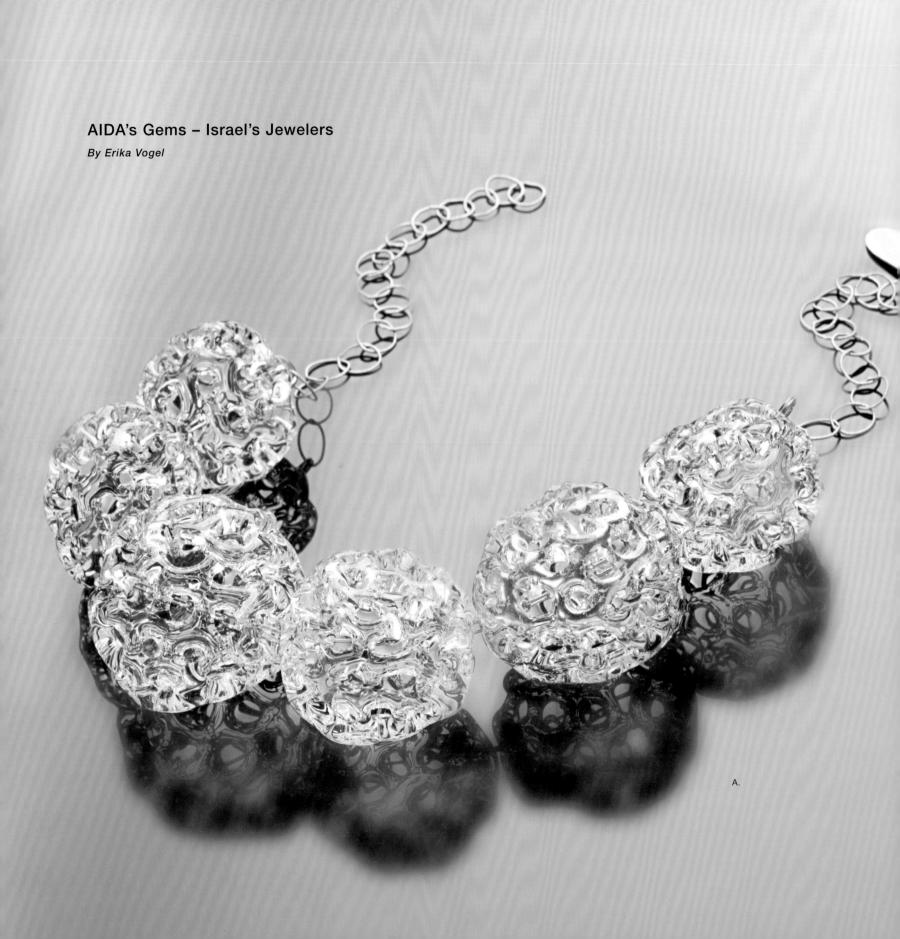

A.

A.
Nirit Dekel
Necklace, *2009*
borosilicate glass,
22k gold leaf, gold-filled wire

B.
Anat Gelbard
Earrings, *2008*
22k gold, pink sapphires,
diamonds

C.
Anat Gelbard
Earrings, *2009*
22k gold, precious and
semi precious stones

D.
Deganit Stern Schocken
Moving Ring, *2007*
18k gold, amethyst

AIDA's story is about discovering gems. It's the story of providing an international platform to incredible talent and creativity from a small country. It's the story of allowing artists to realize their dreams.

Over the years, AIDA has repeatedly told this story at SOFA CHICAGO by exhibiting Israel's contemporary treasures made of ceramic, glass, metal and fiber. Of the work exhibited, AIDA has found that visitors repeatedly come back seeking out its jewelry. Collectors are drawn to the craftsmanship, attention to detail and diversity of styles and materials of this wearable art form. For this reason, in 2009, AIDA's special exhibit at SOFA focuses on objects of beauty and body adornment, jewels of all shapes, sizes and materials.

Few art media represent the Israel of today better than jewelry. From the exquisitely hand-crafted style of Shay Lahover to the contemporary industrial work by Yael Herman, to the glass jewelry of Nirit Dekel, to the leather work of Avital Coorsh, the diversity of style and material reflect the complicated mosaic that makes up today's Israel.

The history of contemporary Israeli jewelry pre-dates the birth of Israel, going back to 1906 with the founding of the Bezalel School of Arts and Crafts in Jerusalem by Boris Schatz. Today, the school is known as the Bezalel Academy of Art and Design and continues to be one of Israel's leading art academies. The metalwork department was one of the first divisions established and the earliest students were comprised mainly of Yemenite artisans. In the early years, the Bezalel style could be characterized as a combination of Western methods with Oriental motifs and techniques. With the large wave of German-Jewish refugees in the 1930s, the style shifted towards Modernism. Combined with today's technologies and amorphous borders, the current style has become international, marked by a strong European influence.

In 1998, the Shenkar College of Engineering and Design in Ramat Gan opened their own Department of Jewelry Design. The department's embrace of cutting-edge technology and an interdisciplinary approach to learning has had a significant impact on Israel's jewelry community, with many of Shenkar's graduates receiving international recognition for their achievements. In 1998, the first Israeli jewelry biennial was held at the Eretz Israel Museum; the next one of this ongoing program will be held in 2010. With many Israeli-trained jewelers traditionally choosing to market to the commercial jewelry or Judaica markets, the establishment of the biennial has encouraged more artists to produce one-of-a-kind art objects. As a result, Israel has seen a rise in jewelry exhibitions throughout the country, both in museums and top design galleries. As teachers at both Shenkar and Bezalel, many AIDA artists have played an active role in encouraging the next generation of Israeli jewelers to pursue artistic careers. AIDA is proud to encourage this dialogue and support this community.

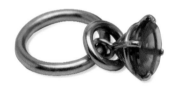

D.

B.

C.

Through a multi-faceted approach, AIDA has enabled Israel's decorative artists to present their work on the world stage. Within the Israeli jewelry community, the successes have shined brilliantly. Once known only to the local Israeli market, jewelers such as Anat Gelbard and Shay Lahover are now represented by galleries and expositions throughout the U.S. and Europe. As Shay remarked, "The entire experience has been amazing. Thanks to AIDA, I'm now working in some of the world's top jewelry galleries." Nirit Dekel, a sociologist by training and a former high tech expert, changed careers several years ago after seeing the exhibition, *Chihuly In the Light of Jerusalem 2000,* in order to pursue her passion— glass jewelry. Since being discovered by AIDA, Nirit has exhibited in galleries and museum shops across the U.S. She recently returned from an AIDA-sponsored workshop at the Studio at the Corning Museum of Glass where she studied with Paul Stankard. As Nirit stated, "My relationship with AIDA has changed my life. I can't say thank you enough." Shay and Nirit are not alone; AIDA jewelers are currently represented by top galleries in the U.S., Israel, Europe and Asia and can be found at booths across SOFA CHICAGO.

In 2006 AIDA was a supporter of *Women's Tales,* an in-depth study of the work of four of Israel's leading contemporary jewelers: Bianca Eshel-Gershuni, Vered Kaminski, Esther Knobel, and Deganit Stern-Schocken. The exhibit opened at the Racine Art Museum and traveled to the Bellevue Arts Museum, Houston Center for Contemporary Craft and the Newark Museum, and will conclude its tour at The Israel Museum, Jerusalem in 2010. These four jewelers, well known throughout Israel and Europe, were newcomers to the U.S. art scene. As a result of this exhibit, these masters are now known designers in the U.S. and their work can be found in permanent museum collections and galleries across the country.

AIDA's Network

Every organization is only as good as its friends. AIDA and its artists have been fortunate to build a network of invaluable supporters who believe in the organization's mission. These supporters have come in many forms: architects, designers, event producers, gallery owners, curators, museum directors, individual and corporate donors and the list goes on and on. Without these cheerleaders, AIDA's artists would never have succeeded in the ways they have.

This year, AIDA is fortunate enough to not only recognize, but also partner with one of our supporters, Nancy Yaw, former owner of the Yaw Gallery of Birmingham, Michigan. Over the years Nancy has recognized the talent of a number of AIDA's jewelry designers and has not only represented them, but has mentored them, seeking out galleries and other representatives for them. The Yaw Gallery embodied AIDA's vision of fostering Israel's artists, not only selling their work but also teaching the artists how to master their craft, as well as navigate the professional retail environment. Thanks to Nancy's mentoring, the AIDA artists she once represented are now represented in galleries and museums shops throughout the U.S. including: Sabbia, de Novo, Aaron Faber Gallery, Morgan Contemporary Glass Gallery, the Museum of Art and Design, and the Corning Museum of Glass, among others.

AIDA is lucky enough to bring Nancy back to SOFA CHICAGO 2009 to co-present an exhibition of Israeli jewelers. Some of the jewelers represented are AIDA alumni while others are newcomers; all work in a range of materials and methods that reflect the diversity of contemporary Israel.

AIDA invites you to visit our booth and experience all our gems have to offer.

Erika Vogel is the Director of the Association of Israel's Decorative Arts.

Published in conjunction with the SOFA CHICAGO 2009 special exhibit *AIDA's Gems – Israel's Jewelers* presented by the Association of Israel's Decorative Art (AIDA). For more information about AIDA visit www.AIDAarts.org.

E.

E.
Shay Lahover
Rings, *2008*
24k and 22k gold, precious and semi precious stones

F.
Shay Lahover
Grape Earrings, *2008*
22k gold, uniquely cut rhodolite, diamonds

G.
Avital Coorsh
Origami Bracelet, *2009*
leather

H.
Yael Herman
Ribbon Ring, *2008*
18k gray gold, diamonds

F.

H.

G.

Will there be a New Generation of Woodturners?

By Mary Lacer

A.

46

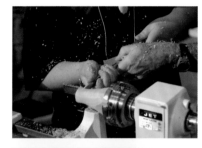

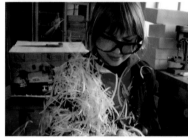

There is no question that within the world of wood art we are blessed with a generation of artists who are talented, vital, and actively carrying the art form forward. But as an organization dedicated to supporting and promoting the art of wood-turning, we see clouds on the horizon that should be of concern to artists, collectors, galleries and museums alike: Where are the young woodturners? How are we nurturing future generations of artists and collectors?

Many current woodturners were exposed to woodturning through shop classes in junior or senior high school, and returned to it later in life, either as a rewarding hobby or as a profession. They may not have turned for years, but the experience stayed with them: the feel of the tool, the satisfaction of creation, and along with that satisfaction (or frustration) a real appreciation for the more accomplished work of others. This experience, no matter what the medium, contributes to what could be termed a 'healthy materialism:' a true appreciation of the created object.

In many ways the world has seemingly gone virtual—and the school system has gone with it, replacing hands-on activities in shop and art classes with computer simulations of the act of creating. Today there is only one-tenth the number of shop classes as in previous decades, drastically reducing opportunities for young people to develop the very human qualities described above. Although not as radically cut, craft and studio art courses have also been slashed. Computer games, Facebook and Twitter all vie for students' attention, but our experience is that for many young people, once they try woodturning or other crafts, they enjoy it.

Working with the hands provides a unique experience. Learning woodturning or another craft also develops personal skills and qualities that are of benefit in all areas of life: the ability to work hard, to focus, to persevere, to create, to design, to problem solve, to follow a project through multiple steps to the finish, to become inspired to do their best work. Learning wood-turning is most effective when it is personal—it is a craft best taught person-to-person, and through those relationships ideas are shared, developments are built upon, and the movement as a whole benefits. The American Association of Woodturners (AAW) has nurtured this form of community learning for twenty-three years, but while our membership has grown steadily, so has the median age of our members. The generations of students who experienced craft hands-on at school are getting older, and the new generation lacks that exposure.

Without shop classes and art classes, where will they get the opportunity to experience the satisfaction of creating with their own hands? Where will the seeds of interest, skill and appreciation be planted?

The AAW has been aware of this shift in educa-tional priorities for some time, and noting the serious decline of young people coming into the field, has taken decisive action. Our goal is to spark curiosity and build interest in all aspects of woodturning by providing instruction, exposure and information. What is this miraculous material called 'wood?' There are thousands of different sub species within a species. What is the attraction of wood? You can make hundreds of things on the lathe. The universe that one steps into is never-ending. Virtually every part of the tree can be turned—the trunk, a fork, a branch, a burl, some people turn bark. Even wood that is decaying, wormy and insect damaged can be turned. A woodturner can also turn different materials—soft metals, stone, bone, antler, plastic, plywood, and construction materials. These questions spark not only their interest in wood-turning but in the world around them, and they look with new eyes at both nature and art.

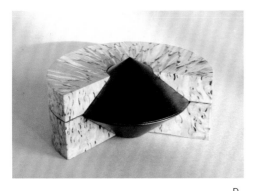

D.

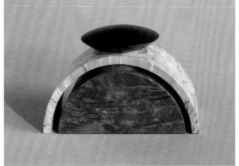

E.

F.

G.

H.

I.

What started as an experimental program to inspire young people to try woodturning has over the past five years become one of the most successful efforts by AAW, fulfilling our goal of stimulating interest in woodturning and recruiting new turners through exposure to the process and the product, as well as through personal instruction from experienced and inspirational woodturners. We provide free hands-on instruction to youth at our annual international symposium, and encourage our local chapters to do the same through grants and other means. Young people ages 10–17 attend the AAW Symposium at no charge, and between 50 and 100 youth register for the program each year. Lathe and tool companies have generously partnered with AAW to donate equipment; each year twenty-five students take lathes home through a drawing at the conclusion of the course. To encourage woodturners and woodworking teachers, AAW produced the instructional guide "Teaching Woodturning Basics." Put together by experienced woodturning instructors, the guide is available at low or no cost as part of our ongoing commitment to education.

In 2007 AAW's Gallery of Wood Art in St. Paul hosted a special exhibition *Turning Toward the Future,* with work by 60 young turners from the United States, Canada and Australia. Visitors to the gallery, young and old, commented that they had no idea young people could create such beautiful pieces. Until a person has been exposed to woodturning they do not know what is possible and many youths were inspired by the show to try it.

AAW members provide demonstrations at schools, craft shows, annual meetings, Boys and Girls Scout troops, 4-H clubs, museums and woodworking stores. Through AAW grants, many local chapters have given woodturning instruction to troubled youth, providing an invaluable opportunity for them to feel a real sense of accomplishment and mastery.

With *Influence & Inspiration: The Evolving Art of Woodturning,* AAW expands its outreach efforts to supporting talented young woodturning artists. We asked emerging woodturning artists to name their influential mentors, and sought suggestions of new names from experienced artists and teachers. It is a tangible representation of AAW's commitment to the future of woodturning.

The AAW is by no means alone in the campaign to keep craft relevant and available to young people. There has been a concerted effort to develop studio craft degree programs at the college level, and many guilds and associations are actively recruiting younger members. Teaching art and craft is an investment in the future of our young people. It gives energy to the human spirit, creating connections between people, and with the world we live in. The seeds we plant now to encourage young artists in pursuing careers in craft will grow by leaps and bounds in the future. The combined efforts of professionals, enthusiasts, collectors, gallery owners, educators, community and school leaders will ensure that fine craft will not only survive, but thrive, providing satisfaction, pleasure and fulfillment to makers and audiences alike.

How You Can Support the Future of Craft

Local Organizations in each state—There are programs across the U.S. that make art instruction available to students. In Chicago, Illinois, the program is Urban Gateways. The program in Minnesota is COMPAS. AAW was just accepted by COMPAS, and our organization will be added to the Young Audiences of Minnesota/Global Arts & Culture teaching roster, bringing more cultural and artistic awareness to the students of Minnesota. In Dallas, Texas, Big Thought is a Young Audience chapter that partners with the

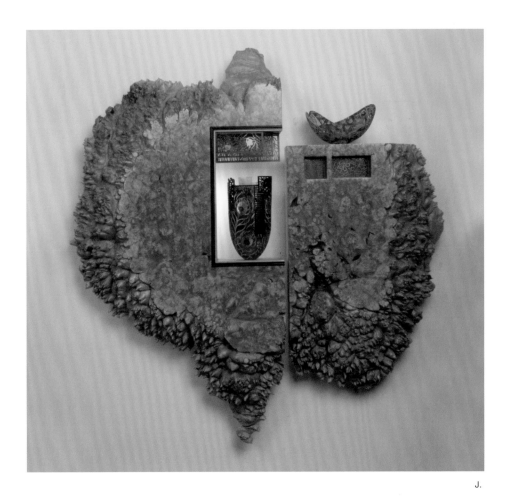

J.

D.
Jakob Weissflog
Open Pointed Box, *2008*
African blackwood,
Masur birch
1.5 x 3.25 x 2.75

E.
Jakob Weissflog
Curve Box, *2008*
Amboyna burl,
Masur birch,
African blackwood
2 x 3.25 x 1.5

F.
Jakob Weissflog
Pointed Side Box, *2007*
Masur birch, cocobolo
3.25 x 2.25 x 2

G.
Hans Weissflog
Small 3rd Rocking
Bowl, *2008*
African blackwood,
boxwood
1.5 x 3.25 x 6.25

H.
Hans Weissflog
Triangle Rocking
Bowl, *2008*
ziricote
4.75 x 5.25 x 6.25

I.
Joey Richardson
Kismet 1, *2009*
beech, sycamore
6 x 6 x 6

J.
Binh Pho
Diminishing Fifth, *2008*
maple burl,
maple, boxelder
46 x 36 x 5

Dallas school district. In Columbus, Ohio, programs work with the Ohio Arts Council. In Pittsburgh, Pennsylvania, grants are made through the Society for Contemporary Craft supported by the Grable and Pittsburgh Foundations.

Another program is Young Audiences Arts for Learning—www.youngaudiences.org. It has 30 affiliates around the country engaged in several network projects that address the needs of children and teachers in local communities. Nationally-funded programs make a positive impact on the Young Audiences Arts for Learning network and the field of arts in education.

A third organization is Arts Education Partnership (www.aep-arts.org). Over 100 national organizations committed to promoting arts education in elementary and secondary schools throughout the country participate in the Partnership.

A fourth program is Upward Bound sponsored by the University of Mary (www.umary.edu) in Bismarck, North Dakota. Upward Bound provides fundamental support to participants in their preparation for college entrance. The goal of Upward Bound is to increase the rate at which participants complete secondary education and enroll in and graduate from institutions of post-secondary education.

These are some ways for individuals and organizations to reach out and introduce art into the lives of young people, to experience the joy of producing pieces with their hands, to spark their interest and desire to learn a way to work with their hands and make a contribution to the world.

Mary Lacer, Woodturner, Executive Director of the American Association of Woodturners, St. Paul, Minnesota.

Published in conjunction with the SOFA CHICAGO 2009 special exhibit *Influence and Inspiration: The Evolving Art of Woodturning* presented by the American Association of Woodturners.

No Pretense: The Evocative Glass Sculpture of Lucy Lyon

By Leanne Goebel

A.

B.

A woman wearing a nightgown sits on the edge of a bed, her shoulders lifted in tension, one hand clasped to each knee, bare feet pressed to the floor. Her back is to a man lying on his side, his back to her, resting his head on one hand, his slippers neatly on the floor beneath the bed. Is he her husband? Her lover? A one-night-stand? What is he looking at so casually? How can he be so at peace while she is so ill at ease?

The answers are not readily apparent upon the first, or even the fourteenth glance at *4 A.M.,* a Lucy Lyon sculpture made of glass and steel. Lyon's work deals not with overt gesture but rather subtle body movements—the slump of a shoulder, the tilt of a head—which convey emotional narratives about ordinary moments. If the goal of an artist is to close the gap between art and life, then Lyon chooses to do so without drama, without shock value. Using a challenging medium, Lyon conveys with an asceticism reminiscent of Edward Hopper, the loneliness of urban life. For more than thirty years, her work has evolved from stained glass

artist, to two-dimensional dioramas, to cast glass, to a sculptor whose chosen medium happens to be glass—one of the most difficult materials an artist can use to create human figures.

Lyon sculpts using the lost wax casting method. A figure is sculpted in wax. A plaster mold called an investment mold is formed around the completed wax sculpture. The wax is steamed out and the mold is placed in the kiln. A flowerpot holding glass is positioned over the mold so when the kiln reaches peak temperature the glass will flow through the hole in the flowerpot into the mold. The kiln heats slowly, allowing moisture to escape and the glass to reach viscosity. The annealing process takes days as the glass must be held at its annealing temperature and then cooled very slowly and steadily to prevent it from cracking or breaking easily when cured. One figure can remain in the kiln for ten days to six weeks.

Lyon is a keen observer of humans and their inter-actions. She wants to convey to the viewer an experience and she would like it to be beautiful—

an overused yet often undefined term that itself evokes reaction in art today. "I'm a sucker for a beautiful face. It's not a classic beauty. I have tended to want a spare look where the bones are evident and character is obvious in the stance and facial structure," Lyon says.

Hence, the problem with defining beauty; it is sub-jective. It's not the golden ratio or some classically informed definition that inspires Lyon, and it's not just the proportions of a face, but a stance, or slightly bent knee that tweaks the artist's interest because it is a form of figurative communication.

Lyon's own story is as evocative as the narratives conveyed in her vignettes and sculptural oeuvre: single figures on slabs of glass like *Precipice;* two figures separated by a wall of glass in *Potential Encounter;* a figure and a column, or two figures and a pillar as in *Tete a Tete*; queues of figures lined up and waiting in *Queue 4;* a gathering of two figures and one outside the group alone, an empty stool between them in *After Eight;* half-life-sized body parts of glass displayed in

windows of metal in *Rear Window;* glass heads like disembodied dinner party guests on slabs of glass or metal; or, what she is most well-known for, figures in libraries.

Her development as an artist did not come from traditional avenues. She did not go to art school, or apprentice with a single master glass artist. She isn't rooted in art theory and lineal art history. Lyon has trained with multiple artists and masters. She began her art career at the age of thirty as a working mother who wanted a flexible career while raising her child. Her artistic growth comes from her own intelligence and effort, along with a dedication to push the medium of glass as far

C.

as she can take it. Her naiveté provided a freedom to explore, because she often didn't know that she wasn't supposed to be able to do something with glass—she just figured out how.

Her dealer, Tom Riley of Thomas R. Riley Galleries in Cleveland, Ohio says: "Lucy is not content just to be decorative. She wants to say something. She's taken the time and has the ability to do that. Every step requires courage. There's a lot of problem solving. There are logistical and technical problems to execute to get the work done. She's conquered them all and we will launch her new breakthrough series at SOFA."

Half-life-sized figures are the breakthrough series to which Riley is referring. The first, an amber yellow young female sitting with her legs crossed, arms resting at her sides, her head tilted slightly upward, the curve in her toe, the angle of her foot suggesting she is bouncing or perhaps swinging a leg. Another sculpture features two of the same figure, one cast in nearly clear white glass, the other a dark brown almost black. One knee is bent, an elbow wrapped around the knee, her head outstretched. The two appear to be leaning in and listening to each other.

Lyon has always been courageous. She was born in 1947 in Colorado Springs, Colorado. Her father was a real estate appraiser and her mother a nurse and teacher, who met during WWII. Books always surrounded Lucy and she recalls spending time looking through her mother's art books as a child, enjoying Thomas Hart Benton's nearly sculptural paintings of figures in everyday scenes. But what she recalls most vividly were visits to the Colorado Springs Fine Arts Center and viewing the crucifixes. The FAC has one of the finest collections of Santos in the country, collected by museum founder and benefactor Alice Bemis Taylor.

Lyon, who was raised as a Unitarian because her father was Jewish and her mother Baptist, grew up as a thinking person. She studied Oriental Philosophy at Antioch College in Yellow Springs, Ohio from 1965-1971 and spent time in the middle of her college days living in Greece and wandering around Europe. She met her husband in New York City where she worked in the Parks and Recreation department as an urban planner during the 1970s. It was here she says she got her art education by visiting museums and galleries. She lived next door to two working artists. It was the first time Lyon realized that making art could be a career. In 1977 she took her first stained glass class at the Riverside Church in New York taught by Ellen Simon.

However, not long after taking her first class, Lucy and her husband, Vincent Yuan, a nuclear physicist, moved to Los Alamos, New Mexico. Lyon studied with glass artist Narcissus Quagliata and apprenticed with artist Larry Fielder. In 1978 her daughter Jada Yuan was born. In 1980, missing New York City, and trying to adjust to life in Los Alamos, Lyon rented a space on Main Street above a department store, and began making stained glass. This location allowed her to be around people, something she needed. Her earliest work featured portraits of people in bars and New York City street life. Then came the images of low rider cars from nearby Espanola, which evolved into scenes of Americana and vignettes of Sparky's Diner, a place literally caught in a time warp, frozen, much like Los Alamos, in the 1950s. Soon she began exploring slumping glass and ways to make her figures three-dimensional. She created thick, flat people that folded and bent like pop-up figures.

One of Lyon's artistic influences is Edward Hopper, who had a retrospective at the Whitney Museum in 1980; his painting *Early Sunday Morning* was on the cover of every New York City phone book around this same time. Lyon appropriated *Early Sunday Morning* and created a stained glass work of the painting, which she called *City Morning*—only she included figures. "I'm not attracted to Hopper's work devoid of

C.
Kenyan Couple, *1986*
glass
20 x 30

D.
Precipice, *2006*
glass
24.5 x 7 x 8
photo: Addison Doty

E.
Seated Figure, *2009*
glass
57 x 27 x 15
photo: Addison Doty

F.
Queue 4, *2009*
glass
22 x 40.5 x 11.75
photo: Addison Doty

D.

people," Lyon says. "I love his New York work. The single figures in public places. I like the idea that you can be alone surrounded by people." Aloneness, loneliness and solitude are deeply resonant themes for Lyon.

Recently, while flipping through a book on Hopper she found his painting *Excursions into Philosophy*, that features a woman lying on her side and a man sitting on the edge of a bed. She had never seen the painting before and was struck by its affinity to her own sculpture *4 A.M.*

In the early 1990s, Lyon created her first library tableaux with flat figures surrounded by shelves of books. A library is another place people go to be alone with their thoughts, while surrounded by others. There is little talking and human interaction. In Lyon's earliest libraries, the books were opaque; later they became translucent and colorful, and she began making the shelves out of metal instead of glass. The Los Alamos library was a sanctuary for her and this series continues to be popular with collectors, having evolved from pop-up figures to early cast glass, to more refined glass sculpted figures sitting, standing, and one even watching television in a library. Critics of her early works consider the glass libraries cute and cliché, but not challenging enough to the viewer. Her early cast figures were deemed awkward, rudimentary, and her skills as a sculptor proximate, her figures more like caricatures, yet her straightforward and fresh approach continues to be commended. The libraries have continued to evolve.

"I like the idea of solitude," Lyon says from her studio in Jaconita, New Mexico about 20 minutes north of Santa Fe, near the Pueblo of Pojoaque. "But these [earlier works] are more about being lonely. Now I'm more content being by myself and my single figures are more contented and less rejected."

They are also more refined, her sculpting skills improving over the years from spontaneous figures, to ones that capture the more detailed nuances of aloneness. A life sculpting group meets weekly in her studio, a territorial style adobe house that sits on land below the traditional adobe house she shares with her husband. The 1,000 square foot building has high-pitched ceilings and two separate workspaces. In one she keeps her kilns and the polishing station. In the other is a sculpting space featuring another half-life-sized figure leaning back on one arm. Outside, under a covered overhang on a concrete slab patio is a wax station and mold-making space.

Lyon is a woman who portrays a quiet happiness, a contentedness with life and her art. Her hair is shoulder-length, straight and the color of sand, she is slight of figure and looks younger than her 62 years, dressed in a black tank top and black Capri pants. She is vivacious and genuine. "With Lucy there's no bluff, no pretense, no mirrors, no hype, no trickery," Tom Riley says of the artist he has worked with for close to 15 years.

Inspired by the book **New Glass** by Otto Rigan, the self-taught glass artist enrolled in a master's course at Pilchuck Glass School in Washington in 1988 where she studied with Paul Marioni, Bertil Vallien and Clifford Rainey. "I didn't know then that they were supposed to be my heroes," Lyon's confesses. She learned from some of the best.

In 1993 she cast her first figure in glass. Later, a workshop with Linda Benglis at the Santa Fe Art Institute would advance her sculpting skills and inspire Lyon to create life-sized heads in glass, and to elaborate on head gestures, which she placed on formed steel or copper wire wrapped bases. She returned to Pilchuck again in 2000 to study with Ann Robinson, an artist from New Zealand. "I was already doing 18 inch figures but her workshop totally changed the way I cast my work. I continue to use her method even for the half-life figures," Lyon says. In 2001 she cast her first half-life sized figure, *Helen*.

Another progression has been to move away from the glassiness of glass. She no longer tries to make the figures shiny, emphasizing the materiality of the work. She embraces the opacity of unpolished glass and has added more texture to the figure's clothing. Her colors have also shifted

away from the Jolly Rancher candy colors seen in earlier works to more translucent amber tones. "I like the warm feeling of yellows, pinks and reds. My people are warm," Lyon says.

Yet her work is not about materiality for the sake of material. In 1985, Lyon told *American Glass Quarterly:* "I am not firmly convinced that technique in itself is a prerequisite for making art in glass." Art is not about a technique, nor is it simply about an idea. Art is about relationships. Lyon has mastered technique and presents compelling narratives about the human condition— the interaction and/or lack thereof among humans pressed together in urban settings, poignantly explored through the simple communication of evocative body movements. And yes, it is often beautiful, but perhaps not in a classical way. It is often sad. It is often lonely. But it resonates with a familiarity to which any viewer can relate.

Leanne Goebel is a member of the International Association of Art Critics. She is a 2009 NEA International Arts Journalism Institute Fellow and a 2007 recipient of the Andy Warhol I Creative Capital Arts Writers Grant.

Published in conjunction with the SOFA CHICAGO 2009 lecture *Lucy Lyon: Adding a Dimension* presented by Thomas R. Riley Galleries, Cleveland, Ohio.

F.

E.

Shozo Michikawa: Nature into Art

By Simon Martin

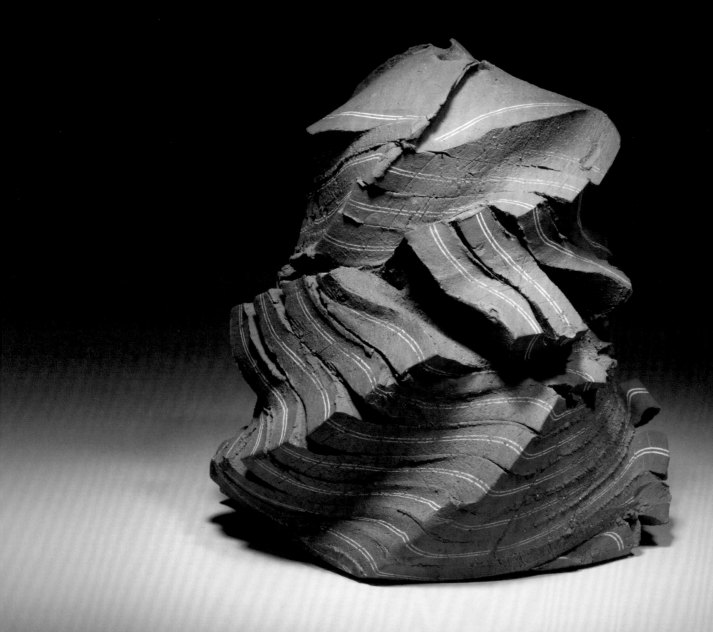

A.

"To retain the natural 'intentions' of the clay
A cold winter morning,
wedging clay in the workshop.
More painful than cold,
the feel of a handful of clay-
steam rises from one's hands
and just for an instant it itches.
Various shapes are born from my hands.
This morning's little satisfaction."

Shozo Michikawa

B.

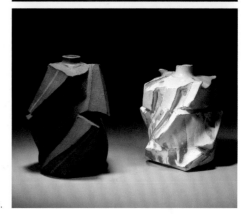

C.

Shozo Michikawa creates pots that have that rare quality of being imbued with both spirit and palpable energy. His work has been described as being like a 'haiku in clay,' a simile that captures a sense not only of the apparent simplicity, but also the complexity of his work. His pots are intriguing because they are replete with contradictions: they have a contemporary feel, yet are somehow timeless; they have an almost impractically sculptural appearance, yet serve functional purposes; they reflect an urban aesthetic, but simultaneously look as if they have grown from nature. While many great thinkers have tried to quantify that elusive Japanese aesthetic of 'Wabi Sabi,' to my Western untutored eye a tea bowl or kohiki incense burner by Shozo seems to be a modern manifestation of its qualities. His ceramics may, or may not, qualify under Soetsu Yanagi's explanation that Wabi Sabi celebrates "the mellow beauty that time and care impart to materials," (after all, Shozo has been nicknamed 'Hurry Potter' for his impressive throwing speed) but they do capture those intense emotions that are so hard to quantify.

When travelling in Japan last November, I had the great pleasure of being Shozo's guest at his home in Seto, a city that is known as one of the 'Six Old Kilns of Japan,' with a history of over 1300 years as a pottery centre. A lesser potter might feel oppressed by the weight of such a tradition, but although Shozo has an acute awareness and respect for the ceramic heritage of Japan, he has forged his own highly distinctive style and technique that makes his work stand out, not only from his contemporaries, but the great potters of the past. Significantly, he was the first Japanese artist to be honoured with a solo exhibition in the Forbidden City in Beijing in 2005. Shozo himself is not a native of Seto, but moved there precisely because of its heritage. He was born in Toya in Hokkaido in the north of Japan in 1953 and originally studied economics

at Aoyama Gakuin University in Tokyo, where he worked in business for a couple of years, but discovered a natural affinity for pottery when he began taking evening classes. In the late 1970s, he took the brave step of giving up his life as a Tokyo businessman to become a potter. Perhaps this background, which is so different from many of his Seto neighbours who come from generations of potters, has brought a different urge to his creativity. Watching him at work was an exciting experience that shattered any preconceptions I might have had about how his pots are created.

At first glance, one would imagine that Shozo's dramatic faceted and twisted forms are hand-built and sculpted but, in fact, the vases he was working on during my visit were created on the wheel. However, he does not 'throw' his vessels in any conventional sense; rather their energy comes from the twisting of fractured planes on an internal axis. It is a different understanding of his materials, to do with cutting and paring down, rather than expanding from a ball of clay. He speaks of having a 'conversation with the clay' and 'assisting the way it wants to go,' which reflects his profound respect for its natural qualities. An early morning walk through the woods with his Japanese Husky dog revealed just as much about his attitude to nature: almost an animist veneration for natural forces such as rocks, trees and the very earth from which the clay is mined, a sensibility that finds expression in the natural intentions of his beautiful pots.

Simon Martin is an art historian, writer and curator. He is Head of Curatorial Services at Pallant House Gallery in Chichester, UK, and International Art Advisor to the Contemporary Art Museum, Kumamoto, Japan, and the author of a number of art books including *Poets in the Landscape: The Romantic Spirit in British Art* and *Colin Self: Art in the Nuclear Age*.

Published in conjunction with Galerie Besson's presentation at SOFA CHICAGO 2009.

A.
*Shozo Michikaw
Tanka, twisted pot, 2009
charcoal fired stoneware
7 x 7*

B.
*Natural-ash, torn and
twisted pot, 2009
anagama fired stoneware
11 x 6.25*

C.
*[left] Kohiki twisted bottle, 2009
stoneware
6 x 4.75*

*[right] Tanka, twisted bottle, 2009
charcoal fired stoneware
6.25 x 5*

all photography: Alan Tabor

SOLO
S AT F A

A singular introduction to new artists, new works. Dedicated spaces for one-person and themed shows on the cutting-edge of concept, technique or materials.

Presented by SOFA CHICAGO dealers in addition to their booth exhibits

Untitled 12 *(Fragment Series), 2006*
kilnformed and coldworked glass
21 x 21 x 3
photo: Rob Little

Ferrin Gallery
Anne Lemanski

Blue Shark, *2008*
copper rod, ink and shellac on paper, artificial sinew
33 x 72 x 41

Rush Hour, *2009*
oil on canvas
34 x 34
photo: Sandi Higgins

Lafrenière & Pai Gallery
Anna Williams

Squadron, *2009*
cast bronze, enamel paint
installation detail of a flock of 34 bronze sparrows in flight
approximately 9.5 x 6 x 7 each

Maria Elena Kravetz
Maria Moreno

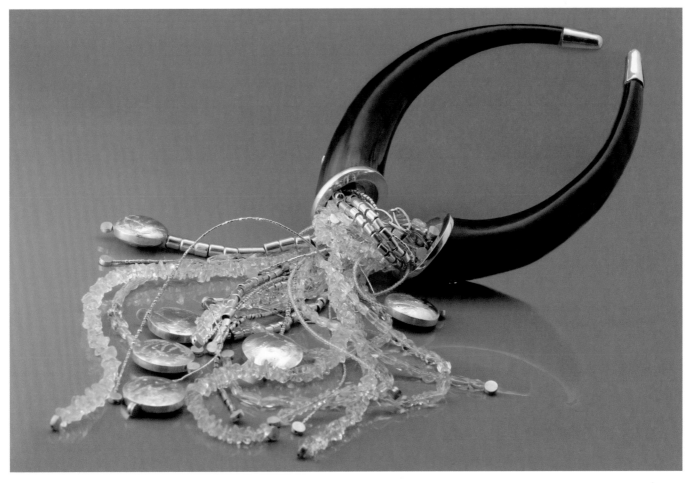

From Bicornios and Minotaurs I Necklace, *2009*
horn, quartz crystal, pearls, 950 silver

Next Step Studio & Gallery
Albert Young

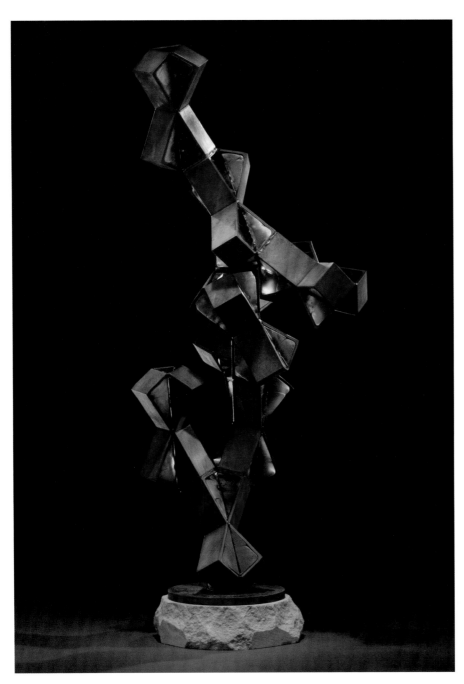

Descending Staircase, *2009*
welded steel, cast glass
55 inches high

State of Grace, *2009*
ceramic installation

Sienna Gallery
Lauren Kalman

Lip Adornment, *2008*
laminated inkjet print
30 x 40

FOLDUP! Bracelet, *2009*
steel, mixed media

Ex

hibitors

Bernd Munsteiner, **Symbolon Pendant,** *2002*
rutilated quartz

Aaron Faber Gallery

20th and 21st century jewelry and timepieces; special SOFA focus Master Series: Bernd Munsteiner

Staff: Edward Faber; Patricia Kiley Faber; Jerri Wellisch; Macouta Sissoko

666 Fifth Avenue
New York, NY 10103
voice 212.586.8411
fax 212.582.0205
info@aaronfaber.com
aaronfaber.com

Exhibiting:
Glenda Arentzen
Margaret Barnaby
Marco Borghesi
Claude Chavent
Petra Class
Marilyn Cooperman
Jack Cunningham
Emanuela Duca
Peggy Eng
Michael Good
Barbara Heinrich
Lucie Heskett-Brem
April Higashi
Melissa Huff
Hongsock Lee
Sydney Lynch
Enric Majoral
Chihiro Makio
Brooke Marks-Swanson
Bernd Munsteiner
Tom Munsteiner
Earl Pardon
Tod Pardon
So Young Park
Linda Kindler Priest
Ginny Whitney
Michael Zobel/
 Peter Schmid

Jack Cunningham, **Fragments Brooch,** *2008*
silver, jade, quartz, tigers eye, cultured pearl, found object, 2.5 x 4 x .5

Marlene Rose, **New Vaseline Birdbath Buddha**, *2009*
cast glass, steel, 64 x 17 x 12

Adamar Fine Arts

Contemporary sculpture and paintings by established and emerging national and international artists
Staff: Tamar Erdberg, owner/director; Adam Erdberg, owner

4141 NE 2nd Avenue
Suite 107
Miami, FL 33137
voice 305.576.1355
cell 305.527.9061
fax 305.576.1922
adamargal@aol.com
adamargallery.com

Exhibiting:
Brad Howe
Tolla Inbar
Zammy Migdal
Gretchen Minnhaar
Niso
Marlene Rose

Tolla Inbar, **Horse,** *2007*
bronze, 84 x 72 x 16

Mary Borgman, **Portrait of Kaveh**
charcoal on Mylar, 55 x 45

Ann Nathan Gallery

Contemporary figurative and realist painting, sculpture, and artist-made furniture by established and emerging artists
Staff: Ann Nathan, owner/director; Victor Armendariz, assistant director; Jan Pieter Fokkens, preparator

212 West Superior Street
Chicago, IL 60654
voice 312.664.6622
fax 312.664.9392
nathangall@aol.com
annnathangallery.com

Exhibiting:
Pavel Amromin
Mary Borgman
Gordon Chandler
Cristina Cordova
Michael Gross
Peter Hayes
Chris Hill
Jesus Curia Perez
Anne Drew Potter
Jim Rose
Jerilyn Virden

Jesus Curia Perez, **Blanco**
bronze, steel, 67 x 18 x 27

Cristina Cordova, **Negra**
ceramic, mixed media, 14 x 15 x 10

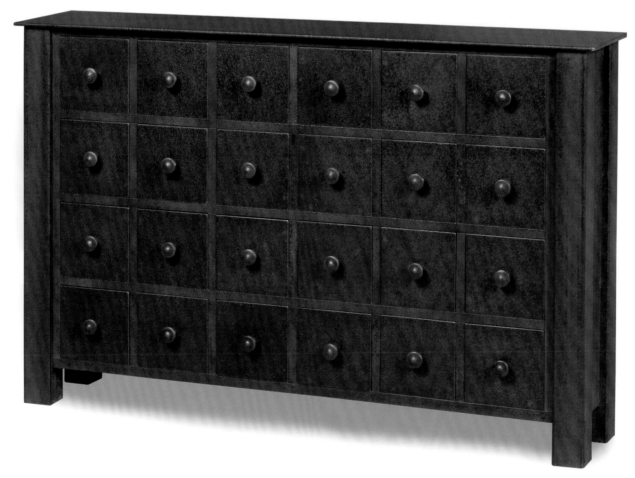

Jim Rose, **Apothecary**
steel, natural rust patina, 32 x 50 x 10

Laura de Santillana, **Flag 6 (Bluviola/Rosso/Violetto)**, *2008*
hand-blown and shaped glass, 17 x 17.25
photo: Fabio Zonta

Barry Friedman Ltd.

Contemporary decorative arts including glass and ceramics; design, painting and photography
Staff: Barry Friedman, owner; Carole Hochman, director; Lisa Jensen; Osvaldo da Silva; Jessica Nicewarner

515 West 26th Street
2nd floor
New York, NY 10001
voice 212.239.8600
fax 212.239.8670
contact@barryfriedmanltd.com
barryfriedmanltd.com

Exhibiting:
Cristiano Bianchin
Jaroslava Brychtová
Wendell Castle
Ingrid Donat
Michael Eastman
Michael Glancy
Stanislav Libenský
Arno Rafael Minkkinen
William Morris
Yoichi Ohira
David Regan
Laura de Santillana
Kondo Takahiro
Akio Takamori
Kukuli Velarde
František Vízner
Toots Zynsky

Akio Takamori, **Alice**, *2008*
stoneware with underglazes, 42 x 27 x 27
photo: Richard Nicol

Silvio Vigliaturo, **Testa Doppia Tonda,** *2009*
glass, 18 x 11
photo: Francesco Allegretto

Berengo Studio 1989

20th century glass has always been regarded as merely decorative, Berengo's vision of uniting artists with glass elevates it to the major medium it is today

Staff: Adriano Berengo, president; Marco Berengo, vice president; Elena Cimenti and Laura Johnson, sales

Fondamenta Vetrai 109/A
Murano, Venice 30141
Italy
voice 39.041.739.453
cell 39.335.600.6392
fax 39.041.527.6588
adberen@yahoo.it
berengo.com

Berengo Collection
Calle Larga San Marco 412/413
Venice 30124
Italy
voice 39.041.241.0763
fax 39.041.241.9456

Berengo Collection
ESQ Hiroo 2F
5-10-37, Minami-azabu
Minato-ku, Tokyo 106-0047
Japan

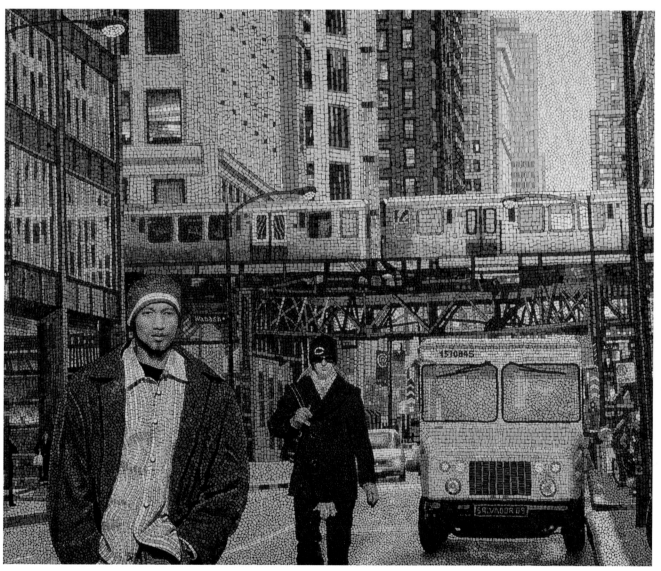

Andrea Salvador, **Walking on a Dream,** *2009*
mosaic, 51.2 x 42.5
photo: Alessio Buldrin, Feg Immagine

Exhibiting:
Mauro Bonaventura
Pino Castagna
Hitoshi Kuriyama
Massimo Lunardon
Juan Ripolles
Andrea Salvador
Silvio Vigliaturo

Tammy Garcia and Preston Singletary, **Night Fisher,** *2009*
blown and sand-carved glass, 13 x 15
photo: Adison Doty

Blue Rain Gallery

Staff: Leroy Garcia, owner; Peter Stoessel, executive director; Denise Phetteplace, director

130 Lincoln Avenue
Suite C
Santa Fe, NM 87501
voice 505.954.9902
fax 505.954.9904
info@blueraingallery.com
blueraingallery.com

Exhibiting:
Rik Allen
Tammy Garcia
Shelley Muzylowski Allen
Preston Singletary

Tammy Garcia and Preston Singletary, **Sikyatki in Blue**
blown and sand-carved glass, 8 x 19
photo: Adison Doty

Michael Rogers, **Emerson Dreams,** *2009*
cast and engraved glass, brass, 17.5 x 15.5 x 3.5
photo: Geoff Tesch

Bullseye Gallery

Supporting artists and projects at the leading edge of contemporary glass
Staff: Lani McGregor, director; Jamie Truppi, assistant director; Ryan Watson, special events

300 NW 13th Avenue
Portland, OR 97209
voice 503.227.0222
fax 503.227.0008
gallery@bullseyeglass.com
bullseyegallery.com

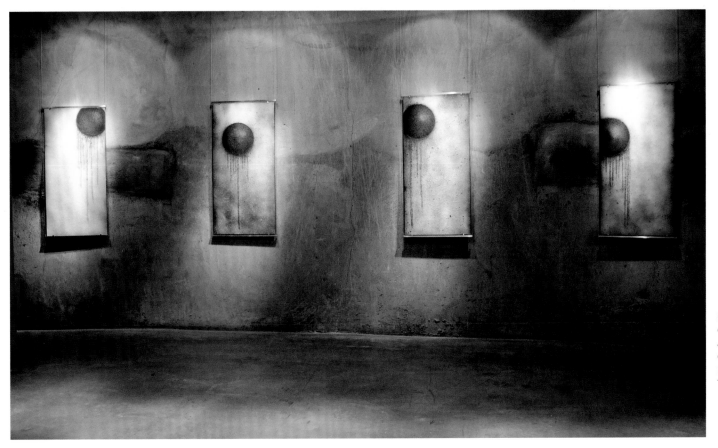

Exhibiting:
Giles Bettison
Jessica Loughlin
Catharine Newell
Michael Rogers
Ted Sawyer

Ted Sawyer, **Note** *I-IV, 2008*
kilnformed glass, 48 x 24 x .25 each
photo: Ryan Watson

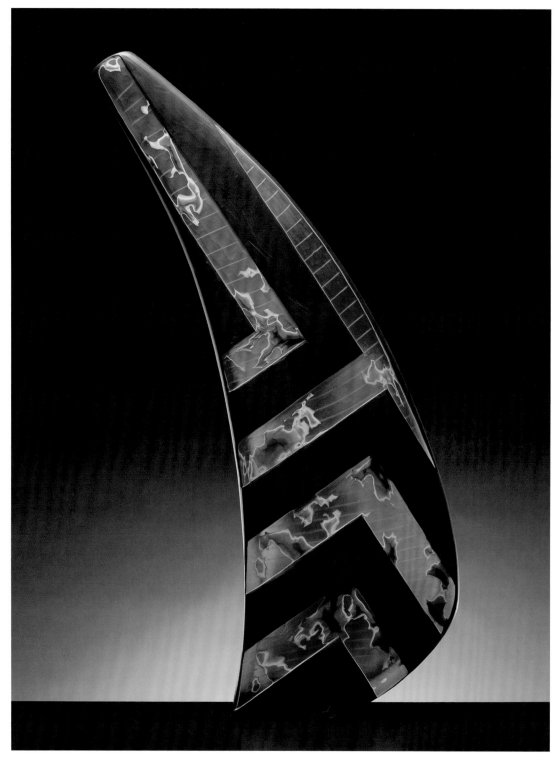

Ethan Stern, **Coco Flag***, 2009*
blown and carved glass, 27 x 11 x 4
photo: Robert Vinnedge

Chappell Gallery

Contemporary glass sculpture

Staff: Alice M. Chappell, director; Richard L. Chappell, chairman

526 West 26th Street
New York, NY 10001
voice 212.414.2673
amchappell@aol.com
chappellgallery.com

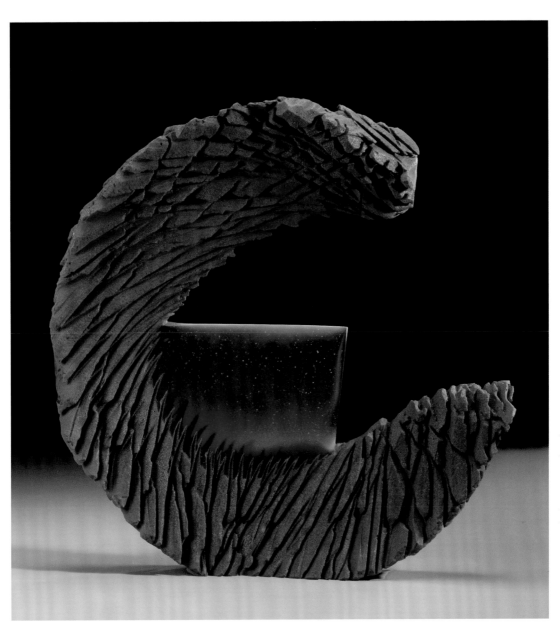

Alex Gabriel Bernstein, **Steel Moon**, *2009*
cast and cut glass, fused steel, 18 x 18 x 3
photo: Steve Mann

Exhibiting:
Mary Ann Babula
Alex Gabriel Bernstein
Kathleen Holmes
Toshio Iezumi
Kazumi Ikemoto
Etsuko Nishi
Kait Rhoads
Takeshi Sano
Youko Sano
Naomi Shioya
Ethan Stern
Sasha Zhitneva

*Stefano Marchetti, **Necklace**, 2009*
gold, oxidized silver, stainless steel
photo: Stefano Marchetti

Charon Kransen Arts

Contemporary innovative jewelry and objects from around the world
Staff: Adam Brown; Lisa Granovsky; Charon Kransen

By Appointment Only
817 West End Avenue, Suite 11C
New York, NY 10025
voice 212.627.5073
fax 212.663.9026
charon@charonkransenarts.com
charonkransenarts.com

Exhibiting:

Efharis Alepedis	Junwon Jung	Daniela Osterrieder
Ralph Bakker	Yeonmi Kang	Barbara Paganin
Michael Becker	Masumi Kataoka	Liana Pattihis
Liv Blavarp	Martin Kaufmann	Natalya Pinchuk
Julie Blyfield	Ulla Kaufmann	Sarah Read
Sophie Bouduban	Jennifer Howard	Zoe Robertson
Florian Buddeberg	Kicinski	Anthony Roussel
Anton Cepka	Jimin Kim	Jackie Ryan
Yu Chun Chen	Christiane Koehne	Lucy Sarneel
Moon Choonsun	Yael Krakowski	Isabell Schaupp
Giovanni Corvaja	Elfrun Lach	Marjorie Schick
Simon Cottrell	Gail Leavitt	Debbie Sheezel
Annemie De Corte	Dongchun Lee	Verena Sieber Fuchs
Saskia Detering	Felieke van der Leest	Roos van Soest
Daniel Di Caprio	Nicole Lehmann	Elena Spano
Babette von Dohnanyi	Nel Linssen	Barbara Stutman
Sina Emrich	Susanna Loew	Janna Syvanoja
Lina Falkesgaard	Robert Longyear	Salima Thakker
Willemijn de Greef	Sim Luttin	Terhi Tolvanen
Birgit Hagmann	Peter Machata	Henriette Tomasi
Sophie Hanagarth	Stefano Marchetti	Silke Trekel
Mirjam Hiller	Vicki Mason	Fabrizio Tridenti
Marian Hosking	Sharon Massey	Catherine Truman
Reiko Ishiyama	Leslie Matthews	Chang-Ting Tsai
Hiroki Iwata	Christine Matthias	Flora Vagi
Hilde Janich	Wendy McAllister	Christel Van Der Laan
Andrea Janosik	Timothy McMahon	Karin Wagner
Mette Jensen	Sonia Morel	Julia Walter
Eun Yeong Jeong	Evert Nijland	Caroline Weiss
Meghann Jones	Melanie Nuetzel	Francis Willemstijn
Machteld van Joolingen	Carla Nuis	Jasmin Winter
Lisa Juen	Angela O'Kelly	Annamaria Zanella

Mirjam Hiller, **Phedoraz Brooch,** *2009*
stainless steel, powder coating, 925/-silver
photo: Mirjam Hiller

John Garrett, **New Age Basket V,** *2009*
recycled steel and copper, wire, paint, paper, 25.5 x 16 x 16
photo: Margot Geist

Chiaroscuro Contemporary Art

Contemporary abstraction and contemporary Native American art in all media
Staff: John Addison; Frank Lux

702 1/2 Canyon Road
Santa Fe, NM 87501
voice 505.992.0711
fax 505.992.0387
gallery@chiaroscuro
 santafe.com
chiaroscurosantafe.com

Flo Perkins, **Esmeralde***, 2009*
blown glass, marble, 18.5 x 9 x 7
photo: Addison Doty

Exhibiting:
Rebecca Bluestone
John Garrett
Lisa Holt
Bebe Krimmer
Peter Millett
Flo Perkins
Harlan Reano

Gurgling Fish Pitcher *designed by Alastair Crawford*
sterling silver, 12 inches high

Crawford Contemporary

Contemporary silver and gold
Staff: Alastair Crawford; Caroline Crawford

1044 Madison Avenue
New York, NY 10075
voice 212.249.3602
fax 212.249.3604
info@alastaircrawford.com
crawfordcontemporary.com

Exhibiting:
Alastair Crawford

The Criss Cross Collection *designed by Alastair Crawford*
sterling silver and 18k gold handmade expandable bracelets
and rings with or without precious stones

Patrick Primeau, **Cactacea Serie,** *2009*
blown glass, 34 x 9 x 9 each
photo: Michel Dubreuil

Crea Gallery

Select contemporary fine craft works in a variety of media by emerging, established and internationally recognized Quebec artists
Staff: Linda Tremblay, gallery director

350 St. Paul East
Montreal, Quebec H2Y 1H2
Canada
voice 514.861.2787, ext. 316
fax 514.861.9191
crea@creagallery.com
creagallery.com

Exhibiting:
Maude Bussières
Laurent Craste
Roland Dubuc
Bruno Gérard
Chantal Gilbert
Karina Guévin
Catherine Labonté
Eva Lapka
Christine Larochelle
Lynn Légaré
Louise Lemieux-Bérubé
Réjane Mercier
Caroline Ouellette
Gilles Payette
Stephen Pon
Patrick Primeau
Colin Schleeh
Luci Veilleux

Laurent Craste, **Iconocraste-Ètudes Colorimétriques,** *2008*
porcelain, glaze, 16 x 5.5 x 6 each
photo: David Bishop Noriega

Marvin Blackmore, **Rainbow Wildlife Kiva Jar,** *2009*
ceramic, hand-etched through clay slips

D & M Fine Arts Ltd.

Contemporary works of fine art featuring ceramics, leather, glass and photography
Staff: David D. Pulito, owner; Richard Coplan, sales

20 Dogwood Glen
Rochester, NY 14625
voice 585.249.9157
cell 585.281.6918
fax 585.249.9157
dpulito@rochester.rr.com

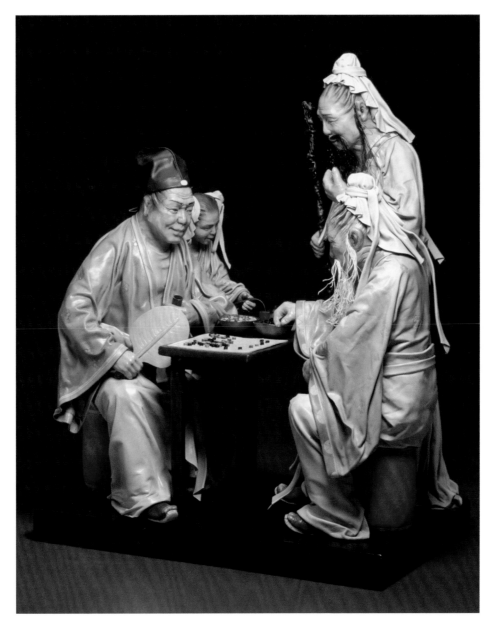

Exhibiting:
Marvin Blackmore
Liu Miao Chan
Steve McCurry
Kevin Naranjo
Wallace Nez
Steven Weinberg

Liu Miao Chan, **Challenge of the Masters,** *2009*
leather sculpture

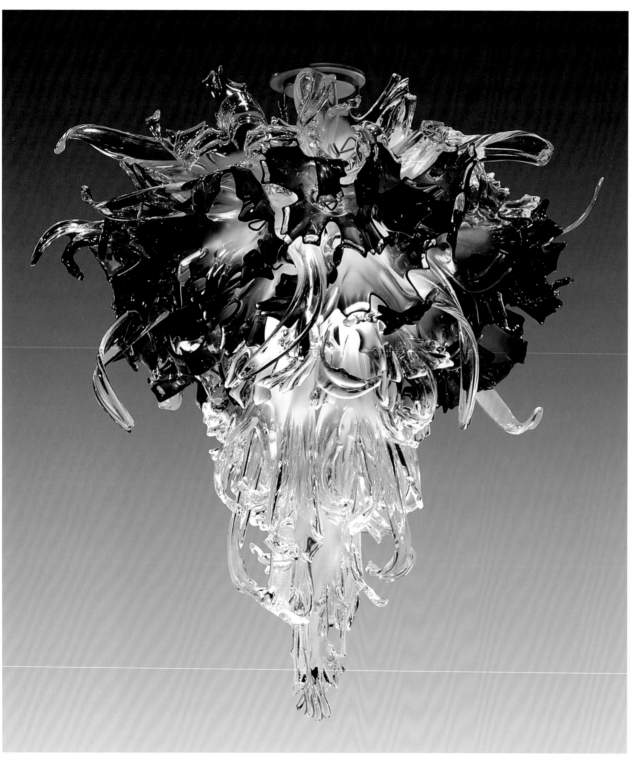

Barry Entner, **Corona Chandelier**, *2008*
steam blown glass, 40 x 32 x 32
photo: Bob Barrett

The Dancing Hands Gallery

Glass and clay art
Staff: Christina Meyer, owner; Wendy Van Reyper, sales

591 Main Street
Park City, UT 84060
voice 435.649.1414
fax 435.649.9523
chris_dhgallery@qwestoffice.net
thedancinghandsgallery.com

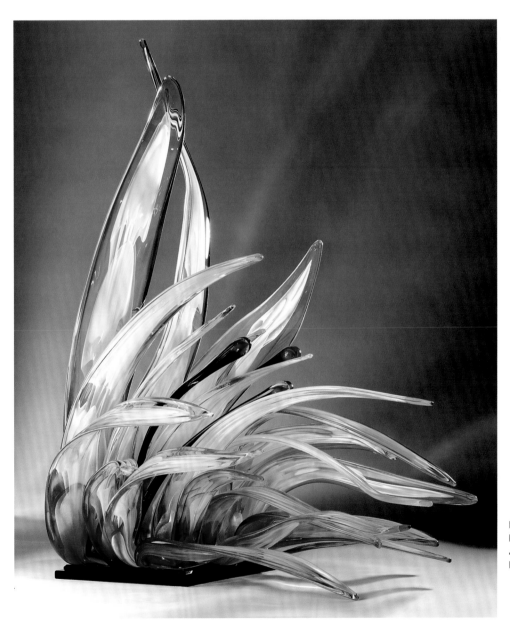

Exhibiting:
Barry Entner
Jeff Margolin
Randy Strong

Randy Strong, **Ode to Georgia,** *2008*
hot glass, cold fusion, 40 x 26 x 40
photo: Keay Edwards

Jean-Yves Gosti, **Home Boy,** *2009*
bronze, 24 x 10 x 11
photo: Sylvain Solaro

DC and Company

Art furniture, lighting, objets d'art in bronze, crystal, leather and wood
Staff: Dominic Chambon, artistic director; Laurier Dubé, North America sales director; Chantal Maury, sales manager

3 Avenue Daumesnil
Paris 75012
France
voice 33.1.4340.3424
cell 33.6.7468.7151
fax 33.1.4340.1604
chantal@dcandco.fr
editions.dube@wanadoo.fr
dcandco.fr

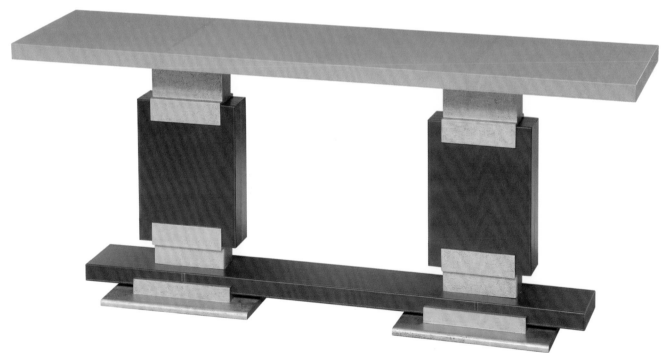

Dominic Chambon, **Console Table Assouan,** *2009*
wood, leather, bronze, 32 x 71 x 18
photo: Régis d'Audeville

Exhibiting:
Juan Luis Baroja Collet
Dominic Chambon
Jean-Yves Gosti
Bernard Remusat

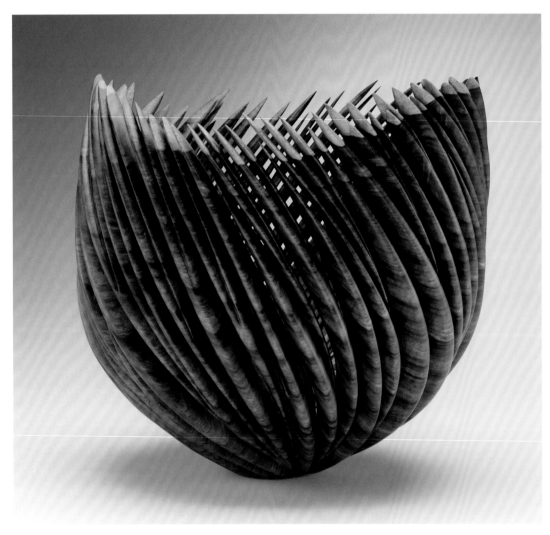

William Hunter, **Stirring Breeze,** *2009*
cocobolo, 9 x 10
photo: Anthony Cunha

del Mano Gallery

Contemporary sculpture in wood, fiber, metal, ceramic and glass
Staff: Ray Leier; Jan Peters; Kirsten Muenster; Kate Killinger; Amanda Bowen

11981 San Vicente Boulevard
Los Angeles, CA 90049
voice 310.476.8508
fax 310.471.0897
gallery@delmano.com
delmano.com

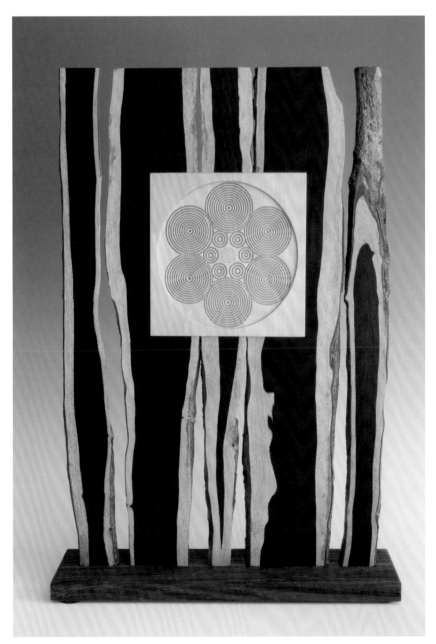

Hans Weissflog, **Star Wall***, 2009*
African blackwood, boxwood, bog oak, 14 x 9.5 x 2.75
photo: Hans Weissflog

Exhibiting:

Gianfranco Angelino	William Moore
Michael Bauermeister	Ed Moulthrop
Jerry Bennett	Matt Moulthrop
Roger Bennett	Philip Moulthrop
Dixie Biggs	David Nittmann
Christian Burchard	Gordon Pembridge
Marilyn Campbell	David Peters
David Carlin	George Peterson
Sharon Doughtie	Michael Peterson
Cindy Drozda	Binh Pho
J. Kelly Dunn	Harry Pollitt
David Ellsworth	Graeme Priddle
Harvey Fein	Tania Radda
J. Paul Fennell	Kalman Radvanyi
Donald E. Frith	Joey Richardson
Robert Gray	Merryll Saylan
Michelle Holzapfel	Betty Scarpino
Robyn Horn	Adrien Rutigliano Segal
Michael Hosaluk	Eric Serritella
David Huang	Steve Sinner
William Hunter	Hayley Smith
John Jordan	Laurie Swim
Stoney Lamar	Joël Urruty
Bud Latven	Jacques Vesery
Ron Layport	Derek Weidman
Jennifer Falck Linssen	Hans Weissflog
Alain Mailland	Jakob Weissflog
Sam Maloof	Molly Winton
Bert Marsh	Andi Wolfe
Guy Michaels	

Peter Voulkos, **Untitled***, 1982*
wood-fired ceramic, 22 inches diameter

Donna Schneier Fine Arts

Modern masters in ceramics, glass, fiber, metal and wood
Staff: Donna Schneier; Leonard Goldberg; Jesse Sadia

By Appointment Only
PO Box 3209
Palm Beach, FL 33480
voice 518.441.2884
dnnaschneier@mhcable.com

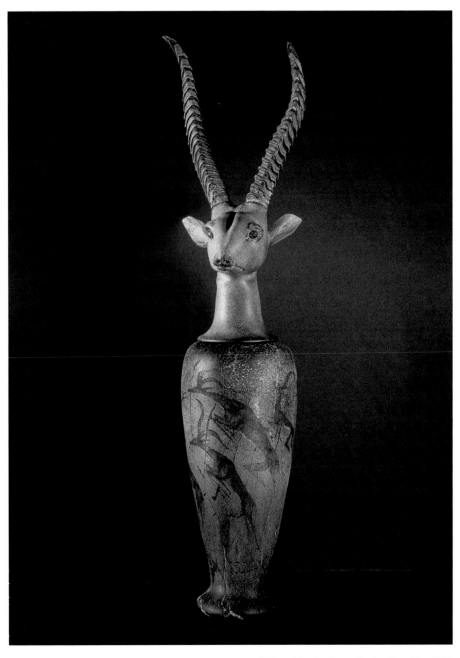

Exhibiting:
Rudy Autio
Dale Chihuly
Ruth Duckworth
Viola Frey
Harvey Littleton
Michael Lucero
James Makins
Philip Moulthrop
Joel Philip Myers
Ed Rossbach
Adrian Saxe
Lino Tagliapietra
Akio Takamori
Bertil Vallien
Betty Woodman

William Morris, **Canopic Jar Gazelle,** *1996*
glass, 52 inches high

Cassandria Blackmore, **Kapnos IV,** *2009*
reverse painted glass mosaic, 30 x 30

Duane Reed Gallery

Contemporary painting, sculpture, glass, ceramics and fiber by internationally recognized artists
Staff: Duane Reed; Daniel McGrath, assistant director; Merrill Strauss; Glenn Scrivner

4729 McPherson Avenue
St. Louis, MO 63108
voice 314.361.4100
fax 314.361.4102
info@duanereedgallery.com
duanereedgallery.com

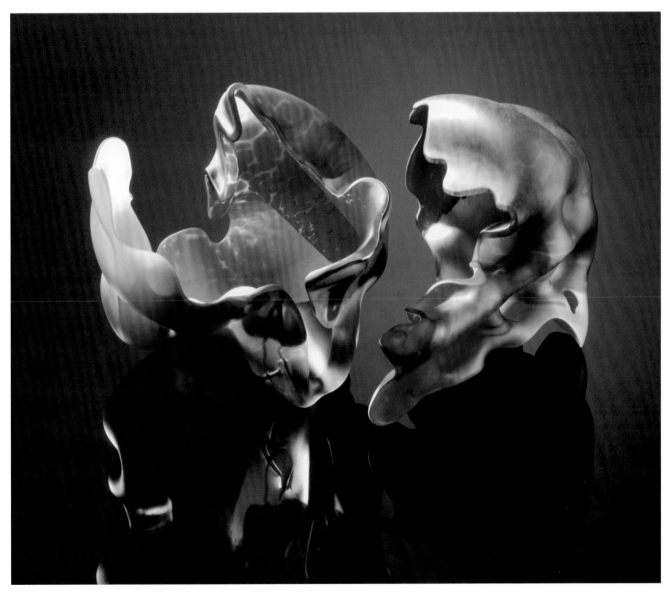

Marvin Lipofsky, **IGS VI #10**, 1997
glass, 13 x 24 x 17
photo: M. Lee Fatherree

Exhibiting:
Rudy Autio
Cassandria Blackmore
Laura Donefer
Paul Dresang
Mary Giles
Jamie Harris
Kreg Kallenberger
Sabrina Knowles
Jiyong Lee
Marvin Lipofsky
Mari Meszaros
Danny Perkins
Jenny Pohlman
Bonnie Seeman

Kurt Wesier, **Luna***, 2009*
porcelain, bronze base, 26 x 16

Ferrin Gallery

Contemporary art and sculpture in all media, specializing in ceramics
Staff: Leslie Ferrin; Donald Clark; Michael McCarthy

437 North Street
Pittsfield, MA 01201
voice 413.442.1622
cell 413.446.0614
fax 413.634.8833
info@ferringallery.com
ferringallery.com

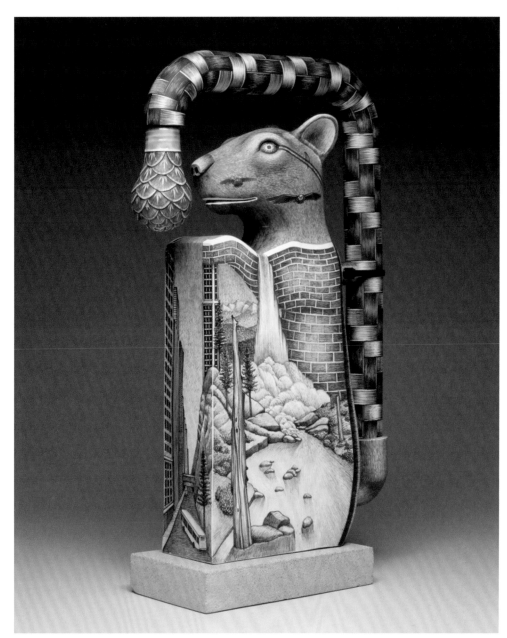

Jason Walker, **Squirrel**, *2009*
porcelain, underglaze, concrete, 15 x 9 x 3.5

Exhibiting:
Chris Antemann
Jessica Calderwood
Fran Douglas
Lucy Feller
Sergei Isupov
Myungjin Kim
Max Lehman
Anne Lemanski
Gerardo Monterrubio
Richard Notkin
Seth Rainville
Mara Superior
Shannon Trudell
Jason Walker
Kurt Weiser
Red Weldon-Sandlin

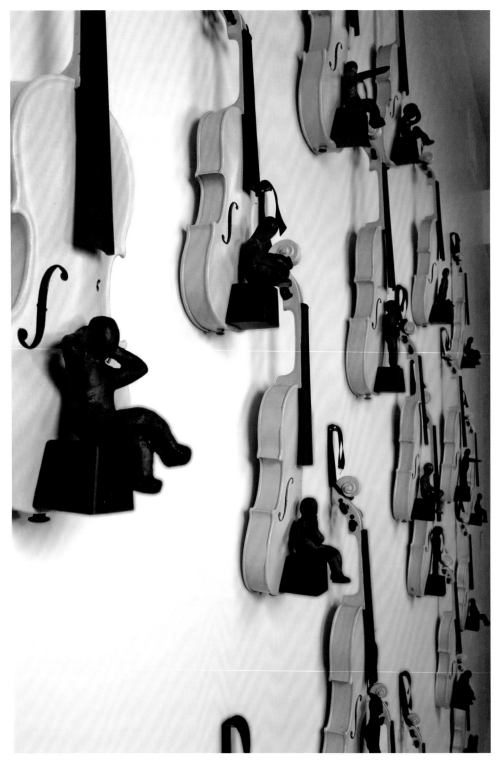

Judith Kindler, **21 Violin Installation**
mixed media
photo: Judith Kindler

Forré & Co. Fine Art

Contemporary art and modern masters featuring paintings, sculpture and works on paper
Staff: Anna Forré-Covers; Guenther Covers; Lena Forré; Laurent Kosinski; Larry White

426 East Hyman Avenue
Aspen, CO 81611
voice 970.544.1607
fax 970.544.1608
anna@forrefineart.com
forrefineart.com

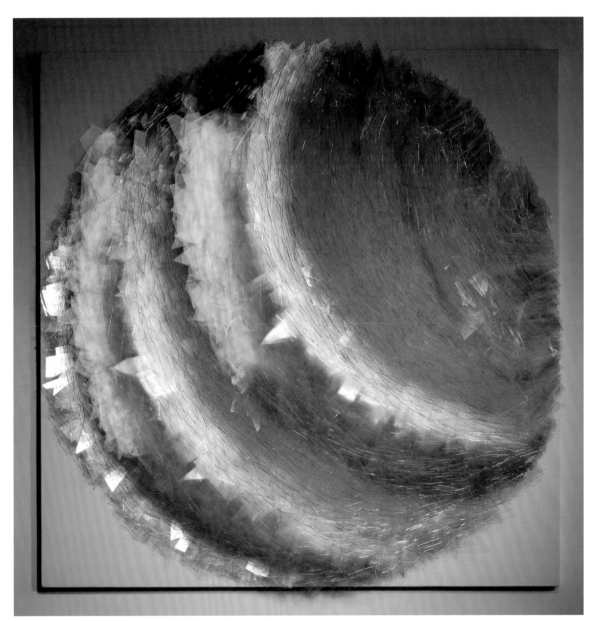

Exhibiting:
Tali Dalton
Josepha Gasch-Muche
Jacqueline Gilmore
Judith Kindler
Edward Lentsch
Brian Russell
Jain Vipul
Ann Wolff

Josepha Gasch-Muche, **Object 18.7.08 White**
glass, wood, 27.5 x 27.5
photo: David Marlow

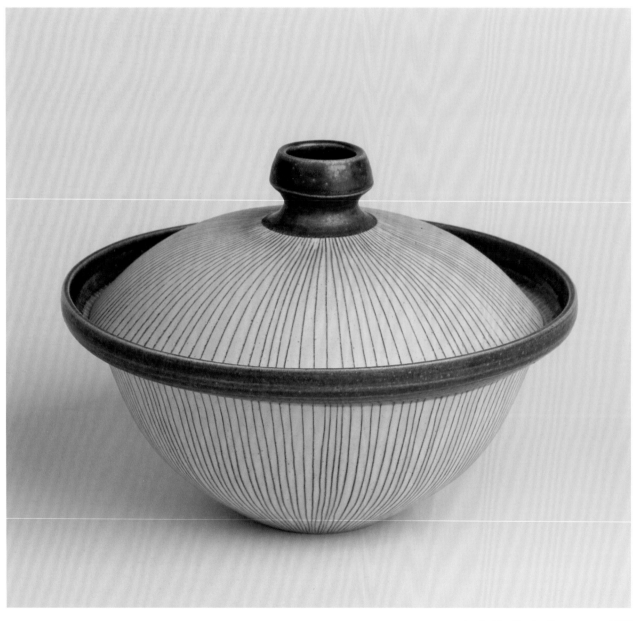

Lucie Rie, **Bowl with cover,** *c. 1966*
porcelain, brown and white with inlaid lines, 6.5 inches diameter
photo: Alan Tabor

Galerie Besson

International contemporary ceramics
Staff: Anita Besson; Matthew Hall; Louisa Anderson

15 Royal Arcade
28 Old Bond Street
London W1S 4SP
England
voice 44.20.7491.1706
fax 44.20.7495.3203
enquiries@galeriebesson.co.uk
galeriebesson.co.uk

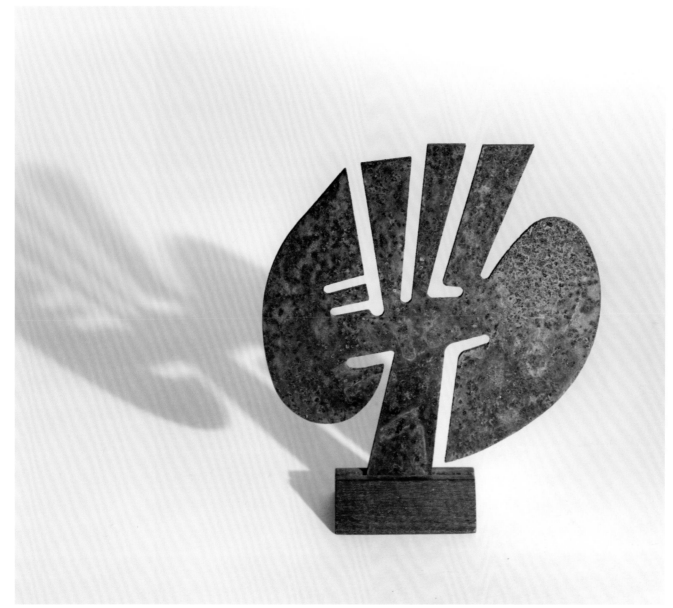

Exhibiting:
Claudi Casanovas
Peter Collingwood
Hans Coper
Ruth Duckworth
Anne Fløche
Shoji Hamada
Karen Karnes
Shozo Michikawa
Gwyn Hanssen Pigott
Lucie Rie
Alev Ebüzziya Siesbye
Howard Smith
Ritta Talanpoika

Howard Smith, **Glyph**, *1995*
laser cut iron, 9 x 7.5
photo: Winfrid Zabowski

Claudi Casanovas, **Camp d'urnes,** *2009*
stoneware, 17 x 12 x 12 each
photo: CECE

Hans Coper, **White Spade form on cylindrical base,** *c. 1965*
stoneware, 10 inches high
photo: Alan Tabor

Annie Pootoogook, **The Homecoming,** *2006*
etching, aquatint, 33 x 36.75

Galerie Elca London

Contemporary and historic Inuit artworks in all media
Staff: Mark London, president; Dale Barrett, associate

224 St-Paul Street West
Montreal, Quebec H2Y 1Z9
Canada
voice 514.282.1173
fax 514.282.1229
info@elcalondon.com
elcalondon.com

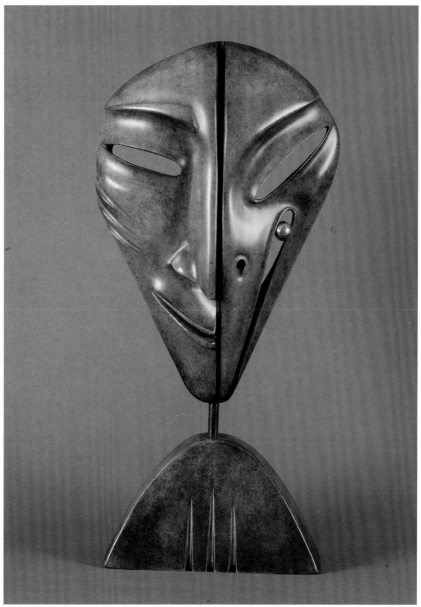

David Ruben Piqtoukun, **Raven Man Steals the Moon,** *2001*
bronze, 23 x 11 x 4.5

Exhibiting:
Ashevak Adla
Kenojuak Ashevak
Noo Atsiaq
Nuna Parr
David Ruben Piqtoukun
Annie Pootoogook
Kananginak Pootoogook
Axangayuk Shaa
Toonoo Sharky
Ashevak Tunnillie
Ovilu Tunnillie

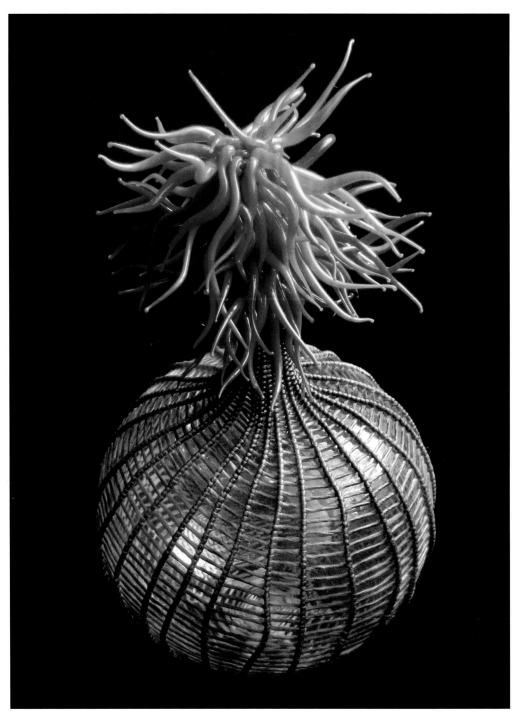

Cathy Strokowsky, **Peppervine II,** *2009*
blown and flameworked glass, woven artificial sinew, 9 x 4.75 x 4.75

Galerie Elena Lee

New directions of contemporary art glass and mixed media for over 30 years
Staff: Elena Lee; Joanne Guimond; Matt Morein; Marie-Eve Joly

1460 Sherbrooke West
Suite A
Montreal, Quebec H3G 1K4
Canada
voice 514.844.6009
info@galerieelenalee.com
galerieelenalee.com

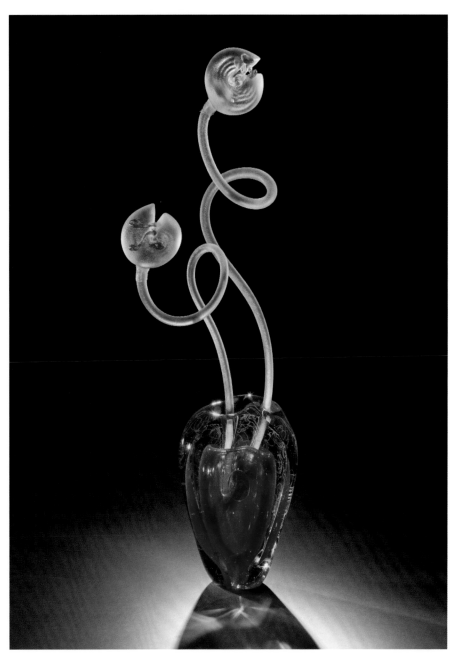

Exhibiting:
Alex Anagnostou
Dominique Beaupré St. Pierre
Annie Cantin
Brad Copping
Susan Edgerley
Tanya Lyons
Donald Robertson
Cathy Strokowsky

Dominique Beaupré St. Pierre, **Subtilité au Jardin Résolu,** *2008*
hot and coldworked glass, 18 x 5 x 3
photo: Michel Dubreuil

119

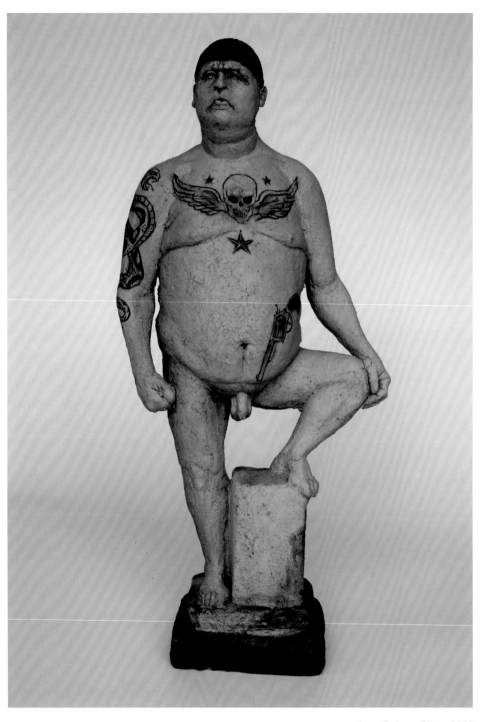

Lars Calmar, **Biker***, 2009*
stoneware, 21 inches high

Galleri Udengaard

Contemporary sculpture, photo and painting by established and emerging Scandinavian artists
Staff: Lotte Udengaard Dahl and Bruno Udengaard Dahl, owners

Vester Alle 9
Åarhus C 8000
Denmark
voice 45.86.259.594
udengaard@c.dk
galleriudengaard.com

Keld Moseholm, **Untitled**, *2009*
bronze and granite, 34 inches high

Exhibiting:
Lars Calmar
Ned Cantrell
Björn Ekegren
Keld Moseholm

121

Riikka Latva-Somppi, **Golden Bottles 1,** *2008*
free-blown glass, metal leaf, 30 x 13.75 x 13.75
photo: Riikka Latva-Somppi

Galleria Norsu

Contemporary Nordic applied art
Staff: Katarina Siltavuori; Saara Kaatra

Kaisaniemenkatu 9
PO Box 152
Helsinki FI-00171
Finland
voice 358.9.2316.3250
galleria@norsu.info
norsu.info

Outi Martikainen, **Girl is Growing***, 2009*
synthetic taffeta, embroidery, 31.5 x 11.75
photo: Outi Martikainen

Exhibiting:
Synnove Dickhoff
Aino Kajaniemi
Riikka Latva-Somppi
Maarit Mäkelä
Outi Martikainen
Tiia Matikainen
Maija Paavola
Pekka Paikkari
Rita Rauteva-Tuomainen
Jari-Pekka Vilkman

Robert'ó, **Dynamism of a Woman**
glass, mosaic mirror, brass, 44.5 x 44.5 x 17.25

Galleria San Marco Arte & Design

Specializing in emerging artists and contemporary design
Staff: Manuel Bortolotto, owner; Roberto Bortolotto and Stefano Toso, sales

Frezzaria San Marco, 1725
Venice 30124
Italy
voice 39.041.894.6940
fax 39.041.894.6940
artecontemporanea@
 antiquariasanmarco.it
galleriasanmarcoarte&design.com

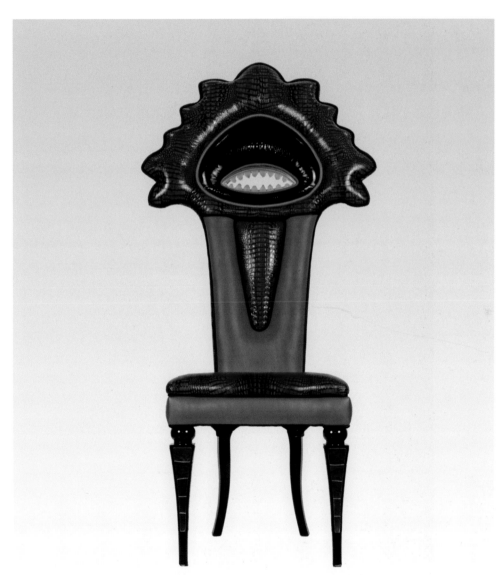

Exhibiting:
Stefano Bertoncello
Svetlana Ostapovici
Robert'ó

Robert'ó, **Squalo 2**
wood, leather, mosaic mirror, 59.25 x 30.75 x 26

Davide Salvadore, **Gagau**, *2008*
blown murrini glass and coldwork, 57 x 25 x 12.75

Habatat Galleries

Developing collections with the finest in contemporary glass from around the world

Staff: Ferdinand Hampson; Kathy Hampson; Corey Hampson; John Lawson; Aaron Schey; Debbie Clason

4400 Fernlee Avenue
Royal Oak, MI 48073
voice 248.554.0590
fax 248.554.0594
info@habatat.com
habatat.com

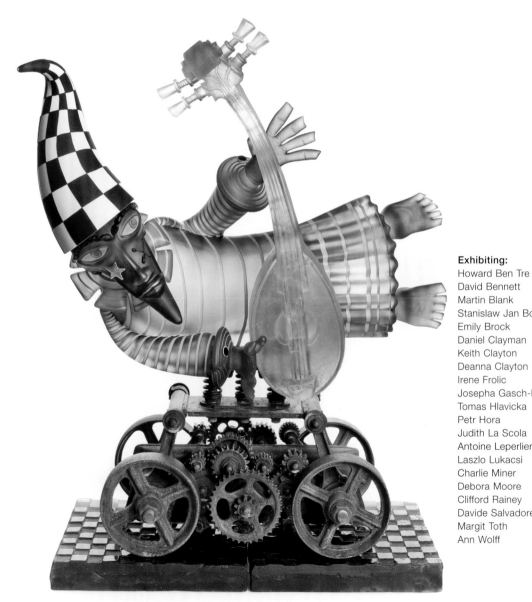

Exhibiting:
Howard Ben Tre
David Bennett
Martin Blank
Stanislaw Jan Borowski
Emily Brock
Daniel Clayman
Keith Clayton
Deanna Clayton
Irene Frolic
Josepha Gasch-Muche
Tomas Hlavicka
Petr Hora
Judith La Scola
Antoine Leperlier
Laszlo Lukacsi
Charlie Miner
Debora Moore
Clifford Rainey
Davide Salvadore
Margit Toth
Ann Wolff

Stanislaw Jan Borowski, **Summoners Tale VII,** *2009*
laminated, fused and polished glass, metal pedestal, 35 x 30 x 21

Cappy Thompson, Bee Keeper, 2009
reverse painted glass, 16.25 x 13.25 framed

Hawk Galleries

Modern masters and emerging artists in contemporary glass
Staff: Thomas Hawk, Jr., director; Susan Janowicz; Eric Rausch

153 East Main Street
Columbus, OH 43215
voice 614.225.9595
cell 614.519.2177
fax 614.225.9550
tom@hawkgalleries.com
hawkgalleries.com

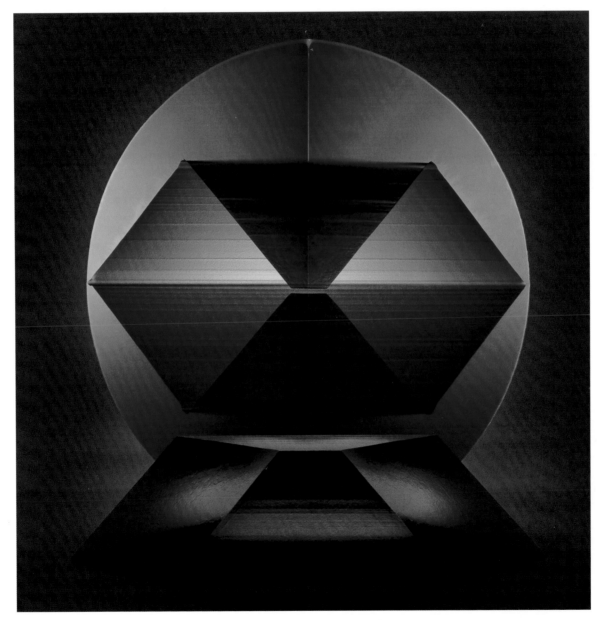

Exhibiting:
Nancy Callan
Leslie Hawk
William Morris
Christopher Ries
Lino Tagliapietra
Cappy Thompson

*Christopher Ries, **Celtic Jewel**, 2009
emerald green optic glass, 18.75 x 7.5; 17.75 x 9 x 4.5
photo: James Kane*

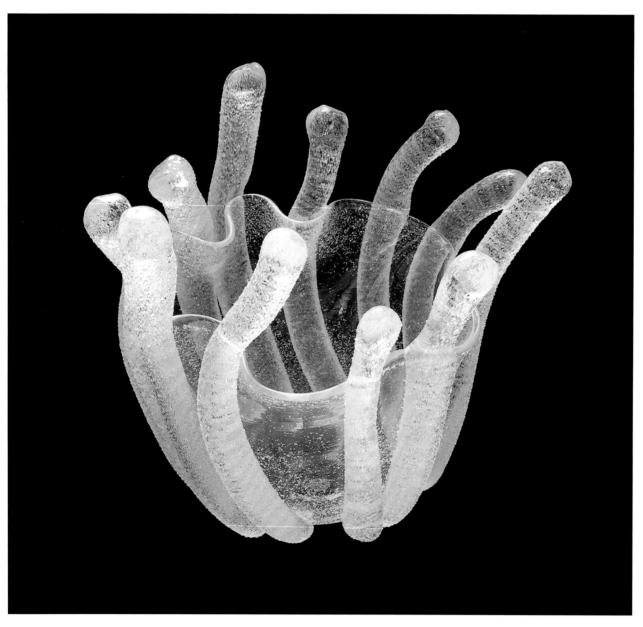

Ritsue Mishima, **Vento del Nord,** *2007*
glass, 14.75 x 15.5

Hedge

20th and 21st century design encompassing furniture, objects and art
Staff: Roth Martin, director; Steven Volpe, creative director; Maggie Schott; Antonio Ametrano

48 Gold Street
San Francisco, CA 94133
voice 415.433.2233
fax 415.433.2234
info@hedgegallery.com
hedgegallery.com

Exhibiting:
Ritsue Mishima
Paul Philp
Aaron Silverstein

Paul Philp, **Ceramic No. 21,** *2007*
ceramic, 8.5 x 9 x 9

Beth Lipman, Laid Table with Watermelon, Acorns, and Chalice, *2009*
glass, wood, 60 x 40 x 40
photo: Robb Quinn

Heller Gallery

Exhibiting sculpture using glass as a fine art medium since 1973
Staff: Douglas Heller; Katya Heller; Michael Heller

420 West 14th Street
New York, NY 10014
voice 212.414.4014
fax 212.414.2636
info@hellergallery.com
hellergallery.com

Exhibiting:
Nicole Chesney
Steffen Dam
Beth Lipman
Tobias Møhl

Steffen Dam, **Fossil Panel***, 2008*
glass, metal, 22 x 40 x 8
photo: Anders Bach

Woodrow Nash, Oluchi, *2008*
clay, 31 x 18 x 14

Higgins Harte International Galleries

Old master works, sculptures, celebrity artists and living masters
Staff: Lori Higgins and Glenn Harte, co-owners

844 Front Street
Lahaina, HI 96761
voice 808.661.4439
cell 808.268.3022
fax 808.661.8440
donaldlamarr@higginsharte.com
higginshartegalleries.com

Exhibiting:
Woodrow Nash
Rascal

Woodrow Nash, **Bahati,** *2008*
clay, 30 x 18 x 14

*Lino Tagliapietra, **Fenice**, 2009*
glass, 18.5 x 17 x 7.5
photo: Russell Johnson

Holsten Galleries

Contemporary art glass

Staff: Kenn Holsten, owner/director; Jim Schantz, art director; Mary Childs, managing director; Stanley Wooley and Francine Britton, associates; Ron Bill, shipping manager

3 Elm Street
Stockbridge, MA 01262
voice 413.298.3044
fax 413.298.3275
artglass@holstengalleries.com
holstengalleries.com

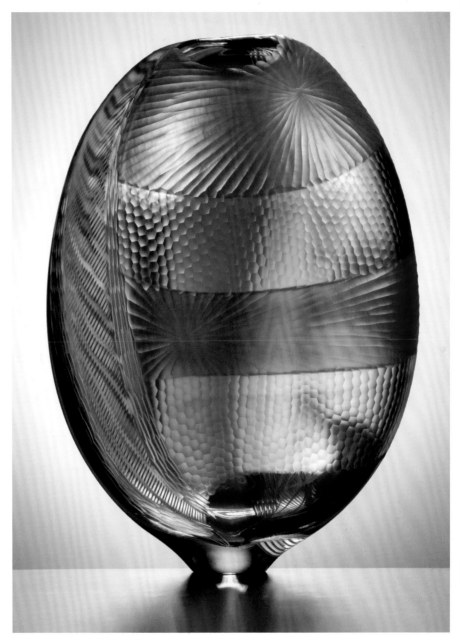

Exhibiting:
Lino Tagliapietra

Lino Tagliapietra, **Dada***, 2009*
glass, 15.5 x 11.25 x 5.5
photo: Russell Johnson

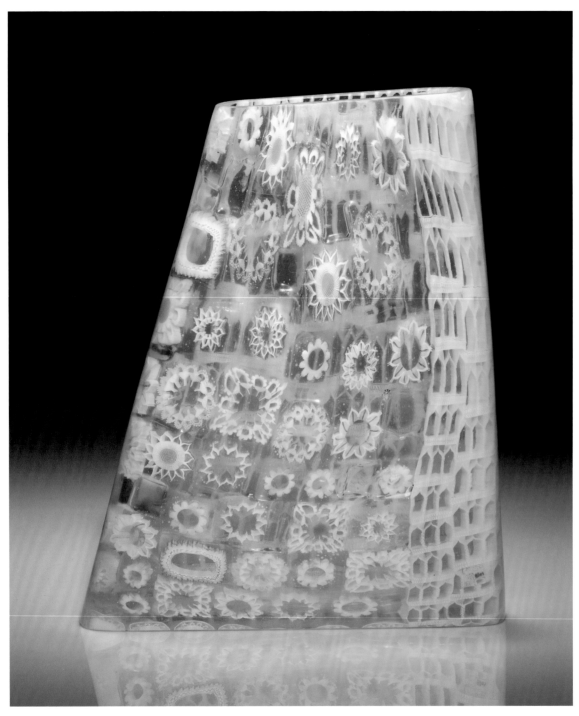

Giles Bettison, **Lace 09 #27,** *2009*
glass, 11 x 9 x 2
photo: Andrew Dunbar

Jane Sauer Gallery

Innovative work by internationally recognized artists in a variety of media
Staff: Jane Sauer, owner/director; Jorden Nye, gallery manager; Richard Boyle, director of communications

652 Canyon Road
Santa Fe, NM 87501
voice 505.995.8513
cell 505.577.6751
fax 505.995.8507
jsauer@jsauergallery.com
jsauergallery.com

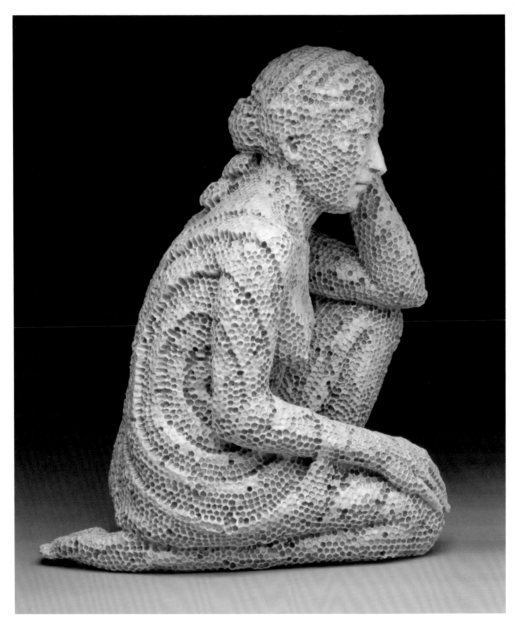

Exhibiting:
Adrian Arleo
Giles Bettison
Geoffrey Gorman
Noel Hart
Jan Hopkins
Charla Khanna
Gugger Petter
Lesley Richmond
Jon Eric Riis
Toland Sand
Carol Shinn
Polly Adams Sutton
Dawn Walden
Brent Kee Young

Adrian Arleo, **Rings II-Honeycomb Woman,** *2009*
clay, glaze, wax, encaustic, 21.5 x 19 x 12
photo: Chris Autio

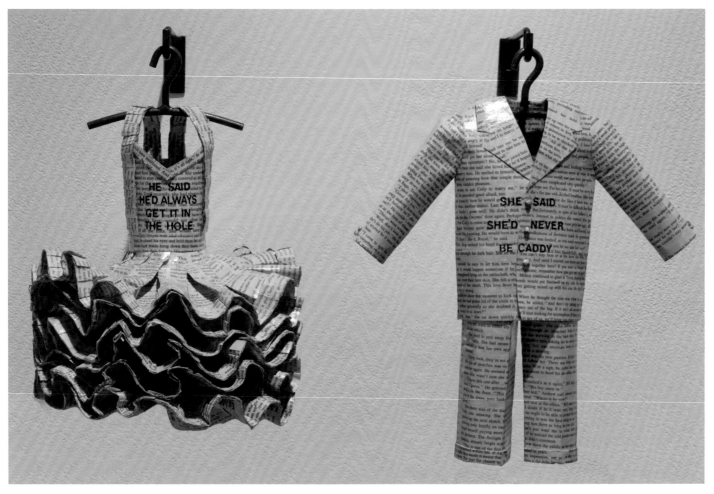

Donna Rosenthal, (He Said...She Said) Playing Golf, *2009*
vintage romance novels, gel medium, steel, 12 x 24 x 10

Jean Albano Gallery

Special SOFA presentation The Feminine Mystique: Art with a Woman's Perspective

Staff: Jean Albano Broday; Theresa Murray; Emanuel Aguilar

215 West Superior Street
Chicago, IL 60654
voice 312.440.0770
fax 312.440.3103
jeanalbano@aol.com
jeanalbanogallery.com

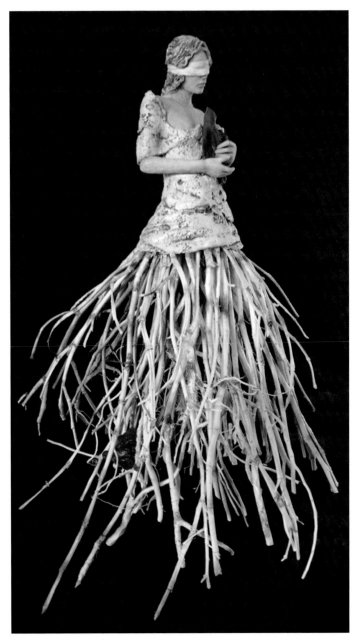

Susan Saladino, **#1 from the Last Bird Series,** *2009*
clay, steel, twigs, oxides, applied pigment, 30 x 24 x 22

Exhibiting:
Diane Cooper
Claudia DeMonte
Gladys Nilsson
Donna Rosenthal
Susan Saladino
Ann Savageau
Margaret Wharton

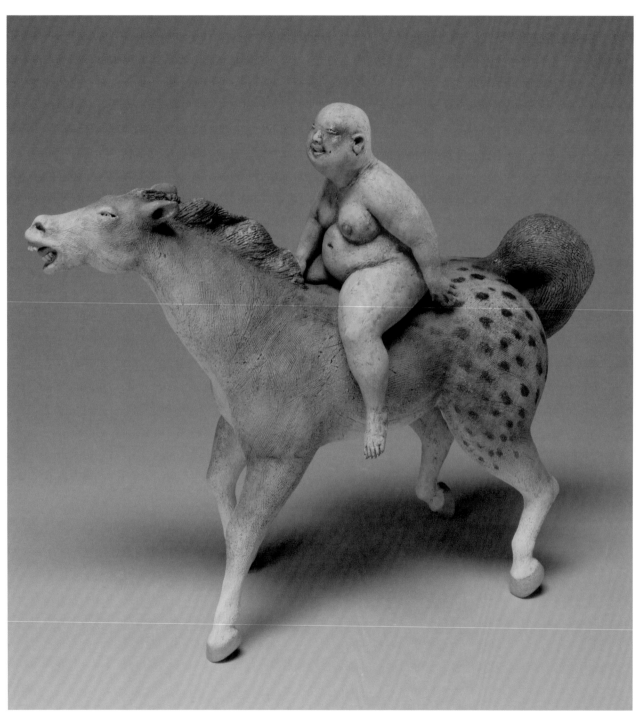

Esther Shimazu, **Gray Appaloosa,** *2009*
ceramic, 12 x 5.5 x 13

John Natsoulas Gallery

California art from the 1950s to present, focusing primarily on figurative sculpture
Staff: John Natsoulas, owner; Steve Rosenzweig, marketing director

521 First Street
Davis, CA 95616
voice 530.756.3938
cell 530.848.8699
art@natsoulas.com
natsoulas.com

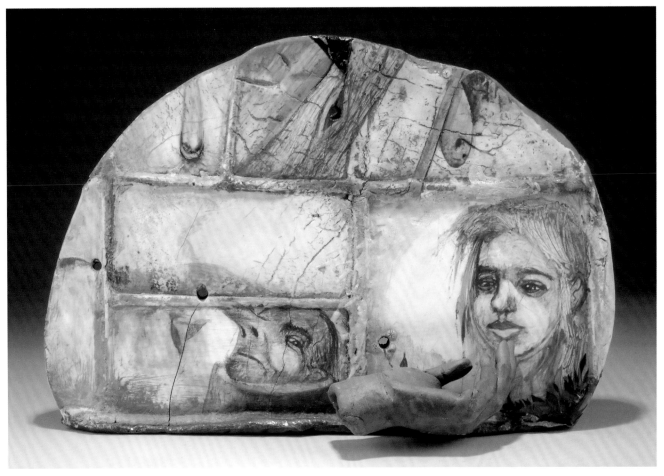

Exhibiting:
Wesley Anderegg
Robert Arneson
Magi Calhoun
Lisa Clague
Arthur Gonzalez
Sean Henry
May Izumi
Margaret Keelan
Michael Lucero
Richard Shaw
Esther Shimazu

Arthur Gonzalez, June 2008 (Morning Suites Series), *2008*
ceramic, 17.5 x 8 x 15

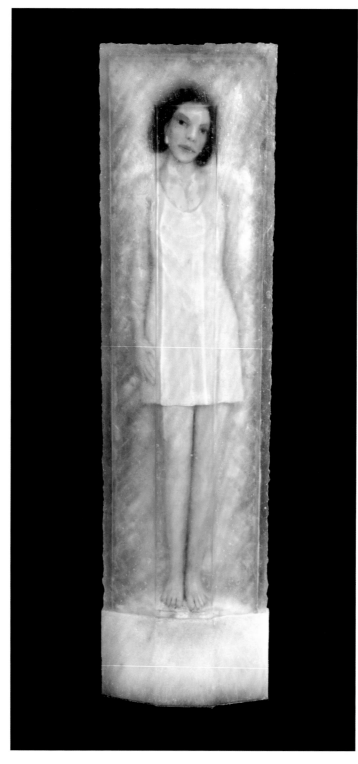

Janusz Walentynowicz, **Amy in Light Blue Dress**
cast glass, steel, oil paint, 73.25 x 20 x 9
photo: Jo-Nell Sieren

Ken Saunders Gallery

Representing the most innovative artists working in glass in the world
Staff: Ken Saunders; Donna Davies, director

230 West Superior Street
Chicago, IL 60654
voice 312.573.1400
fax 312.573.0575
info@kensaundersgallery.com
kensaundersgallery.com

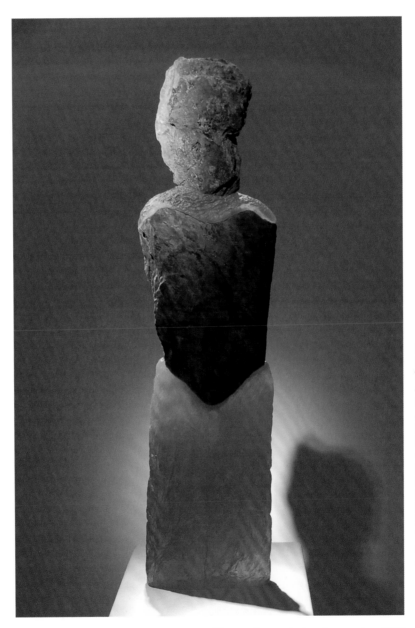

Thomas Scoon, **Amber Companion**, *2008*
cast glass, granite, 37 x 10 x 4
photo: Jo-Nell Sieren

Exhibiting:
Rick Beck
William Carlson
José Chardiet
Sidney Hutter
Jon Kuhn
Carmen Lozar
Dante Marioni
Jay Musler
Mark Peiser
Stephen Rolfe Powell
Richard Ritter
Richard Royal
David Schwarz
Thomas Scoon
Paul Stankard
Janusz Walentynowicz

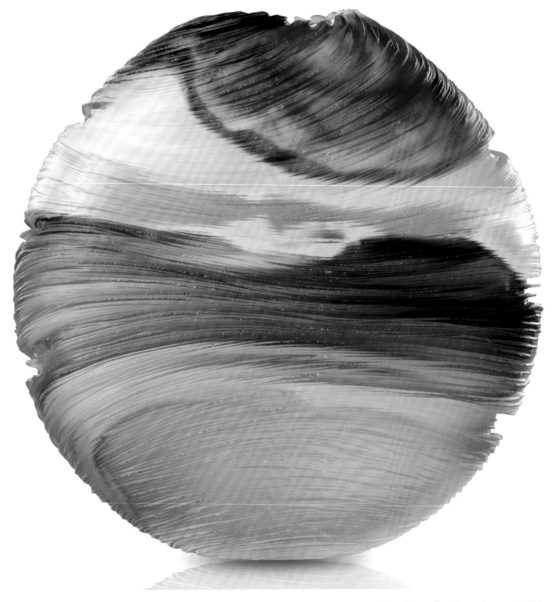

Tim Shaw, **Southern Aurora**, *2008*
blown and wheel carved glass, 14 x 14 x 4

Kirra Galleries

Leaders in the Australian contemporary art glass movement supporting established and emerging artists
Staff: Suzanne Brett, gallery manager; Vicki Winter, administration manager

Federation Square
Cnr Swanston and Flinders Streets
Melbourne, Victoria 3000
Australia
voice 61.3.9639.6388
fax 61.3.9639.8522
gallery@kirra.com
kirragalleries.com

Tegan Empson, **Comfort Zone**, *2008/09*
hand-blown and sculpted furnace glass, wheel-cut and sand-etched, 24 x 7.5 x 5; 24 x 6 x 5

Exhibiting:
Masahiro Asaka
George Aslanis
Richard Clements
Ben Edols
Kathy Elliott
Tegan Empson
Annabel Kilpatrick
Brent King
Simon Maberley
Tim Shaw
Crystal Stubbs
Emma Varga

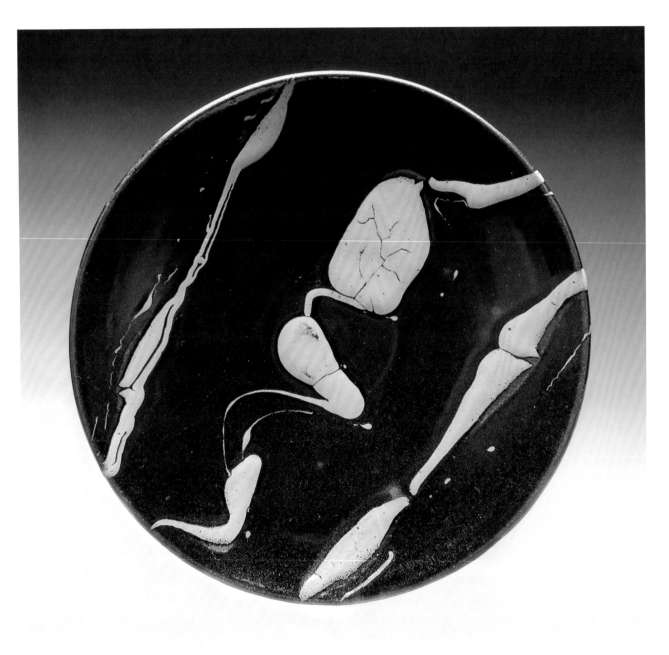

Warren MacKenzie, **Large Temmoku Platter with White,** *2009*
stoneware, 18 x 3.5
photo: George Bouret

Lacoste Gallery

Contemporary ceramics: vessel and sculpture
Staff: Lucy Lacoste; Alinda Zawierucha

25 Main Street
Concord, MA 01742
voice 978.369.0278
fax 978.369.3375
info@lacostegallery.com
lacostegallery.com

Exhibiting:
Barbro Åberg
John Gill
Steve Heinemann
Jim Leedy
Warren MacKenzie
Malene Mullertz
Don Reitz
Tim Rowan
Alev Ebüzziya Siesbye
Goro Suzuki
SunKoo Yuh

Barbro Åberg, **Tulip Bowl***, 2009*
stoneware with volcanic ash, 10 x 17
photo: Lars Henrik Mardahl

*Kevin Lockau, **Sisters**, 2009*
cast glass, concrete, granite, 14 x 11 x 10
photo: T.H. Wall

Lafrenière & Pai Gallery

Contemporary Canadian sculpture and jewelry
Staff: Megan Lafrenière and Lisa Pai, directors; Anna Kempffer-Hossack; Leslie McKay

13 Murray Street
Ottawa, Ontario K1N 9M5
Canada
voice 613.241.2767
info@lapaigallery.com
lapaigallery.com

Exhibiting:
Catherine Allen
Suzanne Carlsen
Matthieu Cheminée
Cinelli + Maillet
Emily Gill
Sandra Noble Goss
Sunmi Jung
Charles Lewton-Brain
Kevin Lockau
Christina Luck
Mary K. McIntyre
Peter Powning
Kye-Yeon Son
Despo Sophocleous
Anna Williams
Lawrence Woodford
Patrycja Zwierzynska

Suzanne Carlsen, **Green Roof Install Brooch**
silver, hand embroidery, 8 x 4 x 1

Václav Cigler, **Vane,** *2008*
metal-sheathed optical glass, 10 x 10 x 4
photo: Michal Motyčka, Martin Vičan

Litvak Gallery

Exclusive projects created by the world's leading contemporary glass artists
Staff: Muly Litvak, owner; Orit Ephrat-Moscovitz, director

4 Berkovich Street
Tel Aviv 64238
Israel
voice 972.3.695.9496
fax 972.3.695.9419
info@litvak.com
litvak.com

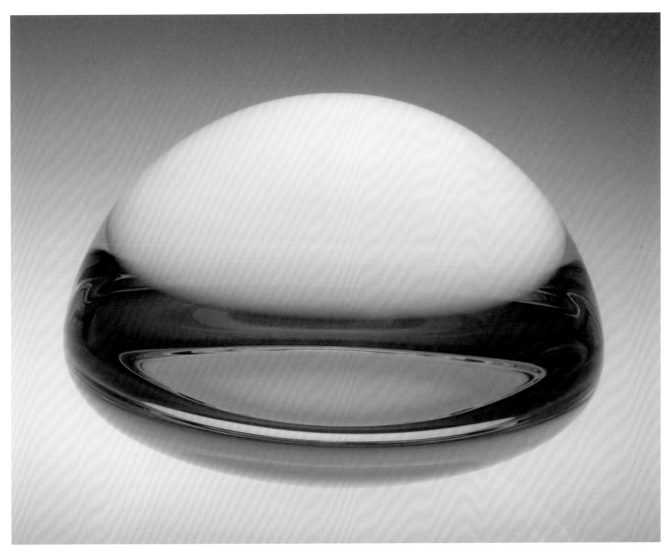

Exhibiting:
Peter Bremers
Lucio Bubacco
Václav Cigler
William Morris
Julius Weiland

Václav Cigler, **Round Panorama,** *2009*
optical glass, 13 x 13 x 9
photo: Avraham Hay and Yona Schley

Lucio Bubacco, **The Blinding of Polyphemus,** *2009*
glass
photo: Norbert Heyl

William Morris, Himself to Himself, *1988*
glass, 36 x 36 x 16
photo: Robert Vinnedge

Julius Weiland, **Light House,** *2009*
stacked and fused glass tubes, 41 x 26 x 9
photo: Andre Bockholdt

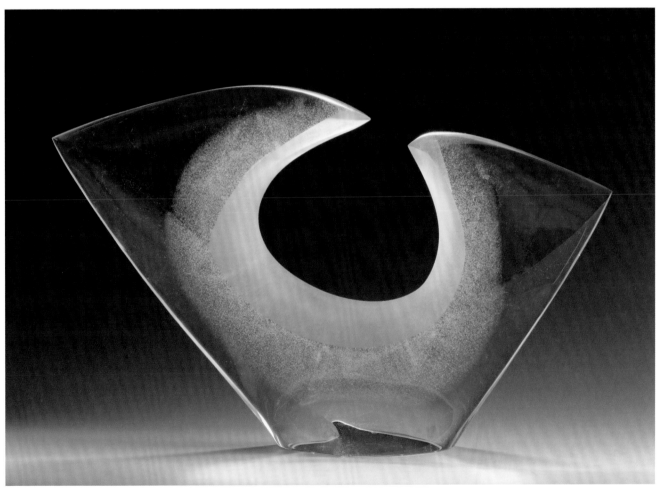

Peter Bremers, Icebergs & Paraphernalia 07-119, *2007*
glass, 35 x 22 x 7
photo: Avraham Hay and Yona Schley

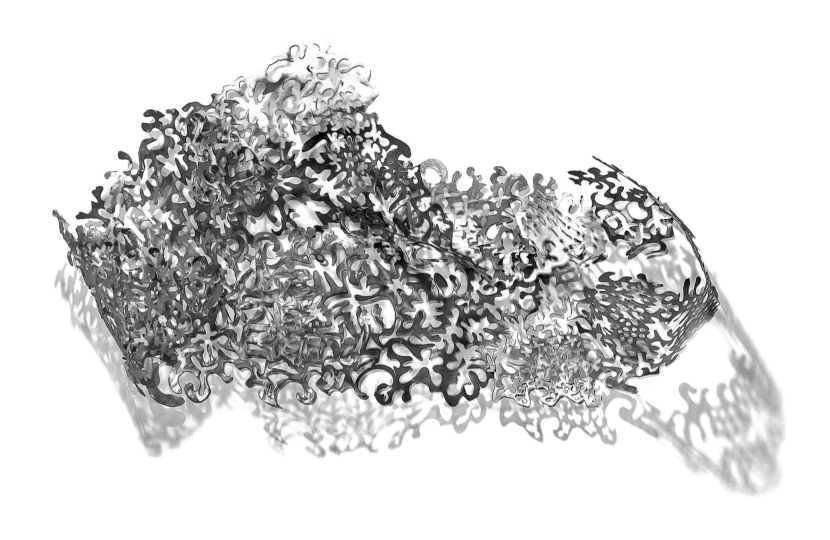

Suzi Trubitz, **Continuum***, 2008*
silicon plate bronze, plasma torch flame cutting, 50 x 27 x 24
photo: Rob DaFoe/Jeremy Ball

Maria Elena Kravetz

Different contemporary art with an emphasis in Latin American expressions
Staff: Maria Elena Kravetz, director; Raúl Nisman; Matías Alvarez, assistant

San Jerónimo 448
Córdoba X5000AGJ
Argentina
voice 54.351.422.1290
mek@mariaelenakravetzgallery.com
mariaelenakravetzgallery.com

Exhibiting:
Lina Amariglio Weiss
Jeanne Beck
Nathan Bennett
Silvina Bottaro
Mariana Caballero
Faba
Matthew Fine
Elizabeth Gavotti
Sol Halabi
Barbara Kobylinska
Ana Mazzoni
Hilde Morin
Carolina Rojas
Tim Shockley
Suzi Trubitz

Nathan Bennett, **Shine for Me***, 2009*
patinated bronze plate, 13.5 x 8

Silvina Bottaro, **Old City***, 2009*
mixed media on canvas, 16.5 x 24.5

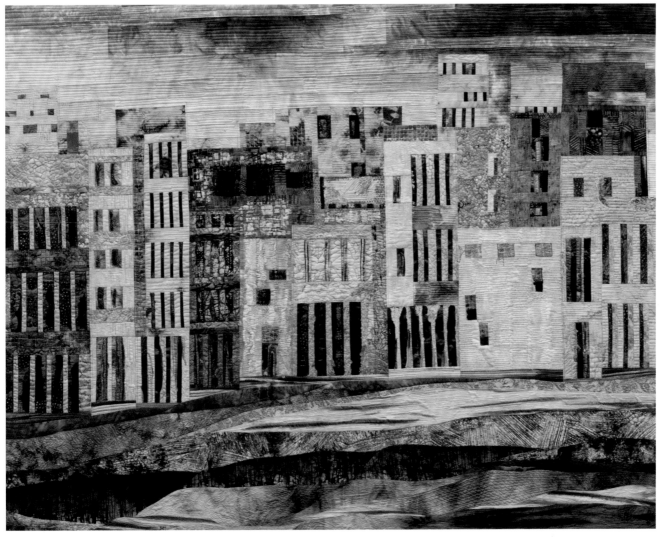

Hilde Morin, **Malecon**, *2009*
commercial and hand dyed cotton, machine pieced, appliqued and quilted, discharge dyed
photo: Bill Bachhuber

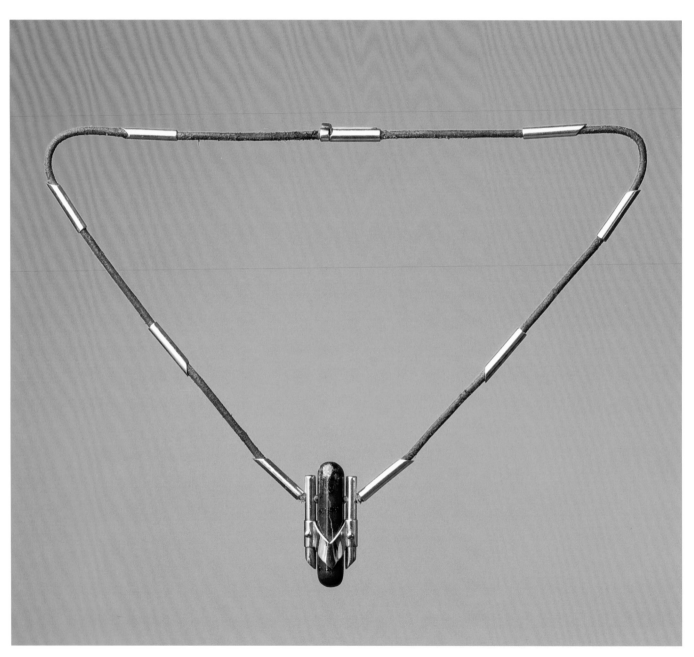

Lina Amariglio Weiss, **Blue Dynamite Necklace**, *2009*
18k gold, lapis lazuli, leather

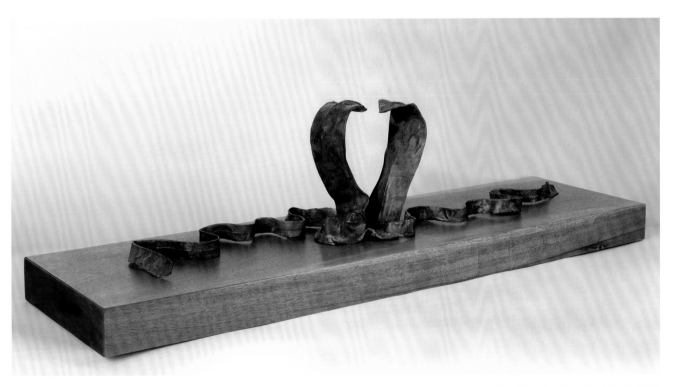

Tim Shockley, **Ties That Bind,** *2009*
bronze with patina, mahogany base, 13 x 48 x 13

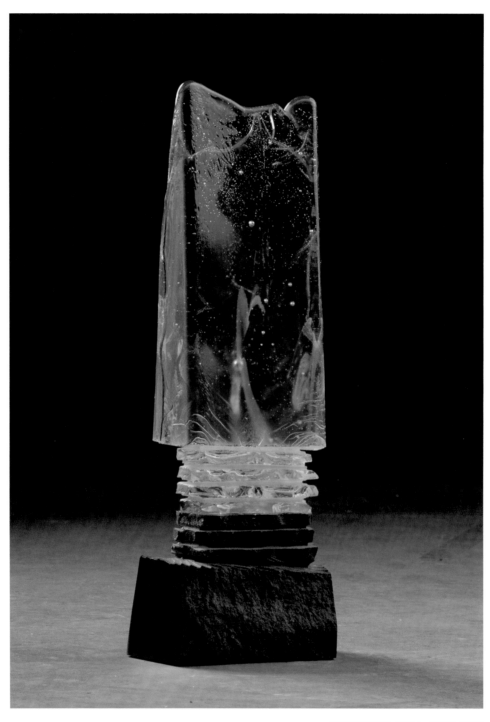

Matthew Fine, **Green Wind,** *2008*
cut and broken cast glass, granite, 19 x 7 x 3

Carolina Rojas, **Man,** *2007*
casting bronze, wood, series of seven, 29.5 x 20.5 x 5

Duncan McClellan, **Heroes Welcome,** *2008*
glass, 18 x 16 x 16
photo: Randall Smith

Mattson's Fine Art

Contemporary art glass and ceramics from the United States and abroad
Staff: Gregory Mattson, director; Walter Mattson; Skippy Mattson

2579 Cove Circle, N.E.
Atlanta, GA 30319-3705
voice 404.636.0342
fax 404.636.0342
sundew@mindspring.com
mattsonsfineart.com

Exhibiting:
Rafal Galazka
Przemyslaw Lasak
Peter Layton
Bruce Marks
Duncan McClellan
Keith Rowe
Mirek Stankiewicz
Jack Storms
James Wilbat
Maciej Zaborski

Peter Layton, **Nautilus Dropper,** *2009*
glass, 14 x 7 x 3
photo: Ester Segarra

Tim Tate, **Artist Attic,** *2009*
lathed and cast glass, LED lights, 24 x 8 x 8
photo: Anything Photographic Studio

Maurine Littleton Gallery

Sculptural work of contemporary masters in glass and ceramics
Staff: Maurine Littleton, director; John LaPrade, assistant director; Drew Graham, shipping

1667 Wisconsin Avenue NW
Washington, DC 20007
voice 202.333.9307
fax 202.342.2004
info@littletongallery.com
littletongallery.com

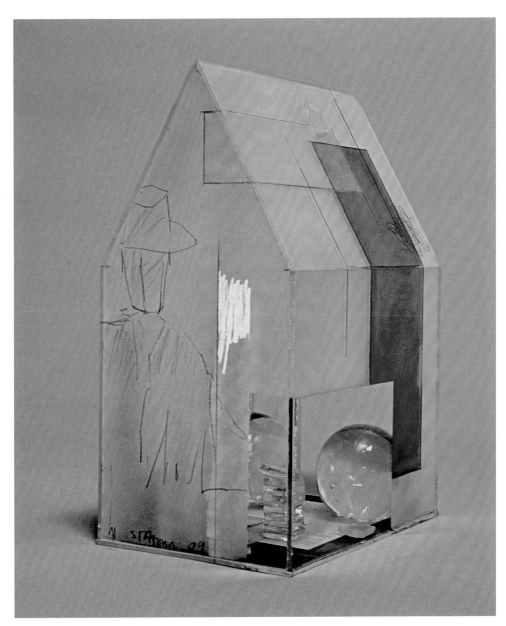

Exhibiting:
Michael Janis
Judith La Scola
Harvey Littleton
John Littleton
Allegra Marquart
Richard Marquis
Colin Reid
Ginny Ruffner
Therman Statom
Tim Tate
Kate Vogel

Therman Statom, **Untitled,** *2009*
glass, acrylic, 12 x 6 x 8.5
photo: Therman Statom Studio

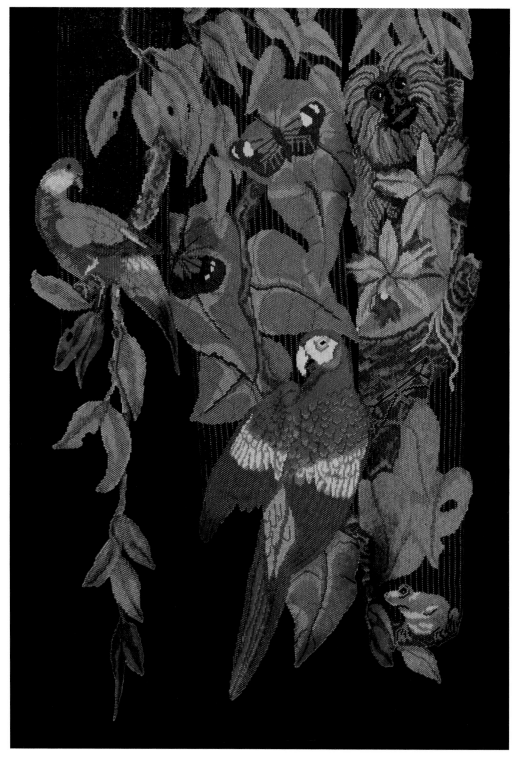

Madelyn Ricks, **Rain Forest**, *2009*
glass beads, 24 x 18 x 3
photo: Doug Goodhue

Mostly Glass Gallery

Contemporary art, novel and technically challenging
Staff: Sami Harawi, owner; Marcia Lepore and Larry Dark, associates; Michael Martz, director of operations

34 Hidden Ledge Road
Englewood, NJ 07631
voice 201.816.1222
fax 201.503.9522
info@mostlyglass.com
mostlyglass.com

Miriam Di Fiore, **The Day I Made Quince Jelly** *detail, 2009*
fused glass, 11 x 192 x 72
photo: Miriam Di Fiore

Exhibiting:
Christine Barney
Jamie Barthel
Mary Ellen Buxton
Gail Crossman-Moore
Mary Darwall
Miriam Di Fiore
Karen Flowers
Elizabeth Hopkins
Hildegund Ilkerl
Vlastislav Janacek
Gabrile Kuestner
Kevin Kutch
Marcia Lepore
Gabriele Malek
Jillian Molettiere
Martie Negri
Elise Ordorica
Fabienne Picaud
Gateson Recko
Madelyn Ricks
Alison Ruzsa
Ira Tiffen
Sharmini Wirasekara

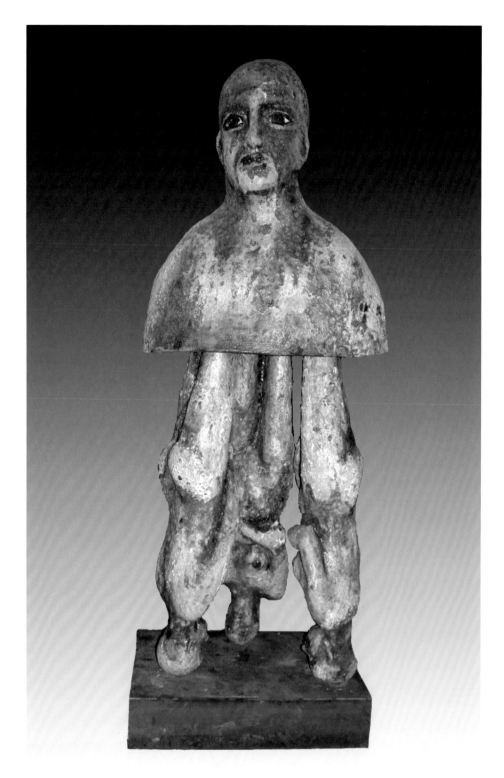

Mark Chatterley, **Reverse Psychology,** *2009*
hand-built clay, crater glaze, 120 x 38 x 24

Next Step Studio & Gallery

Introducing young and upcoming talent to the art world with a strong eye on clay artists
Staff: Kaiser Suidan, owner/director

530 Hilton Road
Ferndale, MI 48220
voice 248.414.7050
cell 248.342.5074
nextstepstudio@aol.com
nextstepstudio.com

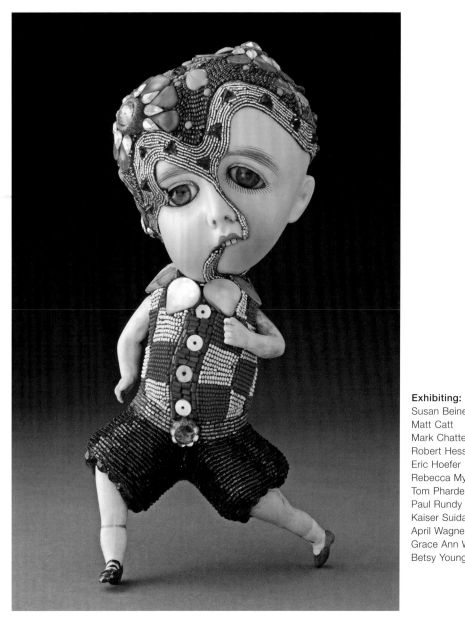

Betsy Youngquist, **Humpty Dumpty Day (Boy)**, *2009*
beaded assemblage
photo: Larry Sanders

Exhibiting:
Susan Beiner
Matt Catt
Mark Chatterley
Robert Hessler
Eric Hoefer
Rebecca Myers
Tom Phardel
Paul Rundy
Kaiser Suidan
April Wagner
Grace Ann Warren
Betsy Youngquist

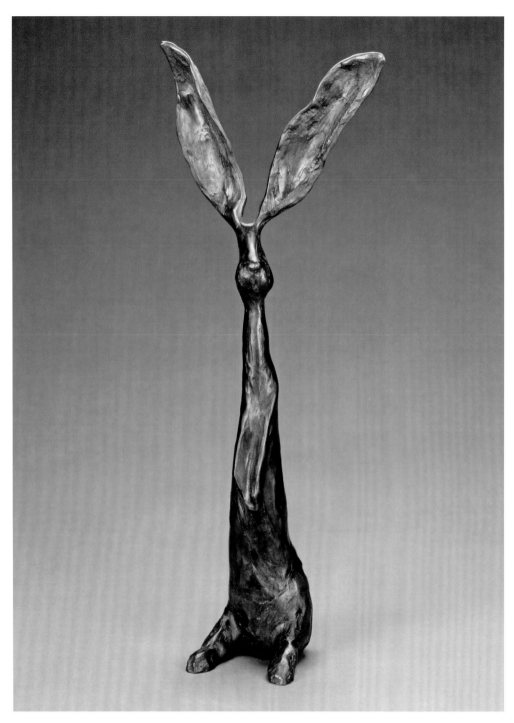

Jim Budish, **Chauncey,** *2007*
cast bronze edition of 250, 22 x 9 x 4
photo: Larry Sanders

Niemi Sculpture Gallery & Garden

Contemporary sculpture
Staff: Bruce A. Niemi, owner; Susan Niemi, director

13300 116th Street
Kenosha, WI 53142
voice 262.857.3456
fax 262.857.4567
gallery@bruceniemi.com
bruceniemi.com

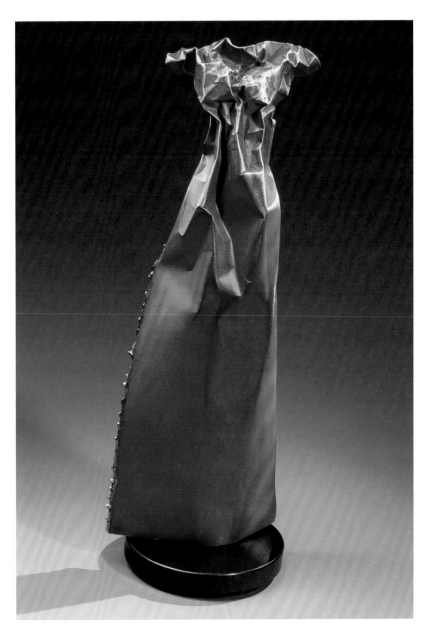

Exhibiting:
Kevin Box
Jim Budish
Bruce A. Niemi
Kimberly Willcox

Kevin Box, **Allegra's Dress,** *2009*
unique cast bronze from paper on granite, 25 x 10 x 8
photo: Dan Morse

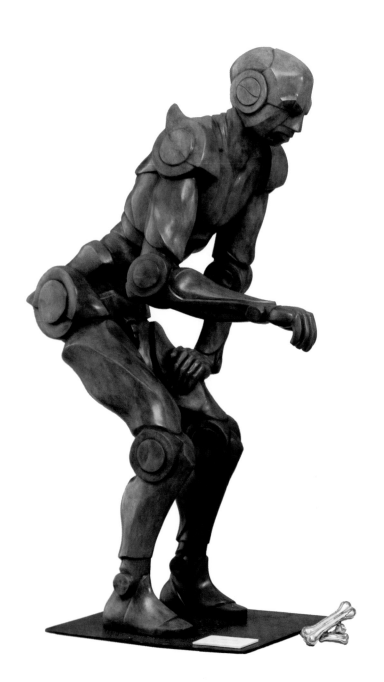

Leon Bronstein, **Take a Bite***, 2008*
bronze, patina, life size
photo: Amnon Yaniv

Old City Caesarea Gallery

Israeli contemporary art

Staff: Betty Bronstein, director; Danny Bronstein, Niv Gal, Ilana Gal and Adar Bronstein, assistants

The Old City
PO Box 5367
Caesarea 38900
Israel
voice 972.4.626.0198
fax 972.4.636.0178
art@caesareaart.com
caesareaart.com

Exhibiting:
Leon Bronstein
Sergey Bunkov
Leo Ray

Sergey Bunkov, **Untitled,** *2008*
sand-blasted glass, 32 x 24
photo: Ran Erde

Philip Zahm, **Sapphire Desire,** *2009*
platinum, blue sapphire, colored sapphires, diamonds, 1.25 x 1 x .5

Oliver & Espig

Museum quality gems from the mines of the world set by award winning jewelers
Staff: Marcia Ribeiro; Marilia Ribeiro; Tielle Larson

1108 State Street
Santa Barbara, CA 93101
voice 805.962.8111
fax 805.962.7458
oliverandespig@cox.net
oliverandespig.com

© 2009

Ingerid J Ekeland

Ingerid Ekeland, **One Pendant, One Woman,** *2009*
sketch for a unique platinum, Paraiba tourmaline and diamond pendant, 1.5 x .25 x .25

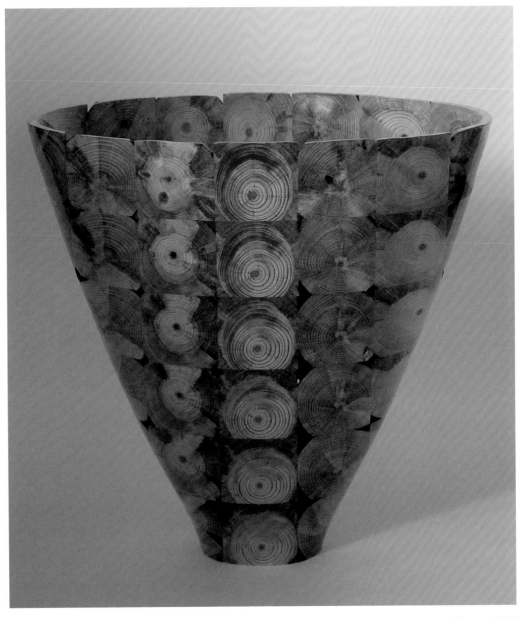

Jim Lorriman, **And the Rocket's Red Glare...,** *2009*
red pine, 9.25 x 10

Option Art

Work by outstanding Canadian contemporary mixed media and craft artists; established in 1985
Staff: Barbara Silverberg, director; Philip Silverberg and Dale Barrett, assistants

4216 de Maisonneuve Blvd. West
Suite 302
Montreal, Quebec H3Z 1K4
Canada
voice 514.501.9440
info@option-art.ca
option-art.ca

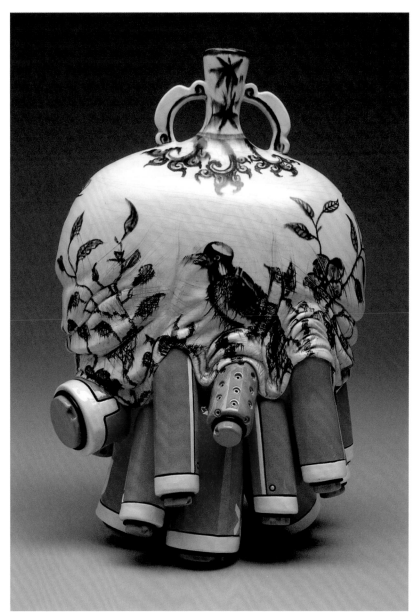

Brendan Tang, **Manga Ormolu**, *2008*
ceramic sculpture, 15 x 11

Exhibiting:
Carolina Echeverria
Joe Fafard
Rosie Godbout
Yvette Hoch Mintzberg
Janis Kerman
Rex Lingwood
Jim Lorriman
Veronique Louppe
Susan Low Beer
Jay Macdonell
Mel Munsen
Susan Rankin
David Samplonius
Brendan Tang
Wendy Walgate
Vanessa Yanow

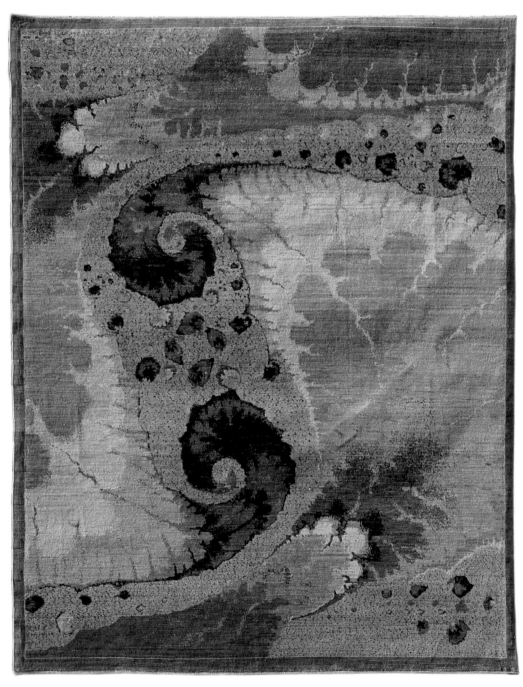

Bahram Shabahang, **Synergy,** *2008*
fiber, 72 x 120

Orley Shabahang

Contemporary Persian carpets
Staff: Bahram Shabahang; Mehran Iravani; Geoffrey Orley

241 East 58th Street
New York, NY 10022
voice 212.421.5800
fax 212.421.5888
newyork@orleyshabahang.com
orleyshabahang.com

240 South County Road
Palm Beach, FL 33480
voice 561.655.3371
fax 561.655.0037
palmbeach@
 orleyandshabahang.com

223 East Silver Spring Drive
Whitefish Bay, WI 53217
voice 414.332.2486
cell 414.379.3388
fax 414.332.9121
whitefishbay@orleyshabahang.com

By Appointment Only
5841 Wing Lake Road
Bloomfield Hills, MI 48301
cell 586.996.5800

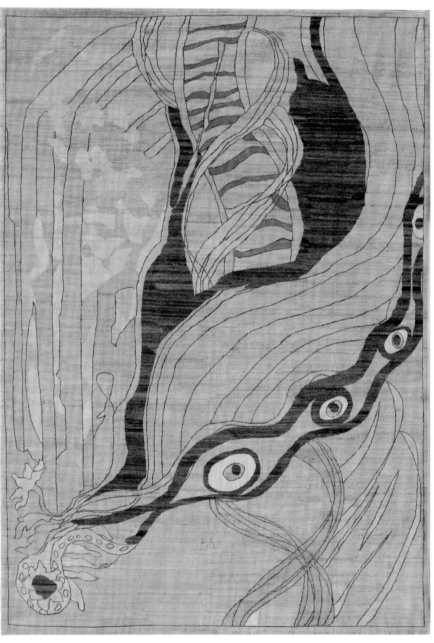

Bahram Shabahang, **Aquatica,** *2009*
fiber, 120 x 168

Exhibiting:
Bahram Shabahang

Iris Eichenberg, **Naked Necklace,** *2009*
silver, glass, leather, beads, textile, nylons, 3 x 3 x 2

Ornamentum

Contemporary international jewelry
Staff: Laura Lapachin; Stefan Friedemann

506.5 Warren Street
Hudson, NY 12534
voice 518.671.6770
fax 518.822.9819
info@ornamentumgallery.com
ornamentumgallery.com

Exhibiting:

Body Politics
Sara Borgegard
Juliane Brandes
Dorothea Brill
Johanna Dahm
Donna D'Aquino
Gemma Draper
Sam Tho Duong
Iris Eichenberg
Ute Eitzenhoefer
Jantje Fleischhut
Maria Rosa Franzin
Caroline Gore
Lisa Gralnick
Batho Guendra
Hanna Hedman
Stefan Heuser
John Iversen
Sergey Jivetin
Dan Jocz
Jiro Kamata
Jutta Klingebiel

Beate Klockmann
Helena Lehtinen
Wolli Lieglein
Marc Monzo
Eija Mustonen
Ted Noten
Joan Parcher
Ruudt Peters
Camilla Prasch
Mary Preston
Katja Prins
Gerd Rothmann
Philip Sajet
Constanze Schreiber
Giovanni Sicuro
Silke Spitzer
Claudia Stebler
Julia Turner
Tarja Tuupanen
Luzia Vogt
Petra Zimmermann

Gerd Rothmann, **Finger Turned to Gold Bracelet,** *2009*
silver, 18k gold, 1.75 x 2.75

Tom McGlauchlin, **The Swimmer,** *2009*
kiln-formed glass, 22 x 25
photo: Jordain Sundt

Palette Contemporary Art and Craft

Global contemporary art glass and jewelry
Staff: Kurt Nelson; Meg Nelson

7400 Montgomery Boulevard NE
Suite 22
Albuquerque, NM 87109
voice 505.855.7777
fax 505.855.7778
palette@qwestoffice.net
palettecontemporary.com

Exhibiting:
Belle Brooke
Emma Camden
Angela Gerhard
K Hyewook Huh
Yukako Kojima
Tom McGlauchlin

Emma Camden, **Red Cross**, *2009*
cast glass, 8.625 x 21 x 12

Lia Cook, **Four by Four,** *2007*
woven cotton, 11 x 12

Perimeter Gallery

Ceramics and fiber art from contemporary masters and emerging artists
Staff: Frank Paluch, director; Scott Ashley, assistant director; Holly Sabin, registrar; Scott Endres, preparator

210 West Superior Street
Chicago, IL 60654
voice 312.266.9473
fax 312.266.7984
perimeterchicago@
 perimetergallery.com
perimetergallery.com

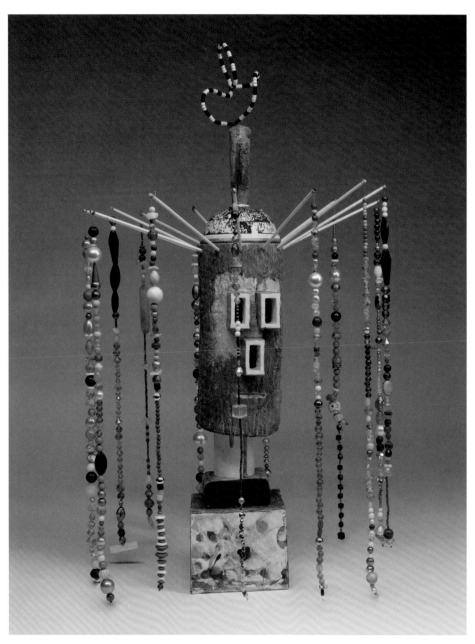

Exhibiting:
Lia Cook
Jack Earl
Edward Eberle
Bean Finneran
Jeffrey Forsythe
The Estate of Margaret
 Ponce Israel
Kiyomi Iwata
Beverly Mayeri
Norma Minkowitz
Eleanor Moty
Joseph Shuldiner
Vanessa L. Smith
Jay Strommen
Toshiko Takaezu
Xavier Toubes
Dick Wickman
Julie York

*Robert Hudson, Kachina Jar, 1997
ceramic, mixed media, 23 x 13 x 13
photo: Tom Van Eynde*

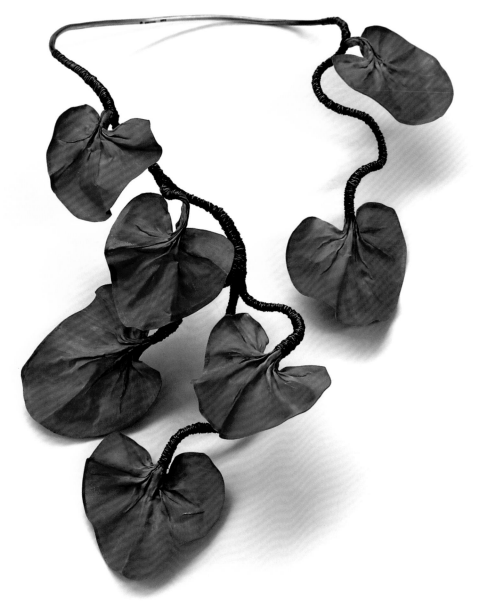

Pawel Kaczynski, **Garden Necklace,** *2007*
steel mesh, silver wire, 5 x 10

Pistachios

Broadening awareness of contemporary metal crafts
Staff: Yann Woolley, director; Catherine Coe, manager; Kari Rinn; Cherise Fleming

55 East Grand Avenue
Chicago, IL 60611
voice 312.595.9437
fax 312.595.9439
pistachi@ameritech.net
pistachiosonline.com

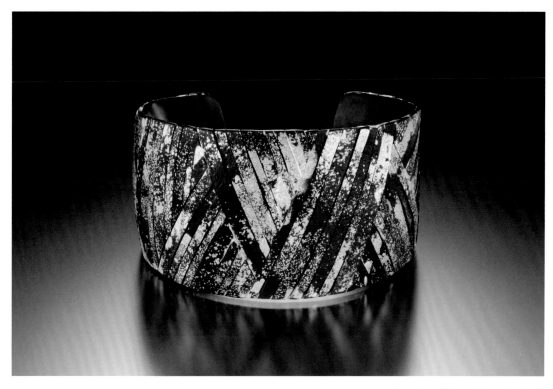

Exhibiting:
Talya Baharal
Iry Dixon
Pat Flynn
Pawel Kaczynski
Gudrun Meyer
Ayala Naphtali

Pat Flynn, **Woven Bracelet,** *2005*
iron, 22k gold, 2 x 2.5 x 1.75

191

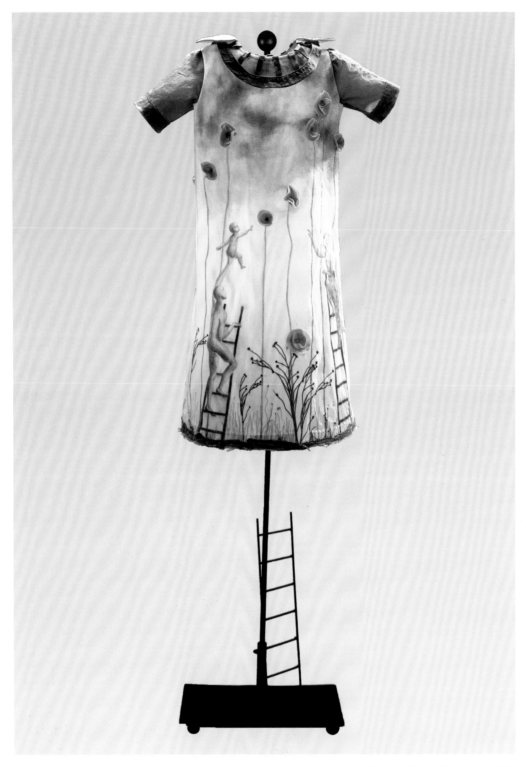

Karen Halt, **Ladder Dress,** *2008*
hand-painted cotton dipped in resin and beeswax, 29 x 19 x 8
photo: Maria Antonieta Oquendo

Portals Ltd

Contemporary two and three dimensional art, sculpture and fiber sculpture
Staff: Nancy and William McIlvaine, owners/directors; Maria Antonieta Oquendo, associate director; Allison Bailey, gallery assistant

742 North Wells Street
Chicago, IL 60654
voice 312.642.1066
fax 312.642.2991
artisnow@aol.com
portalsgallery.com

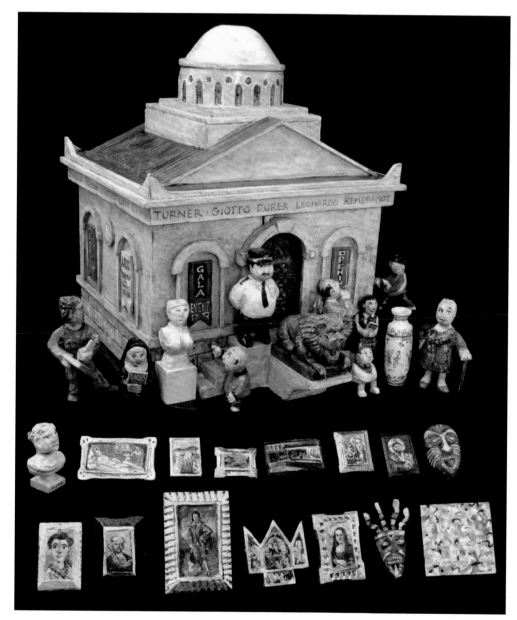

Constance Roberts, **Art Tea**, *2009*
teapot and whistles made of carved and painted wood, 15 x 12 x 17
photo: Constance Roberts

Exhibiting:
Mary Bendix
Ted Gall
Karen Halt
Barbara Kohl-Spiro
Cheryl Malone
Constance Roberts
Joel Sanderson
Milton Tomlinson

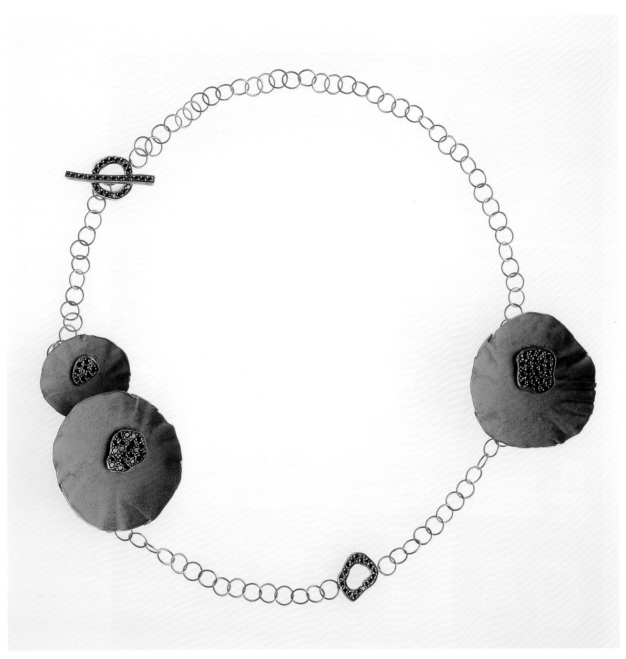

Lina Fanourakis, **Nenuphars Necklace,** *2009*
hand-painted gold, black diamonds

SABBIA

Elegant and imaginative jewelry; a blend of modern designs with classic motifs
Staff: Deborah Friedmann; Tina Vasiliauskaite; Amy Endres; Lourdes McKillop

75 East Walton
Chicago, IL 60611
voice 312.440.0044
fax 312.440.0007
sabbiafinejewelry@hotmail.com
sabbia.com

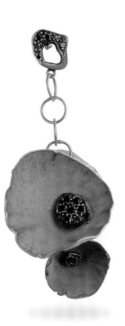

Exhibiting:
Eclat
Lina Fanourakis
Anat Gelbard
Yossi Harari
Alex Sepkus
Michael Zobel

Lina Fanourakis, **Nenuphars Earrings,** *2009*
hand-painted gold, black diamonds

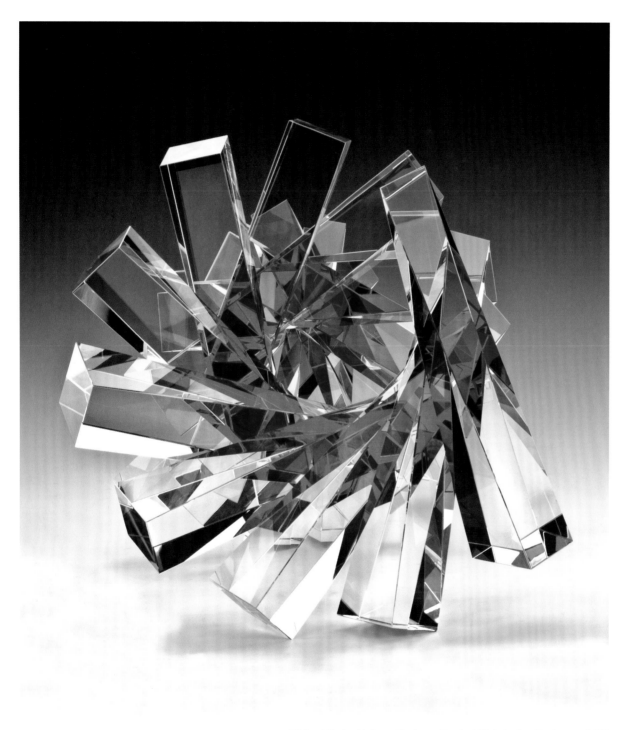

Michael Taylor, Helix or Boring a Conical Hole in the Darkness, *2009*
cast optical, dichoric and pigmented glass, 26 x 26 x 26
photo: Bruce Miller

Scott Jacobson Gallery

Representing established artists in contemporary glass sculpture and studio art furniture
Staff: Scott Jacobson; Terry Davidson; Eric Troolin

114 East 57th Street
New York, NY 10022
voice 212.872.1616
fax 212.872.1617
info@scottjacobsongallery.com
scottjacobsongallery.com

Exhibiting:
Garry Knox Bennett
Greg Bloomfield
Yves Boucard
William Carlson
José Chardiet
Scott Chaseling
Lu Chi
KéKé Cribbs
Dan Dailey
Ivana Houserova
David Huchthausen
Richard Jolley
Kreg Kallenberger
John Lewis
Thomas Loeser
Linda MacNeil
Seth Randal
Paul Seide
Tommy Simpson
Jay Stanger
Michael Taylor
Cappy Thompson
Gianni Toso
Steven Weinberg
Ann Wolff
Loretta Yang
Jirina Zertova

Tommy Simpson, **Moon Feathers Clock***, 2009*
poplar and bass wood, 76 x 18 x 18
photo: Brad Stanton

197

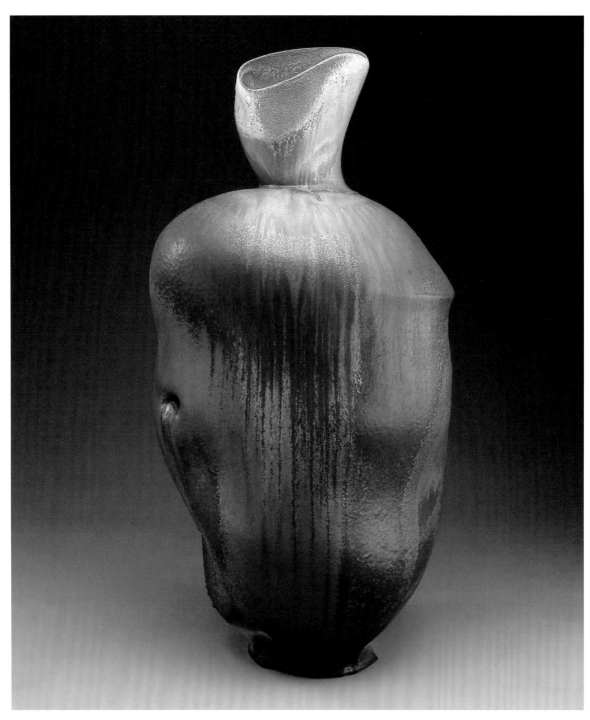

Chris Gustin, #0828, 2009
wood-fired ceramic, 48 x 24 x 26

Sherrie Gallerie

Contemporary art, ceramic sculpture and art jewelry
Staff: Sherrie Hawk; Renee Fairchild, assistant director; Steve Louis

694 North High Street
Columbus, OH 43215
voice 614.221.8580
cell 614.266.9595
fax 614.221.8550
sherrie@sherriegallerie.com
sherriegallerie.com

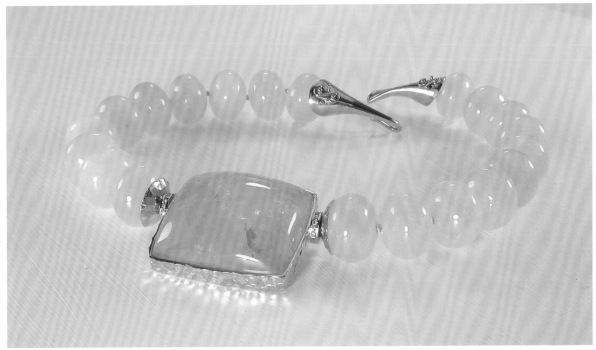

Exhibiting:
Elaine Coleman
Tom Coleman
Scott Dooley
Julie Elkins
Christian Faur
Karen Gilbert
Chris Gustin
Sharon Meyer
Keith Schneider
Janis Mars Wunderlich

Sharon Meyer, **Ocean's Blue***, 2009*
229 ct. Madagascar aquamarine, diamonds, 18k gold, 17 inches diameter
photo: Sharon Meyer

Mike Bray, Remembering, Repeating, and Working Through, *2009*
Lambda print, 40 x 50

Sienna Gallery

International contemporary art, jewelry + object
Staff: Sienna Patti; Raissa Bump

80 Main Street
Lenox, MA 01240
voice 413.637.8386
info@siennagallery.com
siennagallery.com

Exhibiting:
Johan van Aswegan
Lola Brooks
Jamie Bennett
Melanie Bilenker
Iris Bodemer
Mike Bray
Raissa Bump
Noam Elyashiv
Susie Ganch
Gesine Hackenberg
Arthur Hash
Lauren Kalman
Monika Krol
Myra Mimlitsch-Gray
Barbara Seidenath
Sondra Sherman
Bettina Speckner
Tracy Steepy

Barbara Seidenath, **Brooch,** *2009*
silver, enamel, yellow sapphire, 2.75 x 2 x .25

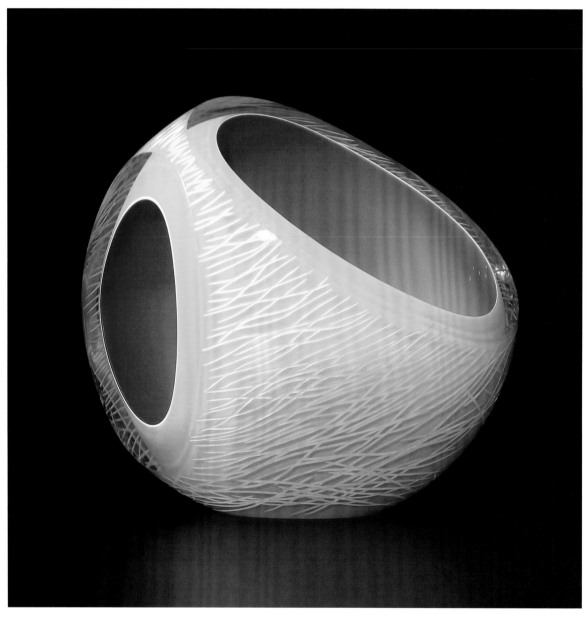

Mark Leputa, **Radiant Stare***, 2009*
glass, 9 x 9.5 x 5
photo: Mark Leputa

Silica Galleries

Our mission is to promote contemporary sculptors with a concentration in glass
Staff: Ian Kerr and Nathan Purcell, directors; Emily Ost, gallery assistant

908-A North 3rd Street
Philadelphia, PA 19123
voice 215.627.3655
fax 215.627.3655
silica@silicagalleries.com
silicagalleries.com

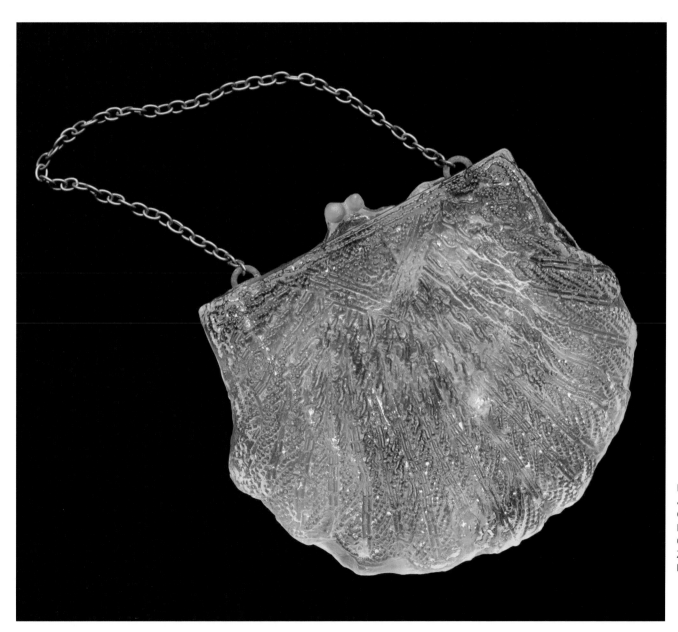

Exhibiting:
Jennifer Blazina
Charlene Foster
Mark Leputa
Christopher Lydon
Zachary Puchowitz
Nathan Purcell

Jennifer Blazina, **Purse,** *2008*
cast glass, 5 x 6 x 2
photo: Matthew Hollerbush

Judith Larzelere, **Tsunami**, *2005*
cotton, 94 x 78
photo: Marty Doyle

Snyderman-Works Galleries

Contemporary textile/fiber, glass, jewelry, furniture, found object, painting and sculpture

Staff: Rick and Ruth Snyderman, proprietors; Bruce Hoffman, director, Snyderman-Works; Kathryn Moran, assistant director; Michael Bukowski, preparator; Francis Hopson, director, Works Gallery; Leeor Sabbah and Lynn Schuberth, associates

303 Cherry Street
Philadelphia, PA 19106
voice 215.238.9576
fax 215.238.9351
bruce@snyderman-works.com
snyderman-works.com

Lucy Arai, **2006.01 Diptych,** *2005*
mixed media, 28 x 22 each panel

Exhibiting:
Lucy Arai
Ines Arndt
Yvonne Pacanovsky
 Bobrowicz
Douglas J. Bucci
John Eric Byers
Nancy Crow
Kate Cusack
Marcia Docter
Robert Ebendorf
Anne Floche
Steven Ford
David Forlano
Karen Gilbert
Alex Irvine
Ron Isaacs
Judith Larzelere
C. Pazia Mannella
Rachel McKnight
Bruce Metcalf
Karen Misher
Marilyn Pappas
Joyce Scott
Barbara Lee Smith
Jo Stealey
Eva Steinberg
Hans Vangso
Grethe Wittrock
Yoko Yagi

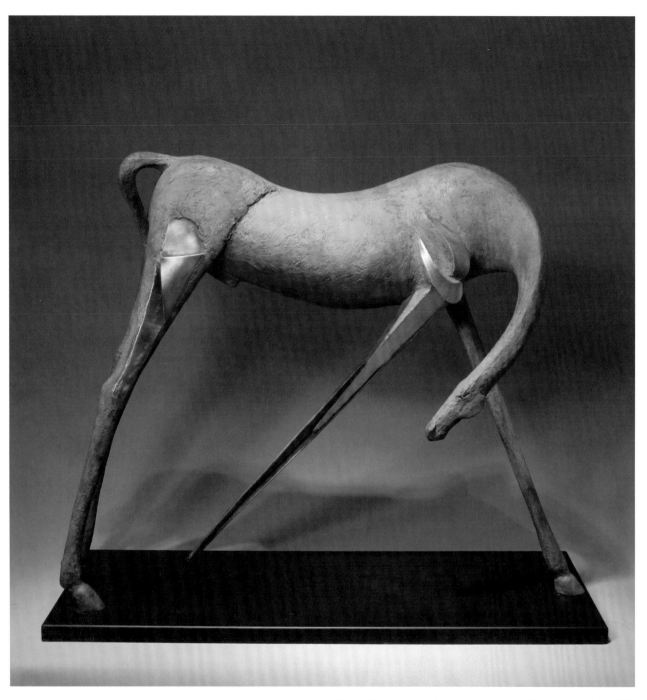

Kirk H. Slaughter and Elisabett Gudmann, **Morning Stretch,** *2008*
bronze with patina, 28 x 36 x 12

ten472 Contemporary Art

Contemporary art
Staff: Hanne Sorensen; Catherine Conlin; Elisabett Gudmann

10472 Alta Street
Grass Valley, CA 95945
voice 707.484.2685
fax 707.484.2685
info@ten472.com
ten472.com

1340 Bryant
San Francisco, CA 94103
info@ten472.com
ten472.com

Exhibiting:
Scott Gruss
Elisabett Gudmann
Gino Miles
Kirk H. Slaughter

Elisabett Gudmann, **Urban Relic: City Blue**
etched copper panel with chemical patinas, 36 x 32 x 2

Philip Soosloff, **The Nonconformist**, *2009*
mixed media wall construction, 42 x 48 x 12
photo: Steve Pitkin

Thomas R. Riley Galleries

Timeless forms evocative of intellectual and emotional responses
Staff: Thomas R. Riley and Cynthia Riley, owners; Cheri Discenzo, director

28699 Chagrin Boulevard
Cleveland, OH 44122
voice 216.765.1711
cell 614.316.2288
fax 216.765.1311
trr@rileygalleries.com
rileygalleries.com

Lucy Lyon, **Seated Figure,** *2009*
cast glass, 57 x 15 x 27
photo: Addison Doty

Exhibiting:
Valerie Beck
Latchezar Boyadjiev
Eoin Breadon
Jason Chakravarty
Grace Chin
Josh Cole
KéKé Cribbs
Matthew Curtis
Donald Derry
Rick Eggert
Carole Freve
Cherry Goldblatt
Mark Harris
Jeremy Lepisto
Alicia Lomné
Lucy Lyon
John Miller
Janis Miltenberger
Milo Mirabelli
John Moran
Nick Mount
Woodrow Nash
Marc Petrovic
Binh Pho
Jeremy Popelka
Doug Randall
David Reekie
Sally Rogers
Kari Russell-Pool
Harriet Schwarzrock
Philip Soosloff
Jacob Stout
Stephanie Trenchard
Jenifer Violette
Jette Vogt
Hiroshi Yamano

Binh Pho, **Amber Dream,** *2009*
glass, 22k gold leaf, 13.5 x 8
photo: Deryl Duer

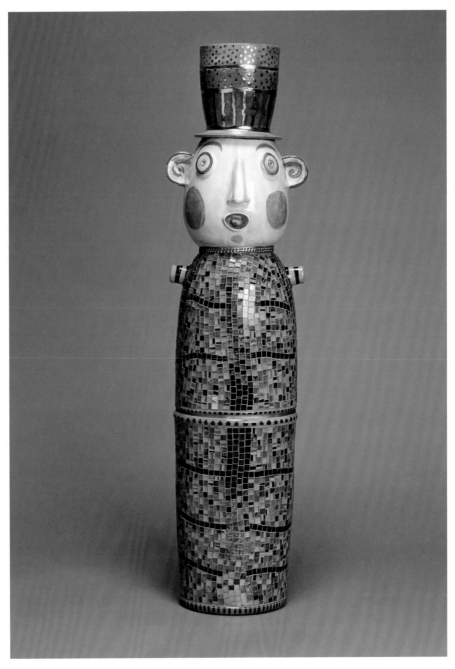

KéKé Cribbs, **Mr. Stubbs**, *2006*
reverse fired enamel mosaics, stoneware, glaze, gold luster, 25.5 x 7 x 6

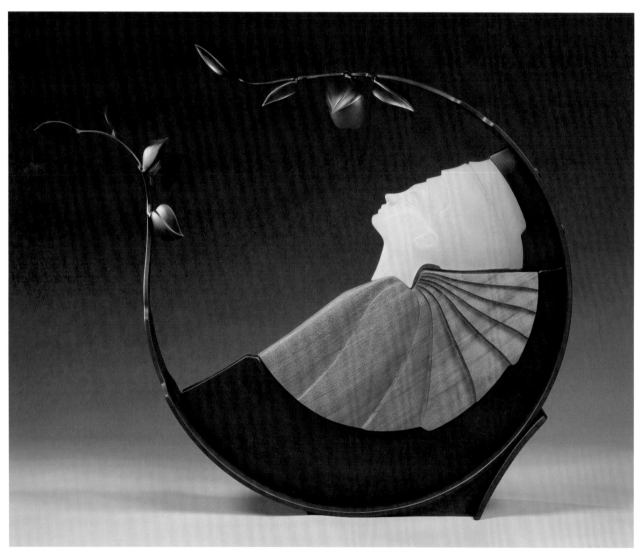

Sally Rogers, **Beguiled**, *2009*
forged and fabricated steel, cast glass, voodoo mahogany, 42 x 50 x 12

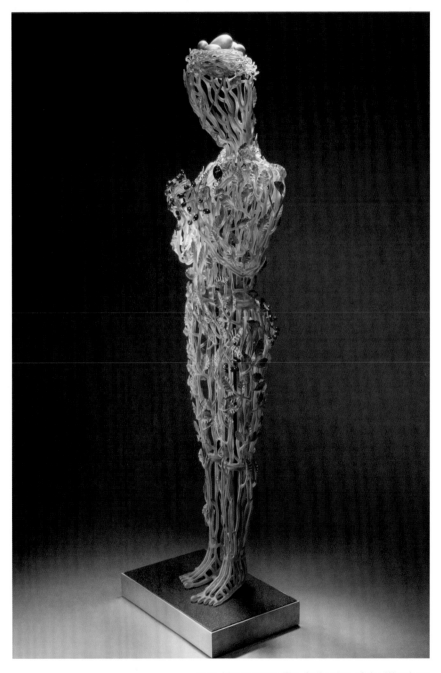

Janis Miltenberger, **The Collection of the Wanderer**
flameworked glass, 64 inches high

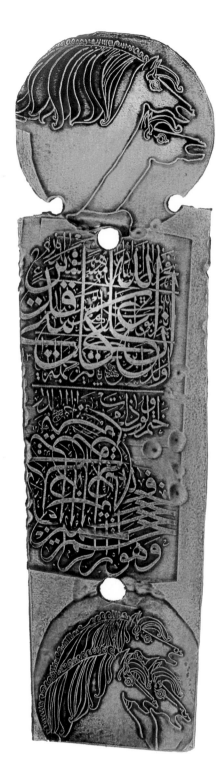

Suleyman Saim Tekcan, **Horses,** *2007*
etching, 15.5 x 20.75
photo: Ecehan Toprak

Turkish Cultural Foundation

Devoted to promoting and preserving Turkish culture, art and heritage

Staff: Guler Koknar and Sema Muslu, Washington, DC; Hulya Yurtsever, Istanbul; Carol Ann Jackson, Boston; Dr. Nurhan Atasoy, resident scholar; Dr. Sumiyo Okumura, art historian

1025 Connecticut Avenue NW
Suite 1000
Washington, DC 20036
voice 202.370.1399
fax 202.370.1398
director@turkishculture.org
turkishculturalfoundation.org

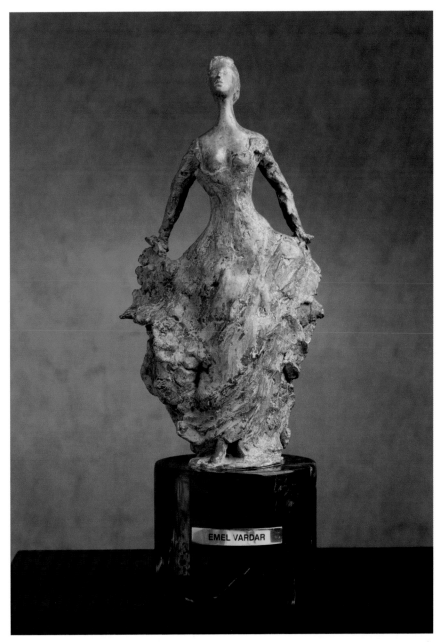

Emel Vardar, **Greenlady,** *2006*
bronze, 12.5 x 7.5 x 3.5
photo: Mufit Cirpanli

Exhibiting:
Ebru Dosekci
Suleyman Saim Tekcan
Emel Vardar
Ebru Yilmaz

215

Ebru Dosekci, **Endless,** *2009*
polyester, 13.75 x 21.5 x 23.5
photo: Yes Crea

Ebru Yilmaz, I have Always Been Here: Remain, *2008*
wood, 23.5 x 23.5 x 23.5
photo: Ebru Yilmaz

William Morris, **Medicine Jar IV,** *2006*
blown glass, steel stand, 11 x 6 x 5
photo: Robert Vinnedge

Wexler Gallery

Specialists in secondary market contemporary glass, studio furniture, and design
Staff: Lewis Wexler, proprietor; Sherri Apter Wexler, co-proprietor; Sienna Freeman, associate director; Michele Amicucci, gallery administrator

201 North 3rd Street
Philadelphia, PA 19106
voice 215.923.7030
fax 215.923.7031
info@wexlergallery.com
wexlergallery.com

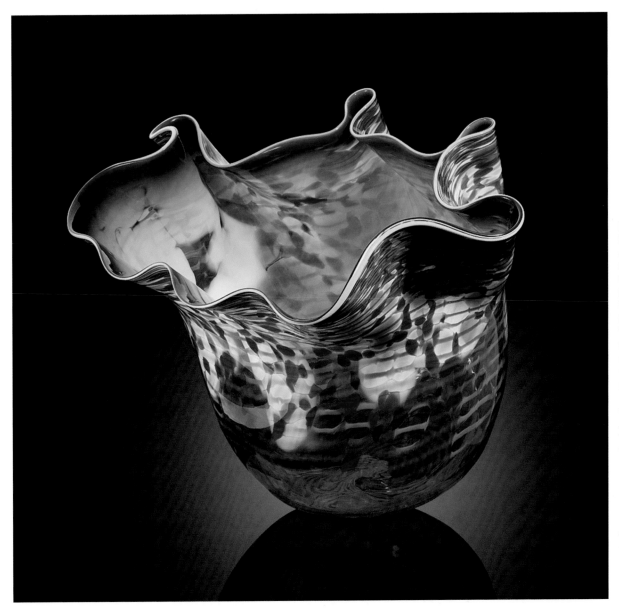

Dale Chihuly, **Hooker's Green Macchia,** *1986*
blown glass, 17 x 21
photo: Morgan Rockhill

Exhibiting:
Howard Ben Tre
José Chardiet
Dale Chihuly
Kyohei Fujita
Michael Glancy
Kimiake Higuchi
Brian Hirst
Tomas Hlavicka
Dominick Labino
Harvey Littleton
Dante Marioni
Richard Marquis
Klaus Moje
William Morris
Joel Philip Myers
Yoichi Ohira
Tom Patti
Mark Peiser
Laura de Santillana
Dirk Staschke
Lino Tagliapietra
Bertil Vallien
Janusz Walentynowicz
Steven Weinberg

Bradley Bowers, **Eat Your Vegetables,** *2007*
plaster, India ink, copper, 22 inches high
photo: Bradley Bowers

The William & Joseph Gallery

Contemporary glass, sculpture, encaustic and objets d'art
Staff: Mary Bonney, owner; Heather Bowler, sales

727 Canyon Road
Santa Fe, NM 87501
voice 505.982.9404
fax 505.982.2321
mary@thewilliamandjoseph
 gallery.com
thewilliamandjosephgallery.com

Exhibiting:
Bradley Bowers
Barrett DeBusk
Chris Donnelly
Elodie Holmes
Patrick Morrissey
Richard Potter
Ken Rosenfeld
Brian Scott

Patrick Morrissey, **Fire & Ice***, 2009*
steel, glass, 21 x 16
photo: Patrick Morrissey

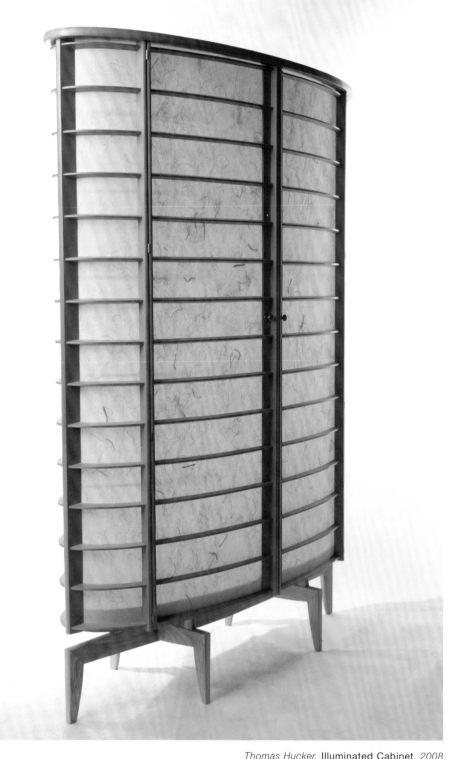

Thomas Hucker, **Illuminated Cabinet**, *2008*
douglas fir, synthetic rice paper, LED lighting, glass, 74 x 44 x 16

William Zimmer Gallery

Superior studio arts with an emphasis on studio furniture
Staff: William Zimmer and Lynette Zimmer, owners; Barbara Hobbs, associate

PO Box 263
Mendocino, CA 95460
voice 707.937.5121
fax 707.937.2405
wzg@mcn.org
williamzimmergallery.com

Exhibiting:
Carolyn Morris Bach
Bennett Bean
Vivian Beer
Garry Knox Bennett
Afro Celotto
Timothy Coleman
Michael Jean Cooper
David Crawford
John Dodd
John Dunnigan
David Ebner
Gail Fredell
Tom Hucker
Michael Hurwitz
Silas Kopf
Tai Lake
Thomas Loeser
Wendy Maruyama
Alphonse Mattia
Hiroki Morinoue
Brian Newell
Richard Scott Newman
Timothy Philbrick
Elizabeth Rand
Sylvie Rosenthal
Cheryl Rydmark
James Schriber
Rosanne Somerson
Kent Townsend
Joe Tracy
Jeff Wise
Susan Wise
Rusty Wolfe

Michael Jean Cooper, **Blue***, 2009*
wood, steel, aluminum, 57 x 26 x 54

P

Partners

artners

YOU JUST CAN'T DOWNLOAD THIS.

All the
world's a stage.
Performances daily.
250 cities.
40 countries.
One airline.

 We know why you fly® **American**Airlines®

AA.com

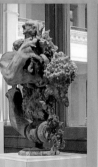 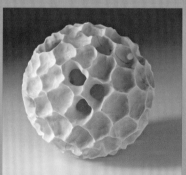 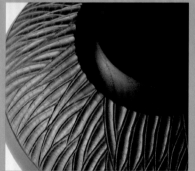 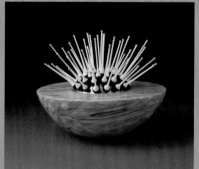 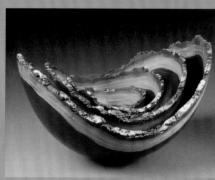

american craft

Published bimonthly by the American Craft Council, <u>American Craft</u> celebrates the modern makers who shape the world around us.

Join today to receive all the benefits of membership in the Council, including a subscription to the magazine.

Visit <u>americancraftmag.org</u> or call 888-313-5527.

PHOTOGRAPH BY BRADY FONTENOT

Above:
Andy Brayman, Bowl, 2009, porcelain with gold, {h. 5 in, w. 8½ in, d. 7 in}.

+

The number one art, antiques and decoration magazine of Turkey, **Antik Dekor**, publishes the news regarding the important auctions, art and antiques fairs worldwide. With richly illustrated and academically proven essays written by scholars the secrets of world's masterpieces in every field of art are revealed. In every issue a special section on the latest decoration trends and fashionably decorated houses are presented to our quality readers together with the interviews with renowned artists and watch makers. In depth coverage of art and antiques market is also provided alongside twenty pages devoted to the latest art books and exhibitions worldwide.

From now on **Antik Dekor** is two magazine. **Artam Global Art** which informs readers about changes, improvements in Modern and Contemporary Art all around the world is going to be on kiosks together with **Antik Dekor**. Exhibitions, fairs, biennials, auctions, interviews with internationally acclaimed artists, academically proven essays written by scholars with richly illustrated images will be covered in **Artam Global Art**. Paintings, sculptures, installations, videos of contemporary artists will be examined. **Artam Global Art** is ready to take part in libraries with its new graphic design and content.

SÜLEYMAN SEBA CAD. TALİMYERİ SOK. MAÇKA 34357 İSTANBUL TURKEY
PHONE: +90 212 236 24 60 FAX: +90 212 236 24 73 www.antikas.com e-mail: antikdekor@antikpalace.com.tr

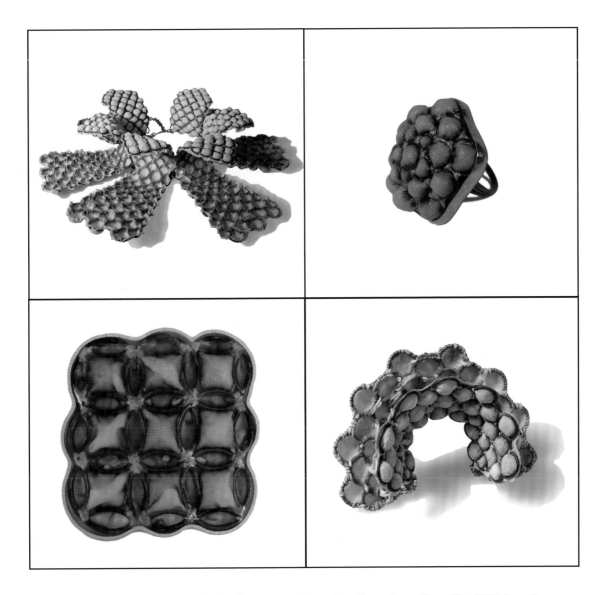

SHARON MASSEY
2009 EMERGING ARTIST AWARD

ART JEWELRY FORUM

ACKNOWLEDGING PROMISE, INNOVATION AND INDIVIDUALITY IN THE WORK OF EMERGING ARTISTS.

AJF P.O. Box 823 Mill Valley, CA 94942 415.522.2924 artjewelryforum.org

YAEL NISAN

AIDA
association of israel's decorative arts

EDDA VARDIMON

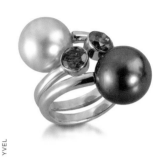

YVEL

ANAT GELBARD

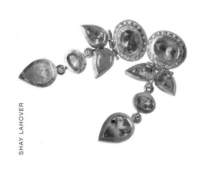

SHAY LAHOVER

MICHAL OREN

ADI ZLOGOTORA

AIDA's Gems: Israel's Jewelers

110 East 59th Street
26th Floor
New York, NY 10022
212.931.0110
www.AIDAarts.org

SHIRAZ ELOHEV

AIDA FOUNDERS

Dale Anderson
Doug Anderson
Andrea Bronfman z"l
Charles Bronfman

BOARD OF DIRECTORS

Sandy Baklor
Sharon Karmazin
Arlene Kaufman
Bill Kopman
Fraeda Kopman
Jane Korman
Leonard Korman
Diane Krane
Doron Livnat
Marianne Livnat
Mark Lyman
Rivka Saker
Elisabeth Sandler
Norman Sandler
Myles Slosberg
Jason Soloway
Anita Wornick
Ron Wornick

ADVISORS

Jane Adlin
John Hoover
Anne Meszko
Jo Mett
Lois Moran
Matt Nolen
Stephen Novick
Yael Reinharz
Jeffrey Solomon
Davira Taragin

STAFF

Erika Vogel
DIRECTOR, NEW YORK

Aviva Ben Sira
DIRECTOR, TEL AVIV

Sharon Shaked
PROJECT COORDINATOR

LIMOR
LESHINSKER

ANAT GELBARD

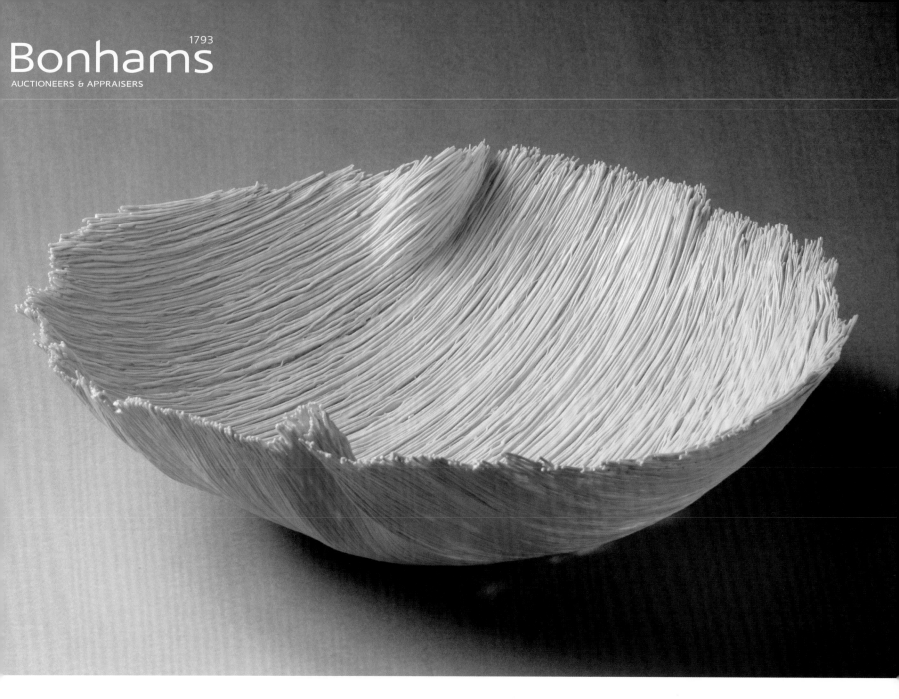

Bonhams ¹⁷⁹³
AUCTIONEERS & APPRAISERS

20th Century Decorative Arts
Wednesday December 9, 1pm
New York

Preview
December 6-8

Inquiries
Frank Maraschiello +1 212 644 9059
frank.maraschiello@bonhams.com

Angela Past +1 323 436 5422
angela.past@bonhams.com

Jason Stein +1 323 436 5405
jason.stein@bonhams.com

Pictured:
A Mary Anne (Toots) Zynsky fused glass bowl
Sold for $9,760, June 2009

London · New York · Paris · San Francisco · Los Angeles · Hong Kong · Melbourne · Dubai

www.bonhams.com/newyork

Breakthrough Ideas

bigg

in Global Glass

BIGG is a dynamic collaboration among The Ohio State University's Department of Art Glass Program, The Ohio State University's Urban Arts Space, and Hawk Galleries. We will introduce to the world 43 international artists who create with a conceptual and working engagement in glass. Through an international juried selection process and critical writing about work in the field, we commit to advancing new and innovative glass art worldwide. This exhibition will be presented from **July 10 through October 10, 2009 at the OSU Urban Arts Space and Hawk Galleries** in downtown Columbus, Ohio, USA. Selected works will be exhibited at **SOFA** CHICAGO, November 5 through 8, 2009, at Chicago's Navy Pier, Chicago, Illinois, USA. For more information visit **uas.osu.edu/bigg** or call (614) 225-9595.

LEAD GIFT BY STEUBEN GLASS

 THE OHIO STATE UNIVERSITY O|S|U URBAN ARTS SPACE HAWK GALLERIES SteubenGlass SOFA CHICAGO

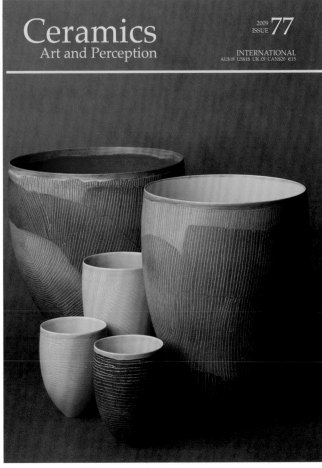

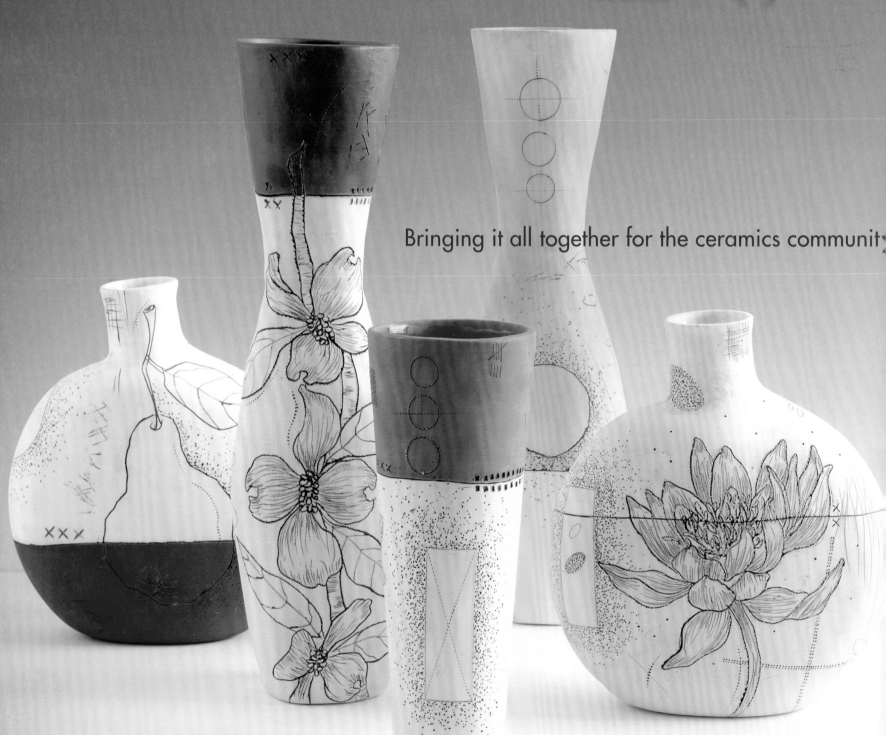

collect

the international art fair
for contemporary objects

presented by the crafts council
www.craftscouncil.org.uk

14 – 17 may 2010

saatchi gallery
duke of york's hq
chelsea london

CRAFTS COUNCIL

Supported by
ARTS COUNCIL
ENGLAND

Crafts Council Registered Charity Number 280956

chicagogallerynews.com

- Gallery exhibition dates + details
- Opening receptions
- Pull-out district maps + online Google Maps
- Exhibiting artists list
- Galleries by specialty
- Art-related services
- A full calendar of city-wide art events
- Directory of alternative spaces, studios, nonprofits

published in January, April and September

chicago news
gallery

Collectors of Wood Art

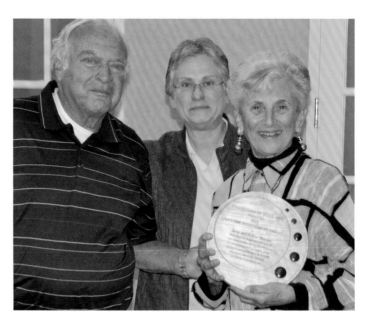

Arthur Mason, Robyn Horn and Jane Mason

Join Collectors of Wood Art Today!

NETWORK with Artists, Collectors & Curators

VISIT Artist Studios

TOUR Private Collections

ENJOY Lectures and Panel Discussions

RECEIVE the Informative CWA Newsletter

Be Part of the Growing Studio Wood Movement!

Collectors of Wood Art

P.O. Box 491973

Los Angeles, California 90049

888.393.8332

www.collectorsofwoodart.org

Arthur and Jane Mason
2009 Recipients
Lifetime Achievement Award

CWA honors Jane and Arthur as major collectors of wood and founding members of CWA. Together they received the McColl Award for Lifetime Achievement from the Mint Museum of Craft + Design in 2003, where they donated a major part of their collection. They were selected as Honorary Lifetime Members of the American Association of Woodturners in 2005.

Jane chaired the Smithsonian Craft Show in 1996. Arthur and Jane have served on the board of the Renwick Alliance and the CWA; Arthur has served on the board of the American Craft Council, the Woodturning Center, and the Mint Museum of Craft + Design.

The Masons have been involved as missionaries for the field, attracting new collectors and assisting new artists in getting recognition.

On view for the first time, this extraordinary collection is one of the most important gifts of studio glass ever donated to a museum.

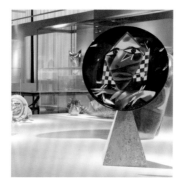

voices of contemporary glass

THE HEINEMAN COLLECTION

CORNING MUSEUM OF GLASS

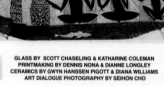
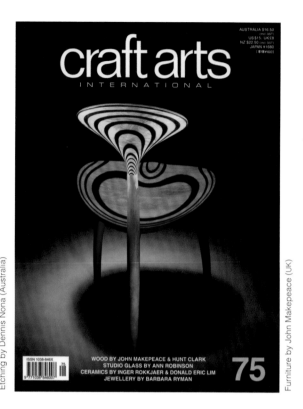

J. Fred Woell

footWork
A collection of miniatures
Raffle to benefit Craft Emergency Relief Fund

Artists not pictured: Shane Fero, Lisa Klakulak, Wendy Maruyama,
Joyce Scott, Mara Superior

Diane Komater

Judy Onofrio

Susan Beiner

Linda Leviton

Polly Adams Sutton

Bonnie Bishoff & J.M. Syron

Roy Superior

Lanie Gannon

Jackie Abrams

Nuala Creed

Wendy Ellsworth

Beth Mueller

Harriete Estel Berman

Raffle tickets are $50 each or books of five for $200

Visit the CERF booth at the **SOFA CHICAGO** Resource Center
Drawing November 8, 2009. You do not need to be present to win.
info@craftemergency.org • 802.229.2306 • www.craftemergency.org

The mission of CERF is to strengthen and sustain the careers of craft artists across the United States.
Special thanks to The Art Fair Company, producer of SOFA CHICAGO for their generous donation of space for this event.

friends of fiber Art International™

Box 468, Western Springs, IL 60558
Phone/fax USA 708-246-9466

Who directs, advises and belongs to
Friends of Fiber Art International?
Learn about members' achievements. **WHO**

What is contemporary fiber art?
See the side-bar gallery.
Discover the organization's mission. **WHAT**

When are
Friends of Fiber Art International's
programs? **WHEN**

Where in the world
may I see contemporary fiber art
exhibitions in museums and galleries? **WHERE**

Why should I support Friends
of Fiber Art International?
What unique benefits will I enjoy? **WHY**

How do I join, post my fiber show in
Friends' WHERE calendar,
or apply for a grant? **HOW**

DISCOVER

The collectible
of
the 21st Century

CONTEMPORARY
FIBER ART

LEARN THE ANSWERS

TO THESE QUESTIONS

WHEN YOU VISIT

OUR NEW WEB SITE

www.FriendsofFiberArt.org

May 5 to 19, 2010
TOUR

Join Friends of Fiber Art's fifth tour to see the most significant international fiber art survey on the planet and discover some of the most important Polish artists working in clay and bronze. The itinerary is now published on the WHEN page of our Web site

www.**FriendsofFiberArt**.org

Visit Gdansk, Krakow, Warsaw and Lodz
See contemporary and art nouveau architecture
Meet artists, collectors and perhaps a man who changed the course of history
Find the up-to-date itinerary posted online
www.friendsoffiberart.org/when.php
or phone USA 708-246-9466

GLASHAUS
3/2009
6,50 EUR

www.glashaus-magazin.de
www.glasshouse.de

ISSN 1435-8565
K49413

GLASHAUS

Internationales Magazin für Studioglas

GLASSHOUSE

Ulrike
Umlauf-Orrom

Saman
Kalantari

IKA
Mechelen

Glaspreis
Immenhausen

Gathering
Light

The James Renwick Alliance

www.jra.org

is an independent national non-profit organization, created to celebrate the achievements of America's craft artists and to foster scholarship, education and public appreciation of craft art. Founded in 1982, the Alliance helps support the nation's showcase of contemporary American craft, the Renwick Gallery of the Smithsonian American Art Museum in Washington, DC.

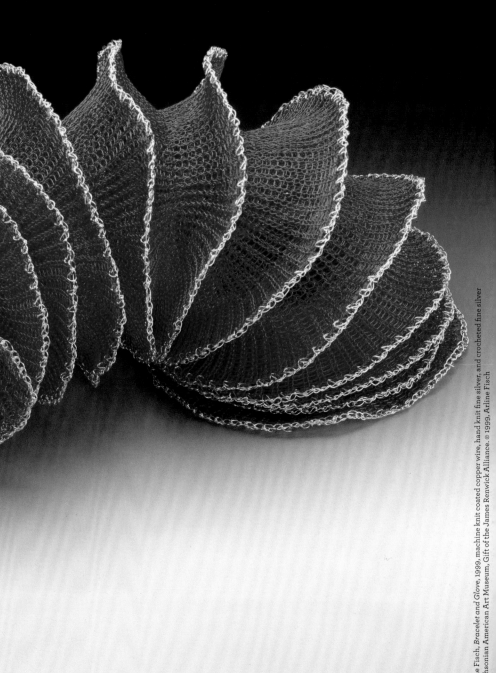

Arline Fisch, *Bracelet and Glove*, 1999, machine knit coated copper wire, hand knit fine silver, and crocheted fine silver. Smithsonian American Art Museum, Gift of the James Renwick Alliance. © 1999, Arline Fisch

Join us for • Spring Craft Weekend • April 23–25, 2010

JAMES RENWICK ALLIANCE

4405 East-West Highway, Suite 510
Bethesda, MD 20814
301.907.3888 / (fax) 301.907.3855
info@jra.org

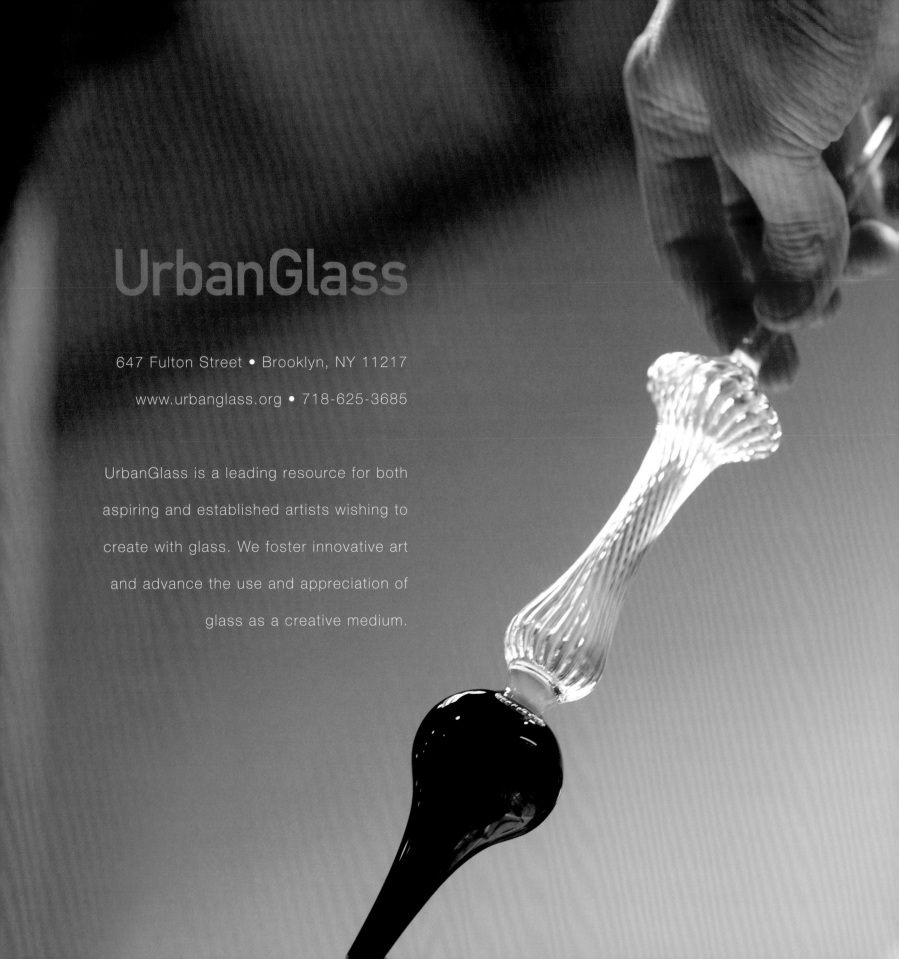

UrbanGlass

647 Fulton Street • Brooklyn, NY 11217

www.urbanglass.org • 718-625-3685

UrbanGlass is a leading resource for both aspiring and established artists wishing to create with glass. We foster innovative art and advance the use and appreciation of glass as a creative medium.

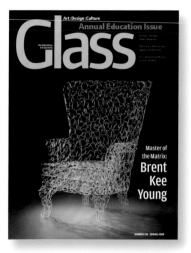

LILLSTREET
ART CENTER

EST. 1975
CHICAGO

October 12 - November 8
Dan Anderson and
Robert Archambeau
Artists Reception:
November 6, 6-10pm

· ·

VIEW AND PURCHASE WORK ONLINE
LILLSTREET.COM/GALLERY

· ·

EXHIBITING

Bob Briscoe • Sam Chung • Susan O'Brien
Michael Corney • Stephen Grimmer
Bernadette Curran • Tammy Marinuzzi
Kristen Kiefer • Lorna Meaden • Ron Meyers
Beth Lo • Posey Bacopoulos
AND MANY OTHERS

4401 N RAVENSWOOD | CHICAGO, ILLINOIS 60640 | 773.769.4226

The thinking person's guide to the world of metalsmithing…

For nearly three decades, the award-winning *Metalsmith* magazine has been the **critical forum** for the **studio jewelry** and **metals** field.

You can count on *Metalsmith* to be **smart**, **provocative**, and **beautiful**.

See what you think.

FOUNDED 1969

Published five times a year by the Society of North American Goldsmiths, the premier organization for artists, designers, jewelers, and metalsmiths.
www.snagmetalsmith.org

Subscribe: 541.345.5689
info@snagmetalsmith.org
Advertise: 413.585.8478
jsavarese@snagmetalsmith.org

metalsmith

ART
DESIGN
JEWELRY
METAL

metalsmith

ART
DESIGN
JEWELRY
METAL

metalsmith

ART
DESIGN
JEWELRY
METAL

$8.50 USA | SN.

$8.50 USA | SN.

$8.50 USA | SNAGMETALSMITH.ORG

Mint Museum of Craft + Design

Mint Museum of Craft + Design
220 North Tryon Street
Charlotte, NC 28202
704/337-2000

m i n t m u s e u m . o r g

Founders' Circle Ltd., is the National Support
Affiliate of the Mint Museum of Craft + Design.
f o u n d e r s c i r c l e . o r g

The Mint Museum is funded, in part,
with operating support by the Arts
& Science Council.

DANTE MARIONI
Black Reticello Acorn 2007
Gift from the Founders' Circle Ltd. to the
Mint Museum of Craft + Design in 2008.
Photo by David Ramsey

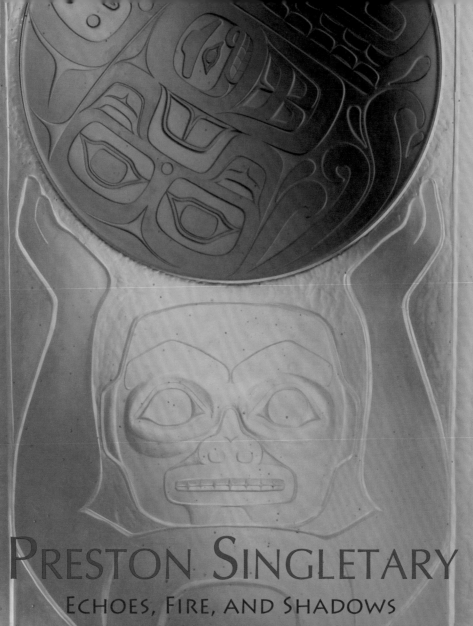

PRESTON SINGLETARY

ECHOES, FIRE, AND SHADOWS

JULY 11, 2009 – SEPTEMBER 19, 2010

Museum of Glass is pleased to present its newest commission and acquisition
Clan House, by artist Preston Singletary, as part of its newly established
Permanent Collection of 20th and 21st century glass.

Presented by Alaska Airlines
Commission sponsored by Leonard and Norma Klorfine Foundation
Exhibition sponsored by Leonard and Norma Klorfine Foundation, Windgate Foundation and JoAnn McGrath
The Seattle Times, City Arts Magazine, KUOW Public Radio, Tulalip Charitable Fund

Preston Singletary (American, b. 1963) *Clan House* (Naakahídi) detail, 2008.
Kiln-cast and sandcarved glass; water-jet-cut, inlaid, and laminated medallion. 16 feet x 10 feet x 2½ inches; Photo by Russell Johnson and Jeff Curtis.

Glimmering Gone

Beth Lipman and Ingalena Klenell

October 23, 2010 - September 19, 2011
Organized by Museum of Glass

A cross-cultural collaborative exhibition combining kiln-formed, blown and sculpted glass in a sequence of installations which engage the visitor in most unusual settings.

Photo by Ken Sager

MUSEUM OF GLASS

Tacoma, WA • 1.866.4MUSEUM • museumofglass.org

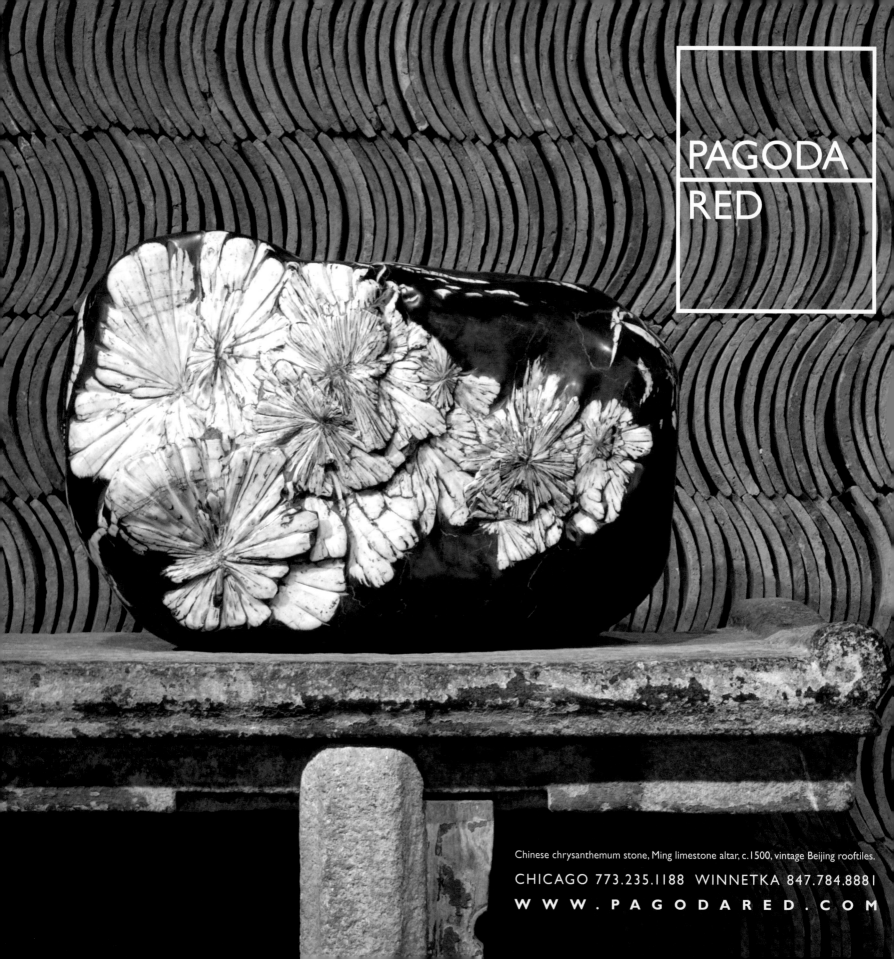

Penland
School *of* Crafts

Helping people live creative lives

Workshops • Gallery • Artist Residencies • Annual Benefit Auction: August 13 – 14, 2010
P.O. Box 37, Penland, NC 28765 • 828.765.2359 • www.penland.org

PILCHUCK GLASS SCHOOL

Join us!

www.Pilchuck.com

Your Museum for Contemporary Crafts

Come for the exhibitions, stay for the art!

The Donna Schneier Collection Arrives at RAM: Art Jewelry of the 1980s and 1990s
Through January 3, 2010

Collection Focus – Michael Lucero at RAM
Through January 17, 2010

And, selections from RAM's nationally respected contemporary crafts collection
by internationally known artists including
Arline Fisch, Carol Eckert, Therman Statom, Lillian Elliott, Michael Lucero
(As shown above, clockwise from top left. Art photos by Michael Tropea, Marc Wollman and Jon Bolton)

Racine Art Museum
Racine, Wisconsin
262.638.8300

www.ramart.org

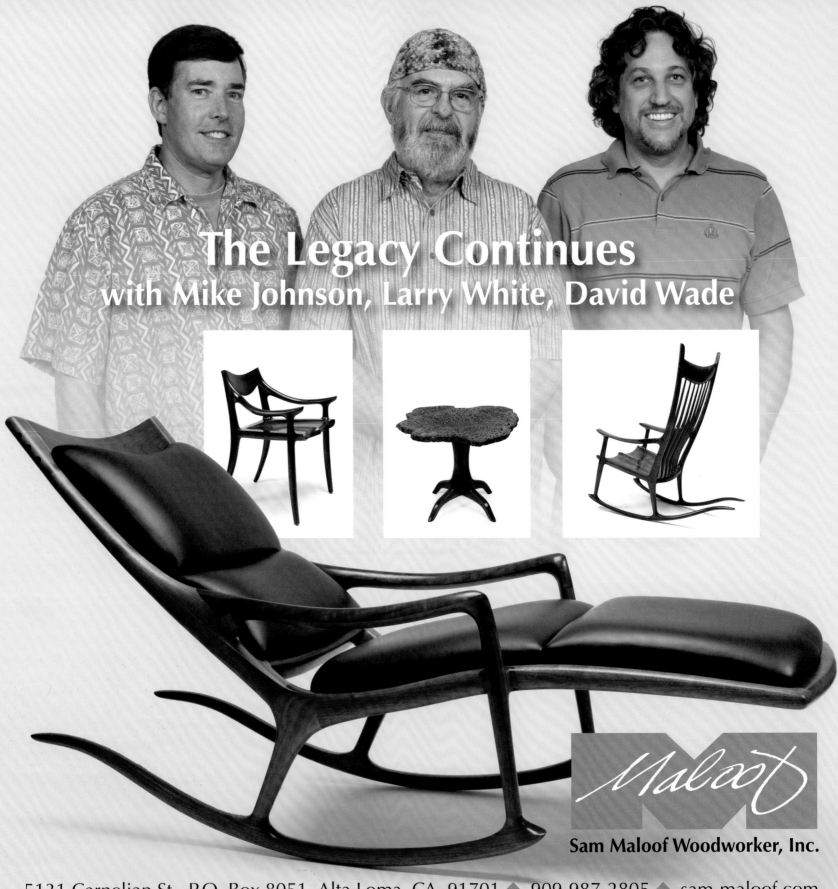

Looking for inspiration?

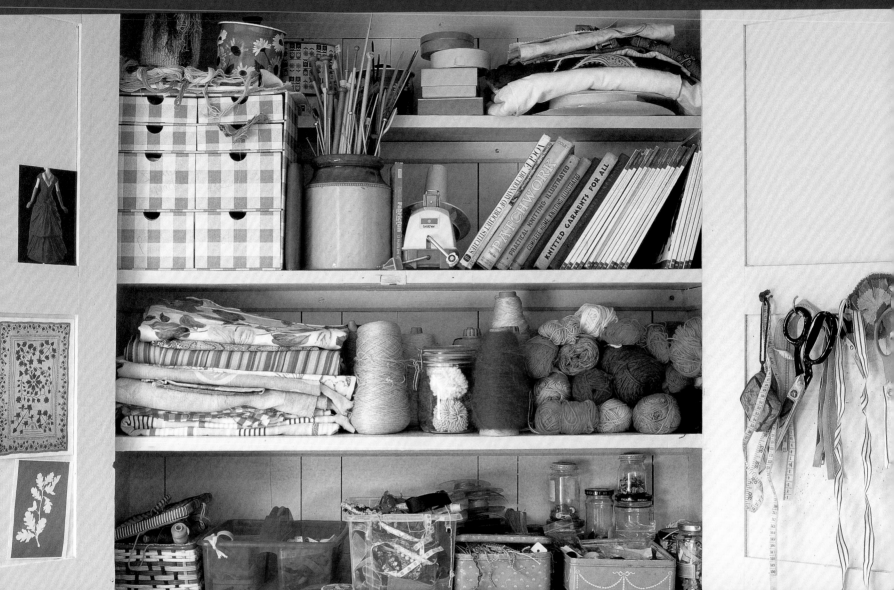

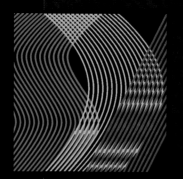
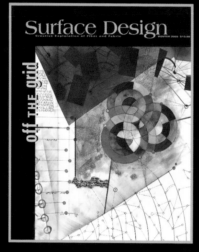

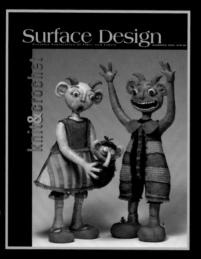

An international residency facility for professional artists *working in clay.*

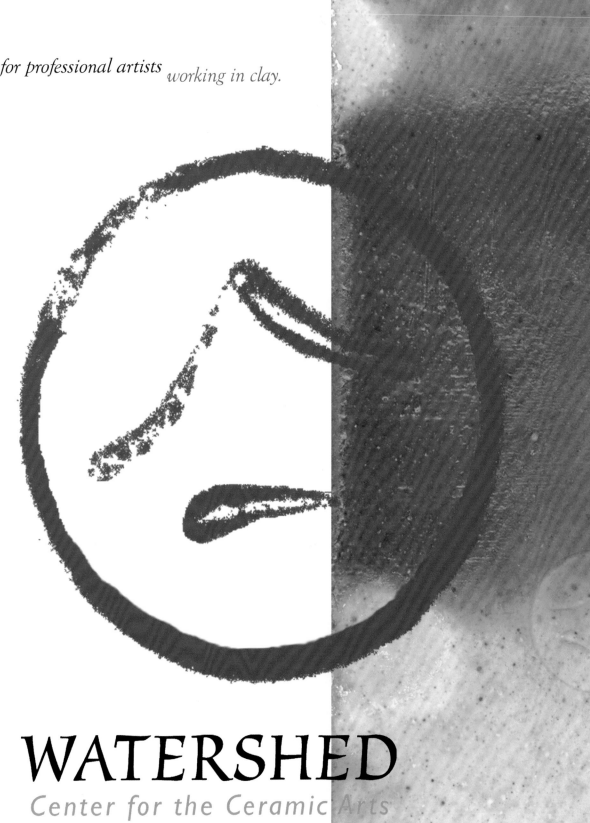

19 Brick Hill Road
Newcastle, Maine 04553-9716
207-882-6075 phone
207-882-6045 fax

Tyler Gulden, Executive Director
director@watershedceramics.org

www.WatershedCeramics.org

WATERSHED
Center for the Ceramic Arts

In sync with art

Judith Villamayor
Grace McKee
Laleper Aytek
Maria Dolores Leal
Manuel Marano
Maria Soledad Leiva
Gaby Herbstein
Katherine Zuniga
Jose Antonio Baselga
Nishi
Ebru Akyildiz
Diana Bonilla
Jose Carlos Ortiz
Jacob Kleyn
Jason Galarraga
Joao Carita
and more…

Contrasts Gallery
Hoet Bekaert Gallery
MiTO Galeria d Art Contemporani
Pékin Fine Art
Tibor De Nagy Gallery
Bernarducci Meisel Gallery
Lazarides
Mai 36 Galerie
Phillips Gallery
Montecatini Gallery
Galerie Elisabeth & Klaus Thoman
Galería Kessler-Battaglia
David Kordansky Gallery
Dagmar De Pooter Gallery
and more…

artn•w
online.com

www.artnowonline.com • info@artnowonline.com

BAREFOOT
WINE

Barefoot Cellars
salutes SOFA on its
16 years at Navy Pier!

Get Barefoot and Have a Great Time!

www.barefootwine.com 1.800.750.8828

hibitors

A

Aaron Faber Gallery
666 Fifth Avenue
New York, NY 10103
212.586.8411
fax 212.582.0205
info@aaronfaber.com
aaronfaber.com

Adamar Fine Arts
4141 NE 2nd Avenue
Suite 107
Miami, FL 33137
305.576.1355
cell 305.527.9061
fax 305.576.1922
adamargal@aol.com
adamargallery.com

Ann Nathan Gallery
212 West Superior Street
Chicago, IL 60654
312.664.6622
fax 312.664.9392
nathangall@aol.com
annnathangallery.com

B

Barry Friedman Ltd.
515 West 26th Street
2nd floor
New York, NY 10001
212.239.8600
fax 212.239.8670
contact@barryfriedmanltd.com
barryfriedmanltd.com

Berengo Studio 1989
Fondamenta Vetrai 109/A
Murano, Venice 30141
Italy
39.041.739.453
cell 39.335.600.6392
fax 39.041.527.6588
adberen@yahoo.it
berengo.com

Berengo Collection
Calle Larga San Marco 412/413
Venice 30124
Italy
39.041.241.0763
fax 39.041.241.9456

Berengo Collection
ESQ Hiroo 2F
5-10-37, Minami-azabu
Minato-ku, Tokyo 106-0047
Japan

Blue Rain Gallery
130 Lincoln Avenue
Suite C
Santa Fe, NM 87501
505.954.9902
fax 505.954.9904
info@blueraingallery.com
blueraingallery.com

Bullseye Gallery
300 NW 13th Avenue
Portland, OR 97209
503.227.0222
fax 503.227.0008
gallery@bullseyeglass.com
bullseyegallery.com

C

Chappell Gallery
526 West 26th Street
New York, NY 10001
212.414.2673
amchappell@aol.com
chappellgallery.com

Charon Kransen Arts
By Appointment Only
817 West End Avenue
Suite 11C
New York, NY 10025
212.627.5073
fax 212.663.9026
charon@charonkransenarts.com
charonkransenarts.com

**Chiaroscuro
Contemporary Art**
702 1/2 Canyon Road
Santa Fe, NM 87501
505.992.0711
fax 505.992.0387
gallery@chiaroscurosantafe.com
chiaroscurosantafe.com

Crawford Contemporary
1044 Madison Avenue
New York, NY 10075
212.249.3602
fax 212.249.3604
info@alastaircrawford.com
crawfordcontemporary.com

Crea Gallery
350 St. Paul East
Montreal, Quebec H2Y 1H2
Canada
514.861.2787, ext. 316
fax 514.861.9191
crea@creagallery.com
creagallery.com

D

D & M Fine Arts Ltd.
20 Dogwood Glen
Rochester, NY 14625
585.249.9157
cell 585.281.6918
fax 585.249.9157
dpulito@rochester.rr.com

DC and Company
3 Avenue Daumesnil
Paris 75012
France
33.1.4340.3424
cell 33.6.7468.7151
fax 33.1.4340.1604
chantal@dcandco.fr
editions.dube@wanadoo.fr
dcandco.fr

The Dancing Hands Gallery
591 Main Street
Park City, UT 84060
435.649.1414
fax 435.649.9523
chris_dhgallery@qwestoffice.net
thedancinghandsgallery.com

del Mano Gallery
11981 San Vicente Boulevard
Los Angeles, CA 90049
310.476.8508
fax 310.471.0897
gallery@delmano.com
delmano.com

Donna Schneier Fine Arts
By Appointment Only
PO Box 3209
Palm Beach, FL 33480
518.441.2884
dnnaschneier@mhcable.com

Duane Reed Gallery
4729 McPherson Avenue
St. Louis, MO 63108
314.361.4100
fax 314.361.4102
info@duanereedgallery.com
duanereedgallery.com

Ferrin Gallery
437 North Street
Pittsfield, MA 01201
413.442.1622
cell 413.446.0614
fax 413.634.8833
info@ferringallery.com
ferringallery.com

Forré & Co. Fine Art
426 East Hyman Avenue
Aspen, CO 81611
970.544.1607
fax 970.544.1608
anna@forrefineart.com
forrefineart.com

Galerie Besson
15 Royal Arcade
28 Old Bond Street
London W1S 4SP
England
44.20.7491.1706
fax 44.20.7495.3203
enquiries@galeriebesson.co.uk
galeriebesson.co.uk

Galerie Elca London
224 St-Paul Street West
Montreal, Quebec H2Y 1Z9
Canada
514.282.1173
fax 514.282.1229
info@elcalondon.com
elcalondon.com

Galerie Elena Lee
1460 Sherbrooke West
Suite A
Montreal, Quebec H3G 1K4
Canada
514.844.6009
info@galerieelenalee.com
galerieelenalee.com

Galleri Udengaard
Vester Alle 9
Aarhus C 8000
Denmark
45.86.259.594
udengaard@c.dk
galleriudengaard.com

Galleria Norsu
Kaisaniemenkatu 9
PO Box 152
Helsinki FI-00171
Finland
358.9.2316.3250
galleria@norsu.info
norsu.info

**Galleria San Marco
Arte & Design**
Frezzaria San Marco, 1725
Venice 30124
Italy
39.014.894.6940
fax 39.041.894.6940
artecontemporanea@
 antiquariasanmarco.it
galleriasanmarcoarte&design.com

Habatat Galleries
4400 Fernlee Avenue
Royal Oak, MI 48073
248.554.0590
fax 248.554.0594
info@habatat.com
habatat.com

Hawk Galleries
153 East Main Street
Columbus, OH 43215
614.225.9595
cell 614.519.2177
fax 614.225.9550
tom@hawkgalleries.com
hawkgalleries.com

Hedge
48 Gold Street
San Francisco, CA 94133
415.433.2233
fax 415.433.2234
info@hedgegallery.com
hedgegallery.com

Heller Gallery
420 West 14th Street
New York, NY 10014
212.414.4014
fax 212.414.2636
info@hellergallery.com
hellergallery.com

**Higgins Harte
International Galleries**
844 Front Street
Lahaina, HI 96761
808.661.4439
cell 808.268.3022
fax 808.661.8440
donaldlamarr@higginsharte.com
higginshartegalleries.com

Holsten Galleries
3 Elm Street
Stockbridge, MA 01262
413.298.3044
fax 413.298.3275
artglass@holstengalleries.com
holstengalleries.com

Jane Sauer Gallery
652 Canyon Road
Santa Fe, NM 87501
505.995.8513
cell 505.577.6751
fax 505.995.8507
jsauer@jsauergallery.com
jsauergallery.com

Jean Albano Gallery
215 West Superior Street
Chicago, IL 60654
312.440.0770
fax 312.440.3103
jeanalbano@aol.com
jeanalbanogallery.com

John Natsoulas Gallery
521 First Street
Davis, CA 95616
530.756.3938
cell 530.848.8699
art@natsoulas.com
natsoulas.com

Ken Saunders Gallery
230 West Superior Street
Chicago, IL 60654
312.573.1400
fax 312.573.0575
info@kensaundersgallery.com
kensaundersgallery.com

Kirra Galleries
Federation Square
Cnr Swanston and
Flinders Streets
Melbourne, Victoria 3000
Australia
61.3.9639.6388
fax 61.3.9639.8522
gallery@kirra.com
kirragalleries.com

Lacoste Gallery
25 Main Street
Concord, MA 01742
978.369.0278
fax 978.369.3375
info@lacostegallery.com
lacostegallery.com

Lafrenière & Pai Gallery
13 Murray Street
Ottawa, Ontario K1N 9M5
Canada
613.241.2767
info@lapaigallery.com
lapaigallery.com

Litvak Gallery
4 Berkovich Street
Tel Aviv 64238
Israel
972.3.695.9496
fax 972.3.695.9419
info@litvak.com
litvak.com

Maria Elena Kravetz
San Jeronimo 448
Cordoba X5000AGJ
Argentina
54.351.422.1290
mek@mariaelenakravetzgallery.com
mariaelenakravetzgallery.com

Mattson's Fine Art
2579 Cove Circle, N.E.
Atlanta, GA 30319-3705
404.636.0342
fax 404.636.0342
sundew@mindspring.com
mattsonsfineart.com

Maurine Littleton Gallery
1667 Wisconsin Avenue NW
Washington, DC 20007
202.333.9307
fax 202.342.2004
info@littletongallery.com
littletongallery.com

Mostly Glass Gallery
34 Hidden Ledge Road
Englewood, NJ 07631
201.816.1222
fax 201.503.9522
info@mostlyglass.com
mostlyglass.com

Next Step Studio & Gallery
530 Hilton Road
Ferndale, MI 48220
248.414.7050
cell 248.342.5074
nextstepstudio@aol.com
nextstepstudio.com

Niemi Sculpture
Gallery & Garden
13300 116th Street
Kenosha, WI 53142
262.857.3456
fax 262.857.4567
gallery@bruceniemi.com
bruceniemi.com

Old City Caesarea Gallery
The Old City
PO Box 5367
Caesarea 38900
Israel
972.4.626.0198
fax 972.4.636.0178
art@caesareaart.com
caesareaart.com

Oliver & Espig
1108 State Street
Santa Barbara, CA 93101
805.962.8111
fax 805.962.7458
oliverandespig@cox.net
oliverandespig.com

Option Art
4216 de Maisonneuve Blvd. West
Suite 302
Montreal, Quebec H3Z 1K4
Canada
514.501.9440
info@option-art.ca
option-art.ca

Orley Shabahang
241 East 58th Street
New York, NY 10022
212.421.5800
fax 212.421.5888
newyork@orleyshabahang.com
orleyshabahang.com

240 South County Road
Palm Beach, FL 33480
561.655.3371
fax 561.655.0037
palmbeach@orleyshabahang.com

223 East Silver Spring Drive
Whitefish Bay, WI 53217
414.332.2486
cell 414.379.3388
fax 414.332.9121
whitefishbay@
 orleyshabahang.com

By Appointment Only
5841 Wing Lake Road
Bloomfield Hills, MI 48301
586.996.5800

Ornamentum
506.5 Warren Street
Hudson, NY 12534
518.671.6770
fax 518.822.9819
info@ornamentumgallery.com
ornamentumgallery.com

P

**Palette Contemporary
Art and Craft**
7400 Montgomery Boulevard NE
Suite 22
Albuquerque, NM 87109
505.855.7777
fax 505.855.7778
palette@qwestoffice.net
palettecontemporary.com

Perimeter Gallery
210 West Superior Street
Chicago, IL 60654
312.266.9473
fax 312.266.7984
perimeterchicago@
 perimetergallery.com
perimetergallery.com

Pistachios
55 East Grand Avenue
Chicago, IL 60611
312.595.9437
fax 312.595.9439
pistachi@ameritech.net
pistachiosonline.com

Portals Ltd
742 North Wells Street
Chicago, IL 60654
312.642.1066
fax 312.642.2991
artisnow@aol.com
portalsgallery.com

S

SABBIA
75 East Walton
Chicago, IL 60611
312.440.0044
fax 312.440.0007
sabbiafinejewelry@hotmail.com
sabbia.com

Scott Jacobson Gallery
114 East 57th Street
New York, NY 10022
212.872.1616
fax 212.872.1617
info@scottjacobsongallery.com
scottjacobsongallery.com

Sherrie Gallerie
694 North High Street
Columbus, OH 43215
614.221.8580
cell 614.226.9595
fax 614.221.8550
sherrie@sherriegallerie.com
sherriegallerie.com

Sienna Gallery
80 Main Street
Lenox, MA 01240
413.637.8386
info@siennagallery.com
siennagallery.com

Silica Galleries
908-A North 3rd Street
Philadelphia, PA 19123
215.627.3655
fax 215.627.3655
silica@silicagalleries.com
silicagalleries.com

Snyderman-Works Galleries
303 Cherry Street
Philadelphia, PA 19106
215.238.9576
fax 215.238.9351
bruce@snyderman-works.com
snyderman-works.com

T

ten472 Contemporary Art
10472 Alta Street
Grass Valley, CA 95945
707.484.2685
fax 707.484.2685
info@ten472.com
ten472.com

1340 Bryant
San Francisco, CA 94103
info@ten472.com
ten472.com

Thomas R. Riley Galleries
28699 Chagrin Boulevard
Cleveland, OH 44122
216.765.1711
cell 614.316.2288
fax 216.765.1311
trr@rileygalleries.com
rileygalleries.com

Turkish Cultural Foundation
1025 Connecticut Avenue NW
Suite 1000
Washington, DC 20036
202.370.1399
fax 202.370.1398
director@turkishculture.org
turkishculturalfoundation.org

W

Wexler Gallery
201 North 3rd Street
Philadelphia, PA 19106
215.923.7030
fax 215.923.7031
info@wexlergallery.com
wexlergallery.com

**The William &
Joseph Gallery**
727 Canyon Road
Santa Fe, NM 87501
505.982.9404
fax 505.982.2321
mary@thewilliamandjoseph
 gallery.com
thewilliamandjosephgallery.com

William Zimmer Gallery
PO Box 263
Mendocino, CA 95460
707.937.5121
fax 707.937.2405
wzg@mcn.org
williamzimmergallery.com

Artists

Åberg, Barbro
Lacoste Gallery

Adla, Ashevak
Galerie Elca London

Alepedis, Efharis
Charon Kransen Arts

Allen, Catherine
Lafrenière & Pai Gallery

Allen, Rik
Blue Rain Gallery

Amariglio Weiss, Lina
Maria Elena Kravetz

Amromin, Pavel
Ann Nathan Gallery

Anagnostou, Alex
Galerie Elena Lee

Anderegg, Wesley
John Natsoulas Gallery

Angelino, Gianfranco
del Mano Gallery

Antemann, Chris
Ferrin Gallery

Arai, Lucy
Snyderman-Works Galleries

Arentzen, Glenda
Aaron Faber Gallery

Arleo, Adrian
Jane Sauer Gallery

Arndt, Ines
Snyderman-Works Galleries

Arneson, Robert
John Natsoulas Gallery

Arthur, Karen
Oliver & Espig

Asaka, Masahiro
Kirra Galleries

Ashevak, Kenojuak
Galerie Elca London

Aslanis, George
Kirra Galleries

Atsiaq, Noo
Galerie Elca London

Autio, Rudy
Donna Schneier Fine Arts
Duane Reed Gallery

Babula, Mary Ann
Chappell Gallery

Bach, Carolyn Morris
William Zimmer Gallery

Baharal, Talya
Pistachios

Bakker, Ralph
Charon Kransen Arts

Barnaby, Margaret
Aaron Faber Gallery

Barney, Christine
Mostly Glass Gallery

Baroja Collet, Juan Luis
DC and Company

Bartels, Rike
Charon Kransen Arts

Barthel, Jamie
Mostly Glass Gallery

Bartley, Roseanne
Charon Kransen Arts

Bauer, Carola
Charon Kransen Arts

Bauer, Ela
Charon Kransen Arts

Bauermeister, Michael
del Mano Gallery

Bean, Bennett
William Zimmer Gallery

Beaupré St. Pierre, Dominique
Galerie Elena Lee

Beck, Jeanne
Maria Elena Kravetz

Beck, Rick
Ken Saunders Gallery

Beck, Valerie
Thomas R. Riley Galleries

Becker, Michael
Charon Kransen Arts

Beer, Vivian
William Zimmer Gallery

Beiner, Susan
Next Step Studio & Gallery

Ben Tre, Howard
Habatat Galleries
Wexler Gallery

Bendix, Mary
Portals Ltd

Bennett, David
Habatat Galleries

Bennett, Garry Knox
Scott Jacobson Gallery
William Zimmer Gallery

Bennett, Jamie
Sienna Gallery

Bennett, Jerry
del Mano Gallery

Bennett, Nathan
Maria Elena Kravetz

Bennett, Roger
del Mano Gallery

Bernstein, Alex Gabriel
Chappell Gallery

Bertoncello, Stefano
Galleria San Marco
 Arte & Design

Bettison, Giles
Bullseye Gallery
Jane Sauer Gallery

Bezold, Brigitte
Charon Kransen Arts

Bianchin, Cristiano
Barry Friedman Ltd.

Biggs, Dixie
del Mano Gallery

Bilenker, Melanie
Sienna Gallery

Blackmore, Cassandria
Duane Reed Gallery

Blackmore, Marvin
D & M Fine Arts Ltd.

Blank, Martin
Habatat Galleries

Blavarp, Liv
Charon Kransen Arts

Blazina, Jennifer
Silica Galleries

Bloomfield, Greg
Scott Jacobson Gallery

Bluestone, Rebecca
Chiaroscuro Contemporary Art

Blyfield, Julie
Charon Kransen Arts

Bobrowicz, Yvonne Pacanovsky
Snyderman-Works Galleries

Bodemer, Iris
Sienna Gallery

Body Politics
Ornamentum

Boieri, Daniela
Charon Kransen Arts

Bonaventura, Mauro
Berengo Studio 1989

Borgegard, Sara
Ornamentum

Borghesi, Marco
Aaron Faber Gallery

Borgman, Mary
Ann Nathan Gallery

Borowski, Stanislaw Jan
Habatat Galleries

Bottaro, Silvina
Maria Elena Kravetz

Boucard, Yves
Scott Jacobson Gallery

Bouduban, Sophie
Charon Kransen Arts

Bowers, Bradley
The William & Joseph Gallery

Box, Kevin
Niemi Sculpture
 Gallery & Garden

Boyadjiev, Latchezar
Thomas R. Riley Galleries

Braeuer, Antje
Charon Kransen Arts

Brandes, Juliane
Ornamentum

Bray, Mike
Sienna Gallery

Breadon, Eoin
Thomas R. Riley Galleries

Bremers, Peter
Litvak Gallery

Brill, Dorothea
Ornamentum

Brock, Emily
Habatat Galleries

Bronstein, Leon
Old City Caesarea Gallery

Brooke, Belle
Palette Contemporary
 Art and Craft

Brooks, Lola
Sienna Gallery

Brychtová, Jaroslava
Barry Friedman Ltd.

Bubacco, Lucio
Litvak Gallery

Bucci, Douglas J.
Snyderman-Works Galleries

Buddeberg, Florian
Charon Kransen Arts

Budish, Jim
Niemi Sculpture
 Gallery & Garden

Bump, Raissa
Sienna Gallery

Bunkov, Sergey
Old City Caesarea Gallery

Burchard, Christian
del Mano Gallery

Bussières, Maude
Crea Gallery

Buxton, Mary Ellen
Mostly Glass Gallery

Byers, John Eric
Snyderman-Works Galleries

Caballero, Mariana
Maria Elena Kravetz

Calderwood, Jessica
Ferrin Gallery

Calhoun, Magi
John Natsoulas Gallery

Callan, Nancy
Hawk Galleries

Calmar, Lars
Galleri Udengaard

Camden, Emma
Palette Contemporary
 Art and Craft

Campbell, Marilyn
del Mano Gallery

Cantin, Annie
Galerie Elena Lee

Cantrell, Ned
Galleri Udengaard

Carlin, David
del Mano Gallery

Carlsen, Suzanne
Lafrenière & Pai Gallery

Carlson, William
Ken Saunders Gallery
Scott Jacobson Gallery

Carney, Shannon
Charon Kransen Arts

Casanovas, Claudi
Galerie Besson

Castagna, Pino
Berengo Studio 1989

Castle, Wendell
Barry Friedman Ltd.

Catt, Matt
Next Step Studio & Gallery

Celotto, Afro
William Zimmer Gallery

Cepka, Anton
Charon Kransen Arts

Chakravarty, Jason
Thomas R. Riley Galleries

Chambon, Dominic
DC and Company

Chan, Liu Miao
D & M Fine Arts Ltd.

Chandler, Gordon
Ann Nathan Gallery

Chardiet, José
Ken Saunders Gallery
Scott Jacobson Gallery
Wexler Gallery

Chaseling, Scott
Scott Jacobson Gallery

Chatterley, Mark
Next Step Studio & Gallery

Chavent, Claude
Aaron Faber Gallery

Cheminée, Matthieu
Lafrenière & Pai Gallery

Chen, Yu Chun
Charon Kransen Arts

Chesney, Nicole
Heller Gallery

Chi, Lu
Scott Jacobson Gallery

Chihuly, Dale
Donna Schneier Fine Arts
Wexler Gallery

Chin, Grace
Thomas R. Riley Galleries

Choonsun, Moon
Charon Kransen Arts

Cigler, Václav
Litvak Gallery

Cinelli + Maillet
Lafrenière & Pai Gallery

Clague, Lisa
John Natsoulas Gallery

Class, Petra
Aaron Faber Gallery

Clayman, Daniel
Habatat Galleries

Clayton, Deanna
Habatat Galleries

Clayton, Keith
Habatat Galleries

Clements, Richard
Kirra Galleries

Cole, Josh
Thomas R. Riley Galleries

Coleman, Elaine
Sherrie Gallerie

Coleman, Timothy
William Zimmer Gallery

Coleman, Tom
Sherrie Gallerie

Collingwood, Peter
Galerie Besson

Cook, Lia
Perimeter Gallery

Cooper, Diane
Jean Albano Gallery

Cooper, Michael Jean
William Zimmer Gallery

Cooperman, Marilyn
Aaron Faber Gallery

Coper, Hans
Galerie Besson

Copping, Brad
Galerie Elena Lee

Cordova, Cristina
Ann Nathan Gallery

Corvaja, Giovanni
Charon Kransen Arts

Cottrell, Simon
Charon Kransen Arts

Craste, Laurent
Crea Gallery

Crawford, Alastair
Crawford Contemporary

Crawford, David
William Zimmer Gallery

Cribbs, KéKé
Scott Jacobson Gallery
Thomas R. Riley Galleries

Crossman-Moore, Gail
Mostly Glass Gallery

Crow, Nancy
Snyderman-Works Galleries

Cunningham, Jack
Aaron Faber Gallery

Curtis, Matthew
Thomas R. Riley Galleries

Cusack, Kate
Snyderman-Works Galleries

D

Dahm, Johanna
Ornamentum

Dailey, Dan
Scott Jacobson Gallery

Dalton, Tali
Forré & Co. Fine Art

Dam, Steffen
Heller Gallery

D'Aquino, Donna
Ornamentum

Darwall, Mary
Mostly Glass Gallery

De Corte, Annemie
Charon Kransen Arts

DeBusk, Barrett
The William & Joseph Gallery

DeMonte, Claudia
Jean Albano Gallery

Derry, Donald
Thomas R. Riley Galleries

Detering, Saskia
Charon Kransen Arts

Di Caprio, Daniel
Charon Kransen Arts

Di Fiore, Miriam
Mostly Glass Gallery

Dickhoff, Synnöve
Galleria Norsu

Dixon, Iry
Pistachios

Docter, Marcia
Snyderman-Works Galleries

Dodd, John
William Zimmer Gallery

Dohnanyi, Babette von
Charon Kransen Arts

Donat, Ingrid
Barry Friedman Ltd.

Donefer, Laura
Duane Reed Gallery

Donnelly, Chris
The William & Joseph Gallery

Dooley, Scott
Sherrie Gallerie

Dosekci, Ebru
Turkish Cultural Foundation

Doughtie, Sharon
del Mano Gallery

Douglas, Fran
Ferrin Gallery

Draper, Gemma
Ornamentum

Dresang, Paul
Duane Reed Gallery

Drozda, Cindy
del Mano Gallery

Dubuc, Roland
Crea Gallery

Duca, Emanuela
Aaron Faber Gallery

Duckworth, Ruth
Donna Schneier Fine Arts
Galerie Besson

Dunn, J. Kelly
del Mano Gallery

Dunnigan, John
William Zimmer Gallery

Duong, Sam Tho
Ornamentum

Earl, Jack
Perimeter Gallery

Eastman, Michael
Barry Friedman Ltd.

Ebendorf, Robert
Snyderman-Works Galleries

Eberle, Edward
Perimeter Gallery

Ebner, David
William Zimmer Gallery

Echeverria, Carolina
Option Art

Eclat
SABBIA

Edgerley, Susan
Galerie Elena Lee

Edols, Ben
Kirra Galleries

Eggert, Rick
Thomas R. Riley Galleries

Eichenberg, Iris
Ornamentum

Eitzenhoefer, Ute
Ornamentum

Ekegren, Björn
Galleri Udengaard

Ekeland, Ingerid
Oliver & Espig

Elkins, Julie
Sherrie Gallerie

Elliott, Kathy
Kirra Galleries

Ellsworth, David
del Mano Gallery

Elyashiv, Noam
Sienna Gallery

Empson, Tegan
Kirra Galleries

Emrich, Sina
Charon Kransen Arts

Eng, Peggy
Aaron Faber Gallery

Entner, Barry
The Dancing Hands Gallery

Espig, Glenn Manfred
Oliver & Espig

Evans, Judith
Oliver & Espig

F

Faba
Maria Elena Kravetz

Fafard, Joe
Option Art

Falkesgaard, Lina
Charon Kransen Arts

Fanourakis, Lina
SABBIA

Faur, Christian
Sherrie Gallerie

Faye-Chauhan, Maureen
Charon Kransen Arts

Fein, Harvey
del Mano Gallery

Fennell, J. Paul
del Mano Gallery

Fine, Matthew
Maria Elena Kravetz

Finneran, Bean
Perimeter Gallery

Fleischhut, Jantje
Ornamentum

Fløche, Anne
Galerie Besson
Snyderman-Works Galleries

Flowers, Karen
Mostly Glass Gallery

Flynn, Pat
Pistachios

Ford, Steven
Snyderman-Works Galleries

Forlano, David
Snyderman-Works Galleries

Forsythe, Jeffrey
Perimeter Gallery

Foster, Charlene
Silica Galleries

Frank, Peter
Charon Kransen Arts

Franzin, Maria Rosa
Ornamentum

Fredell, Gail
William Zimmer Gallery

Frejd, Martina
Charon Kransen Arts

Frève, Carole
Thomas R. Riley Galleries

Frey, Viola
Donna Schneier Fine Arts

Frith, Donald E.
del Mano Gallery

Frolic, Irene
Habatat Galleries

Fujita, Kyohei
Wexler Gallery

Galazka, Rafal
Mattson's Fine Art

Gall, Ted
Portals Ltd

Ganch, Susie
Sienna Gallery

Garcia, Tammy
Blue Rain Gallery

Garrett, John
Chiaroscuro Contemporary Art

Gasch-Muche, Josepha
Forré & Co. Fine Art
Habatat Galleries

Gavotti, Elizabeth
Maria Elena Kravetz

Geese, Claudia
Charon Kransen Arts

Gelbard, Anat
SABBIA

Gerard, Bruno
Crea Gallery

Gerhard, Angela
Palette Contemporary
 Art and Craft

Gilbert, Chantal
Crea Gallery

Gilbert, Karen
Sherrie Gallerie
Snyderman-Works Galleries

Giles, Mary
Duane Reed Gallery

Gill, Emily
Lafrenière & Pai Gallery

Gill, John
Lacoste Gallery

Gilmore, Jacqueline
Forré & Co. Fine Art

Glancy, Michael
Barry Friedman Ltd.
Wexler Gallery

Godbout, Rosie
Option Art

Goldblatt, Cherry
Thomas R. Riley Galleries

Gonzalez, Arthur
John Natsoulas Gallery

Good, Michael
Aaron Faber Gallery

Gore, Caroline
Ornamentum

Gorman, Geoffrey
Jane Sauer Gallery

Goss, Sandra Noble
Lafrenière & Pai Gallery

Gosti, Jean-Yves
DC and Company

Gralnick, Lisa
Ornamentum

Gray, Robert
del Mano Gallery

Greef, Willemijn de
Charon Kransen Arts

Gross, Michael
Ann Nathan Gallery

Gruss, Scott
ten472 Contemporary Art

Gudmann, Elisabett
ten472 Contemporary Art

Guendra, Batho
Ornamentum

Guévin, Karina
Crea Gallery

Gustin, Chris
Sherrie Gallerie

Hackenberg, Gesine
Sienna Gallery

Hagmann, Birgit
Charon Kransen Arts

Halabi, Sol
Maria Elena Kravetz

Halt, Karen
Portals Ltd

Hamada, Shoji
Galerie Besson

Hanagarth, Sophie
Charon Kransen Arts

Harari, Yossi
SABBIA

Harris, Jamie
Duane Reed Gallery

Harris, Mark
Thomas R. Riley Galleries

Hart, Noel
Jane Sauer Gallery

Hash, Arthur
Sienna Gallery

Hawk, Leslie
Hawk Galleries

Hayes, Peter
Ann Nathan Gallery

Hedman, Hanna
Ornamentum

Heindl, Anna
Charon Kransen Arts

Heinemann, Steve
Lacoste Gallery

Heinrich, Barbara
Aaron Faber Gallery

Helmich, Susan
Oliver & Espig

Henry, Sean
John Natsoulas Gallery

Heskett-Brem, Lucie
Aaron Faber Gallery

Hessler, Robert
Next Step Studio & Gallery

Heuser, Stefan
Ornamentum

Higashi, April
Aaron Faber Gallery

Higuchi, Kimiake
Wexler Gallery

Hill, Chris
Ann Nathan Gallery

Hiller, Mirjam
Charon Kransen Arts

Hinz, Leonore
Charon Kransen Arts

Hirst, Brian
Wexler Gallery

Hlavicka, Tomas
Habatat Galleries
Wexler Gallery

Hoch Mintzberg, Yvette
Option Art

Hoefer, Eric
Next Step Studio & Gallery

Holmes, Elodie
The William & Joseph Gallery

Holmes, Kathleen
Chappell Gallery

Holt, Lisa
Chiaroscuro Contemporary Art

Holzapfel, Michelle
del Mano Gallery

Hopkins, Elizabeth
Mostly Glass Gallery

Hopkins, Jan
Jane Sauer Gallery

Hora, Petr
Habatat Galleries

Horn, Robyn
del Mano Gallery

Hosaluk, Michael
del Mano Gallery

Hosking, Marian
Charon Kransen Arts

Houserova, Ivana
Scott Jacobson Gallery

Howe, Brad
Adamar Fine Arts

Huang, David
del Mano Gallery

Huchthausen, David
Scott Jacobson Gallery

Hucker, Tom
William Zimmer Gallery

Huff, Melissa
Aaron Faber Gallery

Hughes, Linda
Charon Kransen Arts

Huh, K Hyewook
Palette Contemporary
Art and Craft

Hunter, William
del Mano Gallery

Hurwitz, Michael
William Zimmer Gallery

Hutter, Sidney
Ken Saunders Gallery

Iezumi, Toshio
Chappell Gallery

Ikemoto, Kazumi
Chappell Gallery

Ilkerl, Hildegund
Mostly Glass Gallery

Inbar, Tolla
Adamar Fine Arts

Irvine, Alex
Snyderman-Works Galleries

Isaacs, Ron
Snyderman-Works Galleries

Ishida, Meiri
Charon Kransen Arts

Ishiyama, Reiko
Charon Kransen Arts

**Israel, The Estate of
Margaret Ponce**
Perimeter Gallery

Isupov, Sergei
Ferrin Gallery

Iversen, John
Ornamentum

Iwata, Hiroki
Charon Kransen Arts

Iwata, Kiyomi
Perimeter Gallery

Izumi, May
John Natsoulas Gallery

Janacek, Vlastislav
Mostly Glass Gallery

Janich, Hilde
Charon Kransen Arts

Janis, Michael
Maurine Littleton Gallery

Janosik, Andrea
Charon Kransen Arts

Jensen, Mette
Charon Kransen Arts

Jeong, Eun Yeong
Charon Kransen Arts

Jivetin, Sergey
Ornamentum

Jocz, Dan
Ornamentum

Jolley, Richard
Scott Jacobson Gallery

Jones, Meghann
Charon Kransen Arts

Joolingen, Machteld van
Charon Kransen Arts

Jordan, John
del Mano Gallery

Juen, Lisa
Charon Kransen Arts

Juenger, Ike
Charon Kransen Arts

Jung, Junwon
Charon Kransen Arts

Jung, Sunmi
Lafrenière & Pai Gallery

K

Kaczynski, Pawel
Pistachios

Kajaniemi, Aino
Galleria Norsu

Kallenberger, Kreg
Duane Reed Gallery
Scott Jacobson Gallery

Kalman, Lauren
Sienna Gallery

Kamata, Jiro
Ornamentum

Kang, Yeonmi
Charon Kransen Arts

Karnes, Karen
Galerie Besson

Kataoka, Masumi
Charon Kransen Arts

Kaube, Susanne
Charon Kransen Arts

Kaufmann, Martin
Charon Kransen Arts

Kaufmann, Ulla
Charon Kransen Arts

Keelan, Margaret
John Natsoulas Gallery

Kerman, Janis
Option Art

Khanna, Charla
Jane Sauer Gallery

Kicinski, Jennifer Howard
Charon Kransen Arts

Kilkus, Jeremy
Charon Kransen Arts

Kilpatrick, Annabel
Kirra Galleries

Kim, Jeong Yoon
Charon Kransen Arts

Kim, Jimin
Charon Kransen Arts

Kim, Myungjin
Ferrin Gallery

Kim, Seung-Hee
Charon Kransen Arts

Kim, Sun Kyoung
Charon Kransen Arts

Kindler, Judith
Forré & Co. Fine Art

King, Brent
Kirra Galleries

Klingebiel, Jutta
Ornamentum

Klockmann, Beate
Ornamentum

Knowles, Sabrina
Duane Reed Gallery

Kobylinska, Barbara
Maria Elena Kravetz

Koehne, Christiane
Charon Kransen Arts

Kohl-Spiro, Barbara
Portals Ltd

Kojima, Yukako
Palette Contemporary
 Art and Craft

Konstantino
Oliver & Espig

Kopf, Silas
William Zimmer Gallery

Krakowski, Yael
Charon Kransen Arts

Kretchmer, Claudia
Oliver & Espig

Kretchmer, Steven
Oliver & Espig

Krimmer, Bebe
Chiaroscuro Contemporary Art

Krol, Monika
Sienna Gallery

Kuestner, Gabrile
Mostly Glass Gallery

Kuhn, Jon
Ken Saunders Gallery

Kuriyama, Hitoshi
Berengo Studio 1989

Kutch, Kevin
Mostly Glass Gallery

L

La Scola, Judith
Habatat Galleries
Maurine Littleton Gallery

Labino, Dominick
Wexler Gallery

Labonté, Catherine
Crea Gallery

Lach, Elfrun
Charon Kransen Arts

Lake, Tai
William Zimmer Gallery

Lamar, Stoney
del Mano Gallery

Lapka, Eva
Crea Gallery

Larochelle, Christine
Crea Gallery

Larzelere, Judith
Snyderman-Works Galleries

Lasak, Przemyslaw
Mattson's Fine Art

Latva-Somppi, Riikka
Galleria Norsu

Latven, Bud
del Mano Gallery

Layport, Ron
del Mano Gallery

Layton, Peter
Mattson's Fine Art

Leavitt, Gail
Charon Kransen Arts

Lee, Dongchun
Charon Kransen Arts

Lee, Hongsock
Aaron Faber Gallery

Lee, Jiyong
Duane Reed Gallery

Leedy, Jim
Lacoste Gallery

Leest, Felieke van der
Charon Kransen Arts

Légaré, Lynn
Crea Gallery

Lehman, Max
Ferrin Gallery

Lehmann, Nicole
Charon Kransen Arts

Lehtinen, Helena
Ornamentum

Lemanski, Anne
Ferrin Gallery

Lemieux-Berube, Louise
Crea Gallery

Lentsch, Edward
Forré & Co. Fine Art

Leperlier, Antoine
Habatat Galleries

Lepisto, Jeremy
Thomas R. Riley Galleries

Lepore, Marcia
Mostly Glass Gallery

Leputa, Mark
Silica Galleries

Lewis, John
Scott Jacobson Gallery

Lewton-Brain, Charles
Lafrenière & Pai Gallery

Libenský, Stanislav
Barry Friedman Ltd.

Lieglein, Wolli
Ornamentum

Lingwood, Rex
Option Art

Linkin, Nancy
Oliver & Espig

Linssen, Jennifer Falck
del Mano Gallery

Linssen, Nel
Charon Kransen Arts

Lipman, Beth
Heller Gallery

Lipofsky, Marvin
Duane Reed Gallery

Littleton, Harvey
Donna Schneier Fine Arts
Maurine Littleton Gallery
Wexler Gallery

Littleton, John
Maurine Littleton Gallery

Lockau, Kevin
Lafrenière & Pai Gallery

Loeser, Thomas
Scott Jacobson Gallery
William Zimmer Gallery

Loew, Susanna
Charon Kransen Arts

Lomné, Alicia
Thomas R. Riley Galleries

Longyear, Robert
Charon Kransen Arts

Lorriman, Jim
Option Art

Loughlin, Jessica
Bullseye Gallery

Louppe, Veronique
Option Art

Low Beer, Susan
Option Art

Lozar, Carmen
Ken Saunders Gallery

Lucero, Michael
Donna Schneier Fine Arts
John Natsoulas Gallery

Luck, Christina
Lafrenière & Pai Gallery

Lukacsi, Laszlo
Habatat Galleries

Lunardon, Massimo
Berengo Studio 1989

Luttin, Sim
Charon Kransen Arts

Lydon, Christopher
Silica Galleries

Lynch, Sydney
Aaron Faber Gallery

Lyon, Lucy
Thomas R. Riley Galleries

Lyons, Tanya
Galerie Elena Lee

M

Maberley, Simon
Kirra Galleries

Macdonell, Jay
Option Art

Machata, Peter
Charon Kransen Arts

MacKenzie, Warren
Lacoste Gallery

MacNeil, Linda
Scott Jacobson Gallery

Mailland, Alain
del Mano Gallery

Majoral, Enric
Aaron Faber Gallery

Mäkelä, Maarit
Galleria Norsu

Makio, Chihiro
Aaron Faber Gallery

Makins, James
Donna Schneier Fine Arts

Malek, Gabriele
Mostly Glass Gallery

Malone, Cheryl
Portals Ltd

Maloof, Sam
del Mano Gallery

Mannella, C. Pazia
Snyderman-Works Galleries

Marchetti, Stefano
Charon Kransen Arts

Margolin, Jeff
The Dancing Hands Gallery

Marioni, Dante
Ken Saunders Gallery
Wexler Gallery

Marks, Bruce
Mattson's Fine Art

Marks-Swanson, Brooke
Aaron Faber Gallery

Marquart, Allegra
Maurine Littleton Gallery

Marquis, Richard
Maurine Littleton Gallery
Wexler Gallery

Marsh, Bert
del Mano Gallery

Martikainen, Outi
Galleria Norsu

Maruyama, Wendy
William Zimmer Gallery

Mason, Vicki
Charon Kransen Arts

Massey, Sharon
Charon Kransen Arts

Matikainen, Tiia
Galleria Norsu

Matthews, Leslie
Charon Kransen Arts

Matthias, Christine
Charon Kransen Arts

Mattia, Alphonse
William Zimmer Gallery

Mayeri, Beverly
Perimeter Gallery

Mazzoni, Ana
Maria Elena Kravetz

McAllister, Wendy
Charon Kransen Arts

McClellan, Duncan
Mattson's Fine Art

McCavour, Amanda
Lafrenière & Pai Gallery

McCurry, Steve
D & M Fine Arts Ltd.

McGlauchlin, Tom
Palette Contemporary
 Art and Craft

McIntyre, Mary K.
Lafrenière & Pai Gallery

McKnight, Rachel
Charon Kransen Arts
Snyderman-Works Galleries

McMahon, Timothy
Charon Kransen Arts

Mercier, Réjane
Crea Gallery

Meszaros, Mari
Duane Reed Gallery

Metcalf, Bruce
Snyderman-Works Galleries

Meyer, Gudrun
Pistachios

Meyer, Sharon
Sherrie Gallerie

Michaels, Guy
del Mano Gallery

Michikawa, Shozo
Galerie Besson

Migdal, Zammy
Adamar Fine Arts

Miles, Gino
ten472 Contemporary Art

Miller, John
Thomas R. Riley Galleries

Millett, Peter
Chiaroscuro Contemporary Art

Miltenberger, Janis
Thomas R. Riley Galleries

Mimlitsch-Gray, Myra
Sienna Gallery

Miner, Charlie
Habatat Galleries

Minkkinen, Arno Rafael
Barry Friedman Ltd.

Minkowitz, Norma
Perimeter Gallery

Minnhaar, Gretchen
Adamar Fine Arts

Mirabelli, Milo
Thomas R. Riley Galleries

Misher, Karen
Snyderman-Works Galleries

Mishima, Ritsue
Hedge

Møhl, Tobias
Heller Gallery

Moje, Klaus
Bullseye Gallery
Wexler Gallery

Molettiere, Jillian
Mostly Glass Gallery

Monterrubio, Gerardo
Ferrin Gallery

Monzo, Marc
Ornamentum

Moore, Debora
Habatat Galleries

Moore, William
del Mano Gallery

Moran, John
Thomas R. Riley Galleries

Morel, Sonia
Charon Kransen Arts

Morin, Hilde
Maria Elena Kravetz

Morinoue, Hiroki
William Zimmer Gallery

Morris, William
Barry Friedman Ltd.
Hawk Galleries
Litvak Gallery
Wexler Gallery

Morrissey, Patrick
The William & Joseph Gallery

Moseholm, Keld
Galleri Udengaard

Moty, Eleanor
Perimeter Gallery

Moulthrop, Ed
del Mano Gallery

Moulthrop, Matt
del Mano Gallery

Moulthrop, Philip
del Mano Gallery
Donna Schneier Fine Arts

Mount, Nick
Thomas R. Riley Galleries

Mullertz, Malene
Lacoste Gallery

Munsen, Mel
Option Art

Munsteiner, Bernd
Aaron Faber Gallery
Oliver & Espig

Munsteiner, Tom
Aaron Faber Gallery
Oliver & Espig

Musler, Jay
Ken Saunders Gallery

Mustonen, Eija
Ornamentum

Muzylowski Allen, Shelley
Blue Rain Gallery

Myers, Joel Philip
Donna Schneier Fine Arts
Wexler Gallery

Myers, Rebecca
Next Step Studio & Gallery

Naphtali, Ayala
Pistachios

Naranjo, Kevin
D & M Fine Arts Ltd.

Nash, Woodrow
Higgins Harte
 International Galleries
Thomas R. Riley Galleries

Negri, Martie
Mostly Glass Gallery

Newell, Brian
William Zimmer Gallery

Newell, Catharine
Bullseye Gallery

Newman, Richard Scott
William Zimmer Gallery

Nez, Wallace
D & M Fine Arts Ltd.

Niemi, Bruce A.
Niemi Sculpture
 Gallery & Garden

Nijland, Evert
Charon Kransen Arts

Nilsson, Gladys
Jean Albano Gallery

Nishi, Etsuko
Chappell Gallery

Niso
Adamar Fine Arts

Nittmann, David
del Mano Gallery

Noten, Ted
Ornamentum

Notkin, Richard
Ferrin Gallery

Nuetzel, Melanie
Charon Kransen Arts

Nuis, Carla
Charon Kransen Arts

Ohira, Yoichi
Barry Friedman Ltd.
Wexler Gallery

O'Kelly, Angela
Charon Kransen Arts

Ordorica, Elise
Mostly Glass Gallery

Ostapovici, Svetlana
Galleria San Marco
 Arte & Design

Osterrieder, Daniela
Charon Kransen Arts

Ouellette, Caroline
Crea Gallery

Paavola, Maija
Galleria Norsu

Paganin, Barbara
Charon Kransen Arts

Paikkari, Pekka
Galleria Norsu

Pappas, Marilyn
Snyderman-Works Galleries

Parcher, Joan
Ornamentum

Pardon, Earl
Aaron Faber Gallery

Pardon, Tod
Aaron Faber Gallery

Park, So Young
Aaron Faber Gallery

Parr, Nuna
Galerie Elca London

Patti, Tom
Wexler Gallery

Pattihis, Liana
Charon Kransen Arts

Payette, Gilles
Crea Gallery

Peiser, Mark
Ken Saunders Gallery
Wexler Gallery

Pembridge, Gordon
del Mano Gallery

Perez, Jesus Curia
Ann Nathan Gallery

Perkins, Danny
Duane Reed Gallery

Perkins, Flo
Chiaroscuro Contemporary Art

Peters, David
del Mano Gallery

Peters, Ruudt
Ornamentum

Peterson, George
del Mano Gallery

Peterson, Michael
del Mano Gallery

Petrovic, Marc
Thomas R. Riley Galleries

Petter, Gugger
Jane Sauer Gallery

Phardel, Tom
Next Step Studio & Gallery

Philbrick, Timothy
William Zimmer Gallery

Philp, Paul
Hedge

Pho, Binh
del Mano Gallery
Thomas R. Riley Galleries

Picaud, Fabienne
Mostly Glass Gallery

Pigott, Gwyn Hanssen
Galerie Besson

Pinchuk, Natalya
Charon Kransen Arts

Piqtoukun, David Ruben
Galerie Elca London

Pohlman, Jenny
Duane Reed Gallery

Pollitt, Harry
del Mano Gallery

Pon, Stephen
Crea Gallery

Pootoogook, Annie
Galerie Elca London

Pootoogook, Kananginak
Galerie Elca London

Popelka, Jeremy
Thomas R. Riley Galleries

Potter, Anne Drew
Ann Nathan Gallery

Potter, Richard
The William & Joseph Gallery

Powell, Stephen Rolfe
Ken Saunders Gallery

Powning, Peter
Lafrenière & Pai Gallery

Prasch, Camilla
Ornamentum

Preston, Mary
Ornamentum

Priddle, Graeme
del Mano Gallery

Priest, Linda Kindler
Aaron Faber Gallery

Primeau, Patrick
Crea Gallery

Prins, Katja
Ornamentum

Puchowitz, Zachary
Silica Galleries

Purcell, Nathan
Silica Galleries

R

Radda, Tania
del Mano Gallery

Radvanyi, Kalman
del Mano Gallery

Rainey, Clifford
Habatat Galleries

Rainville, Seth
Ferrin Gallery

Rand, Elizabeth
William Zimmer Gallery

Randal, Seth
Scott Jacobson Gallery

Randall, Doug
Thomas R. Riley Galleries

Rankin, Susan
Option Art

Rascal
Higgins Harte
 International Galleries

Rauteva-Tuomainen, Rita
Galleria Norsu

Ray, Leo
Old City Caesarea Gallery

Read, Sarah
Charon Kransen Arts

Reano, Harlan
Chiaroscuro Contemporary Art

Recko, Gateson
Mostly Glass Gallery

Reekie, David
Thomas R. Riley Galleries

Regan, David
Barry Friedman Ltd.

Reid, Colin
Maurine Littleton Gallery

Reitz, Don
Lacoste Gallery

Remusat, Bernard
DC and Company

Rhoads, Kait
Chappell Gallery

Richardson, Joey
del Mano Gallery

Richmond, Lesley
Jane Sauer Gallery

Ricks, Madelyn
Mostly Glass Gallery

Rie, Lucie
Galerie Besson

Ries, Christopher
Hawk Galleries

Riis, Jon Eric
Jane Sauer Gallery

Ripolles, Juan
Berengo Studio 1989

Ritter, Richard
Ken Saunders Gallery

Robert'ó,
Galleria San Marco
 Arte & Design

Roberts, Constance
Portals Ltd

Robertson, Donald
Galerie Elena Lee

Robertson, Zoe
Charon Kransen Arts

Rogers, Michael
Bullseye Gallery

Rogers, Sally
Thomas R. Riley Galleries

Rojas, Carolina
Maria Elena Kravetz

Rose, Jim
Ann Nathan Gallery

Rose, Marlene
Adamar Fine Arts

Rosenfeld, Ken
The William & Joseph Gallery

Rosenthal, Donna
Jean Albano Gallery

Rosenthal, Sylvie
William Zimmer Gallery

Rossbach, Ed
Donna Schneier Fine Arts

Rothmann, Gerd
Ornamentum

Roussel, Anthony
Charon Kransen Arts

Rowan, Tim
Lacoste Gallery

Rowe, Keith
Mattson's Fine Art

Royal, Richard
Ken Saunders Gallery

Ruffner, Ginny
Maurine Littleton Gallery

Rundy, Paul
Next Step Studio & Gallery

Russell, Brian
Forré & Co. Fine Art

Russell-Pool, Kari
Thomas R. Riley Galleries

Ruzsa, Alison
Mostly Glass Gallery

Ryan, Jackie
Charon Kransen Arts

Rydmark, Cheryl
William Zimmer Gallery

S

Sajet, Philip
Ornamentum

Saladino, Susan
Jean Albano Gallery

Salvador, Andrea
Berengo Studio 1989

Salvadore, Davide
Habatat Galleries

Samplonius, David
Option Art

Sand, Toland
Jane Sauer Gallery

Sanderson, Joel
Portals Ltd

Sano, Takeshi
Chappell Gallery

Sano, Youko
Chappell Gallery

Santillana, Laura de
Barry Friedman Ltd.
Wexler Gallery

Sarneel, Lucy
Charon Kransen Arts

Savageau, Ann
Jean Albano Gallery

Sawyer, George
Oliver & Espig

Sawyer, Ted
Bullseye Gallery

Saxe, Adrian
Donna Schneier Fine Arts

Saylan, Merryll
del Mano Gallery

Scarpino, Betty
del Mano Gallery

Schaupp, Isabell
Charon Kransen Arts

Schick, Marjorie
Charon Kransen Arts

Schleeh, Colin
Crea Gallery

Schmid, Peter
Aaron Faber Gallery

Schmitz, Claude
Charon Kransen Arts

Schneider, Jason
del Mano Gallery

Schneider, Keith
Sherrie Gallerie

Schreiber, Constanze
Ornamentum

Schriber, James
William Zimmer Gallery

Schuerenkaemper,
Frederike
Charon Kransen Arts

Schwarz, David
Ken Saunders Gallery

Schwarzrock, Harriet
Thomas R. Riley Galleries

Scoon, Thomas
Ken Saunders Gallery

Scott, Brian
The William & Joseph Gallery

Scott, Joyce
Snyderman-Works Galleries

Seeman, Bonnie
Duane Reed Gallery

Segal, Adrien Rutigliano
del Mano Gallery

Seide, Paul
Scott Jacobson Gallery

Seidenath, Barbara
Sienna Gallery

Sepkus, Alex
SABBIA

Serritella, Eric
del Mano Gallery

Seufert, Karin
Charon Kransen Arts

Shaa, Axangayuk
Galerie Elca London

Shabahang, Bahram
Orley Shabahang

Sharky, Toonoo
Galerie Elca London

Shaw, Richard
John Natsoulas Gallery

Shaw, Tim
Kirra Galleries

Sheezel, Debbie
Charon Kransen Arts

Sherman, Sondra
Sienna Gallery

Shimazu, Esther
John Natsoulas Gallery

Shinn, Carol
Jane Sauer Gallery

Shockley, Tim
Maria Elena Kravetz

Shuldiner, Joseph
Perimeter Gallery

Sicuro, Giovanni
Ornamentum

Sieber Fuchs, Verena
Charon Kransen Arts

Siesbye, Alev Ebüzziya
Galerie Besson
Lacoste Gallery

Silverstein, Aaron
Hedge

Simpson, Tommy
Scott Jacobson Gallery

Singletary, Preston
Blue Rain Gallery

Sinner, Steve
del Mano Gallery

Slaughter, Kirk H.
ten472 Contemporary Art

Smith, Barbara Lee
Snyderman-Works Galleries

Smith, Hayley
del Mano Gallery

Smith, Howard
Galerie Besson

Smith, Vanessa L.
Perimeter Gallery

Soest, Roos van
Charon Kransen Arts

Somerson, Rosanne
William Zimmer Gallery

Son, Kye-Yeon
Lafrenière & Pai Gallery

Soosloff, Philip
Thomas R. Riley Galleries

Sophocleous, Despo
Lafrenière & Pai Gallery

Spano, Elena
Charon Kransen Arts

Speckner, Bettina
Sienna Gallery

Spitzer, Silke
Ornamentum

Stanger, Jay
Scott Jacobson Gallery

Stankard, Paul
Ken Saunders Gallery

Stankiewicz, Mirek
Mattson's Fine Art

Staschke, Dirk
Wexler Gallery

Statom, Therman
Maurine Littleton Gallery

Stealey, Jo
Snyderman-Works Galleries

Stebler, Claudia
Ornamentum

Steepy, Tracy
Sienna Gallery

Steinberg, Eva
Snyderman-Works Galleries

Stern, Ethan
Chappell Gallery

Storms, Jack
Mattson's Fine Art

Stout, Jacob
Thomas R. Riley Galleries

Strokowsky, Cathy
Galerie Elena Lee

Strommen, Jay
Perimeter Gallery

Strong, Randy
The Dancing Hands Gallery

Stubbs, Crystal
Kirra Galleries

Stutman, Barbara
Charon Kransen Arts

Suidan, Kaiser
Next Step Studio & Gallery

Sumiya, Yuki
Charon Kransen Arts

Superior, Mara
Ferrin Gallery

Sutton, Polly Adams
Jane Sauer Gallery

Suzuki, Goro
Lacoste Gallery

Swim, Laurie
del Mano Gallery

Syvanoja, Janna
Charon Kransen Arts

Tagliapietra, Lino
Donna Schneier Fine Arts
Hawk Galleries
Holsten Galleries
Wexler Gallery

Takaezu, Toshiko
Perimeter Gallery

Takahiro, Kondo
Barry Friedman Ltd.

Takamori, Akio
Barry Friedman Ltd.
Donna Schneier Fine Arts

Talanpoika, Ritta
Galerie Besson

Tang, Brendan
Option Art

Tate, Tim
Maurine Littleton Gallery

Taylor, Michael
Scott Jacobson Gallery

Tekcan, Suleyman Saim
Turkish Cultural Foundation

Thakker, Salima
Charon Kransen Arts

Thompson, Cappy
Hawk Galleries
Scott Jacobson Gallery

Thompson, Joanne
Charon Kransen Arts

Tiffen, Ira
Mostly Glass Gallery

Tolvanen, Terhi
Charon Kransen Arts

Tomasi, Henriette
Charon Kransen Arts

Tomlinson, Milton
Portals Ltd

Toso, Gianni
Scott Jacobson Gallery

Toth, Margit
Habatat Galleries

Toubes, Xavier
Perimeter Gallery

Townsend, Kent
William Zimmer Gallery

Tracy, Joe
William Zimmer Gallery

Trekel, Silke
Charon Kransen Arts

Trenchard, Stephanie
Thomas R. Riley Galleries

Tridenti, Fabrizio
Charon Kransen Arts

Trubitz, Suzi
Maria Elena Kravetz

Trudell, Shannon
Ferrin Gallery

Truman, Catherine
Charon Kransen Arts

Tsai, Chang-Ting
Charon Kransen Arts

Tunnillie, Ashevak
Galerie Elca London

Tunnillie, Ovilu
Galerie Elca London

Turner, Julia
Ornamentum

Tuupanen, Tarja
Ornamentum

Urruty, Joël
del Mano Gallery

Vagi, Flora
Charon Kransen Arts

Vallien, Bertil
Donna Schneier Fine Arts
Wexler Gallery

van Aswegen, Johan
Sienna Gallery

Van Der Laan, Christel
Charon Kransen Arts

Vangso, Hans
Snyderman-Works Galleries

Vardar, Emel
Turkish Cultural Foundation

Varga, Emma
Kirra Galleries

Veers, Lilli
Charon Kransen Arts

Veilleux, Luci
Crea Gallery

Velarde, Kukuli
Barry Friedman Ltd.

Vermandere, Peter
Charon Kransen Arts

Vesery, Jacques
del Mano Gallery

Vigliaturo, Silvio
Berengo Studio 1989

Vilkman, Jari-Pekka
Galleria Norsu

Violette, Jenifer
Thomas R. Riley Galleries

Vipul, Jain
Forré & Co. Fine Art

Virden, Jerilyn
Ann Nathan Gallery

Vizner, Frantisek
Barry Friedman Ltd.
Wexler Gallery

Vogel, Kate
Maurine Littleton Gallery

Vogt, Jette
Thomas R. Riley Galleries

Vogt, Luzia
Ornamentum

W

Wagner, April
Next Step Studio & Gallery

Wagner, Karen
Charon Kransen Arts

Walden, Dawn
Jane Sauer Gallery

Walentynowicz, Janusz
Ken Saunders Gallery
Wexler Gallery

Walgate, Wendy
Option Art

Walker, Jason
Ferrin Gallery

Walter, Julia
Charon Kransen Arts

Wander, Robert
Oliver & Espig

Warren, Grace Ann
Next Step Studio & Gallery

Watanuki, Yasunori
Charon Kransen Arts

Weidman, Derek
del Mano Gallery

Weiland, Julius
Litvak Gallery

Weinberg, Steven
D & M Fine Arts Ltd.
Scott Jacobson Gallery
Wexler Gallery

Weiser, Kurt
Ferrin Gallery

Weiss, Caroline
Charon Kransen Arts

Weissflog, Hans
del Mano Gallery

Weissflog, Jakob
del Mano Gallery

Weldon-Sandlin, Red
Ferrin Gallery

Wharton, Margaret
Jean Albano Gallery

Whitney, Ginny
Aaron Faber Gallery

Wickman, Dick
Perimeter Gallery

Wilbat, James
Mattson's Fine Art

Willcox, Kimberly
Niemi Sculpture
 Gallery & Garden

Willemstijn, Francis
Charon Kransen Arts

Williams, Anna
Lafrenière & Pai Gallery

Winter, Jasmin
Charon Kransen Arts

Winton, Molly
del Mano Gallery

Wirasekara, Sharmini
Mostly Glass Gallery

Wise, Jeff
William Zimmer Gallery

Wise, Susan
William Zimmer Gallery

Wittrock, Grethe
Snyderman-Works Galleries

Wolfe, Andi
del Mano Gallery

Wolfe, Rusty
William Zimmer Gallery

Wolff, Ann
Forré & Co. Fine Art
Habatat Galleries
Scott Jacobson Gallery

Woo, Jin-Soon
Charon Kransen Arts

Woodford, Lawrence
Lafrenière & Pai Gallery

Woodman, Betty
Donna Schneier Fine Arts

Wunderlich, Janis Mars
Sherrie Gallerie

Yagi, Yoko
Snyderman-Works Galleries

Yamano, Hiroshi
Thomas R. Riley Galleries

Yang, Loretta
Scott Jacobson Gallery

Yanow, Vanessa
Option Art

Yi, Jung-Gyu
Charon Kransen Arts

Yilmaz, Ebru
Turkish Cultural Foundation

York, Julie
Perimeter Gallery

Young, Brent Kee
Jane Sauer Gallery

Youngman, Phillip
Oliver & Espig

Youngquist, Betsy
Next Step Studio & Gallery

Yuh, SunKoo
Lacoste Gallery

Z

Zaborski, Maciej
Mattson's Fine Art

Zahm, Philip
Oliver & Espig

Zanella, Annamaria
Charon Kransen Arts

Zertova, Jirina
Scott Jacobson Gallery

Zhitneva, Sasha
Chappell Gallery

Zimmermann, Petra
Ornamentum

Zobel, Michael
Aaron Faber Gallery
SABBIA

Zwierzynska, Patrycja
Lafrenière & Pai Gallery

Zynsky, Toots
Barry Friedman Ltd.

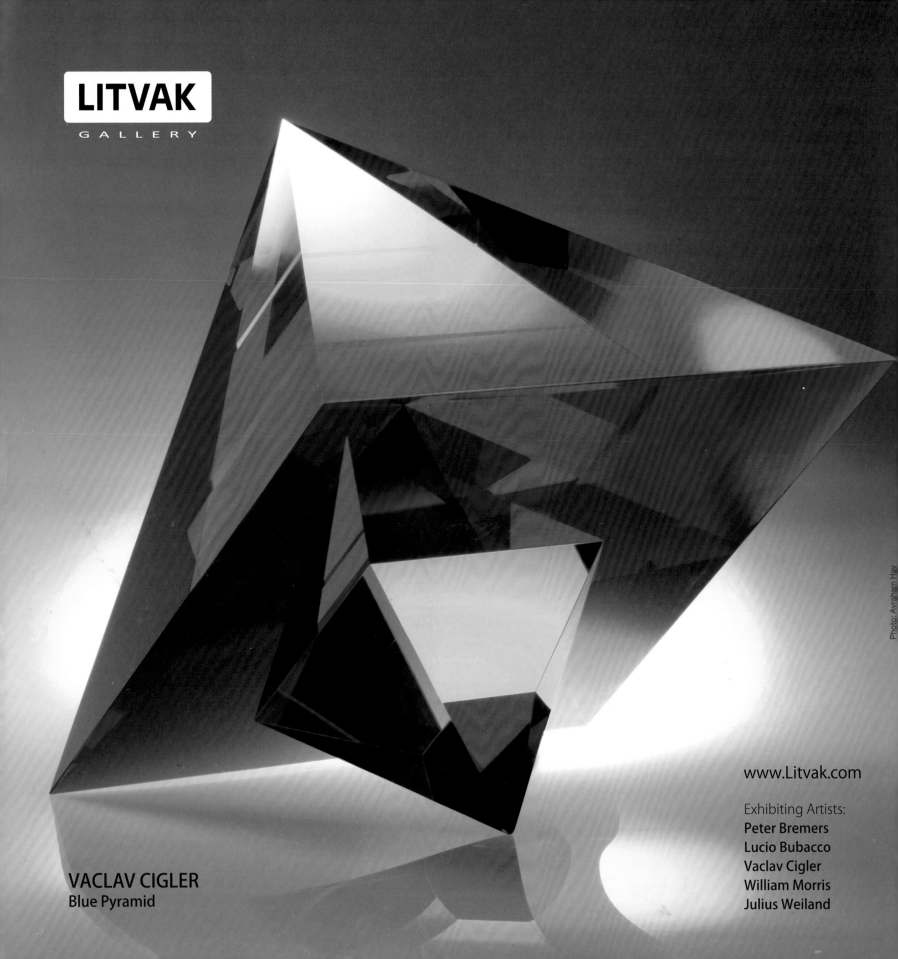

LITVAK
GALLERY

Photo: Avraham Hav

www.Litvak.com

Exhibiting Artists:
Peter Bremers
Lucio Bubacco
Vaclav Cigler
William Morris
Julius Weiland

VACLAV CIGLER
Blue Pyramid